ADAM DUCKWORTH
THE FLASH PHOTOGRAPHY FIELD GUIDE

Shaping the light to suit your photographs

I L E X

First published in the UK in 2012 by
ILEX
210 High Street
Lewes
East Sussex BN7 2NS
www.ilex-press.com

Copyright © 2012 The Ilex Press Limited

Publisher: Alastair Campbell
Associate Publisher: Adam Juniper
Creative Director: James Hollywell
Managing Editor: Natalia Price-Cabrera
Editor: Tara Gallagher
Specialist Editor: Frank Gallaugher
Senior Designer: Kate Haynes
Designer: Jon Allan
Illustrator: John Woodcock
Colour Origination: Ivy Press Reprographics

British Library Cataloguing-in-Publication Data
A catalogue record for this book is available from
the British Library.

ISBN: 978-1-907579-91-2

Printed and bound in China

10 9 8 7 6 5 4 3

CONTENTS

ADAM DUCKWORTH
THE FLASH PHOTOGRAPHY FIELD GUIDE

INTRODUCTION

All committed photographers continually ask themselves the question, "how can I take better pictures?" Well, there are two steps. The first step is to stand in front of something more interesting! This may sound obvious, but it's a serious point. More broadly, it means that you need to think about what you're photographing: who the subject is, and what they're doing, and also to think about the composition, choice of lens, and the viewpoint.

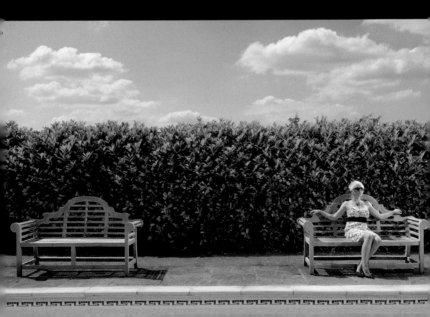

Basics

7

Equipment

Camera setup

Techniques

Ambient light

Lighting

Case studies

Advanced

I wish I could take credit for coming up with the phrase "stand in front of something interesting," but I borrowed it from another photographer, who admitted to stealing it from another—and so it goes on. Now you can pass it off as your own piece of advice!

The second way to improve your shots is to photograph the light. The light can turn your photograph from simply showing what the subject looks like to something far more exciting. Amazing light can turn the most humdrum picture into something interesting, and can transform a good picture into something truly spectacular.

Of course, light is all around us: from natural sunlight, to moonlight, to artificial lights from houses and streetlights. The masters of available-light photography seem to be able to work magic with what is available, using only a few reflectors or diffusers to give it a boost or to manipulate it.

However, when lovely, quality light just isn't there, isn't spectacular, or you aren't able to wait for that sunset or sunrise, there is another option—to create and control your own light using flash. If you've only ever used your camera's onboard flash or a flashgun fastened to the hotshoe, then chances are you've had disappointing results. Hard, unflattering shadows, red eye, and a loss of natural atmosphere are regular complaints from photographers who often go to extreme lengths to avoid using strobe power. There is a way to utilize flash properly, however. Taking control of your flash, changing its position relative to the subject, and altering its light output via different modifiers is a great way to achieve amazing, professional-quality results.

Using flash in this way was previously the reserve of the well-kitted professional, armed with years of technical knowledge and experience. Nowadays, however, it's far easier and cheaper thanks to built-in wireless triggering systems and a glut of aftermarket accessories. Also, with digital photography you can see the results instantly on your LCD screen, which is a massive aid to getting well-lit images. *The Flash Photography Field Guide* aims to counsel you in how to effectively use your flashgun, as well as to inspire you with some great images and details of how they were taken.

OPPOSITE

A stunning poolside location and a pretty model are the basis of a potentially good image, but harsh overhead sun ruined the light on the model. A flash, just out of frame to the right, reduces the harsh shadows. *Nikon D3X; 35mm focal length; ISO 100; 1/250 sec at f/11.*

BASICS

Whether it's coming from your flash, the sun, or the interior lights in a building, all light has certain properties that a clued-in photographer should be aware of. It doesn't matter if you're shooting a lovely landscape, a natural-light portrait, or blasting away with an on-camera flash in a dark nightclub: if you learn to consider the properties of the light, then you're in a great position to understand how the photo will look. You'll also understand how you can alter the light, or introduce your own effectively.

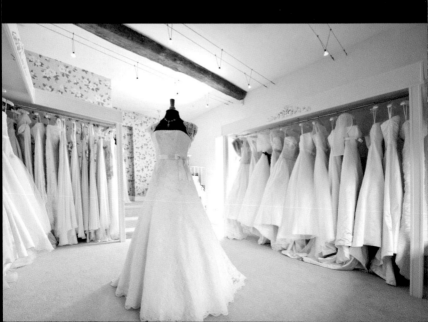

Equipment

Camera setup

Techniques

Ambient light

Lighting

Case studies

Advanced

Whenever you take a photo, the six key properties of light you should consider are as follows: the quality, direction, contrast, intensity, evenness, and color temperature. You should also bear in mind that if you alter one of those properties by modifying the light in some way, such as by introducing a flash, that these properties will change and affect each other.

That may seem like a lot to have to think about, but the more you do it, the easier and more natural it becomes. Eventually it will feel like second nature and be a real aid in helping you quickly decide what to do with your lighting, such as where to position your flashes, how to modify their output, what color gel you may need, and much more.

Once you've become proficient at judging light and can make informed decisions quickly, it's much easier to focus on your subject. In fact, a lot of getting used to using flashes is all about creating a process that you can easily and quickly modify for lots of different circumstances.

However, none of that is possible without a decent understanding of light. Over the next chapter, we will take the mystery out of light and its properties.

OPPOSITE

Without a clear understanding of light, you'll find it tough to capture natural looking photos of interiors, for example. Mixed light sources—from daylight, to halogen shop lights, to flash—are skillfully combined in this shot. *Nikon D3; 14mm focal length; ISO 200; 1/40 sec at f/8.*

BELOW

The light in this gloomy study was very hard to make flattering, so overpowering it with flashguns—two on the subject and one on the background—was a wise choice. The lighting here is totally different to that in the dress-shop shot. *Nikon D3; 62mm focal length; ISO 200; 1/250 sec at f/11.*

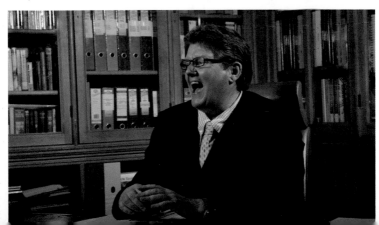

Quality of Light

Quality of light is one of the biggest considerations a photographer should bear in mind when taking a picture. It's a crucial element in the lighting mix that really determines how your subject will look—especially if you're taking a portrait.

Quality is the term used to explain how "hard" or "soft" a light is. It's nothing to do with the quality of the lighting kit you used to take the photo, because—and here's a little secret—once light has left its source, it's just light! It doesn't matter how expensive the light source that it came from was.

Hardness or softness of light is crucial in determining the overall look of your photograph. It's pretty easy to tell the difference between the two kinds of light, and it's important to quickly get to grips with the difference. In general, hard light produces very hard-edged, distinct shadows, while soft light produces much softer shadows. It's all about the transition between the highlighted area to the shadowed part of the photo; if there's a gradual transition, it's usually indicative of soft light, whereas a very hard line is bound to come from hard light.

A soft light is often called a diffuse light, where the beams of light tend to bounce around all over the place and fill in any hard shadows, rather than producing the very parallel beams of light that might come from a small or distant light source.

The easiest way for a photographer to consider the difference is to think about the relative size of the light source compared to the subject, not the actual size of the source. For example, on a bright sunny day with no clouds, the light is very hard and produces dark shadows. The light source, the sun, is huge—in fact planet-sized—but it's a long way away, so is relatively small compared to the subject. On a cloudy day, the clouds will diffuse the light to a varying degree. Relative to the subject, they are much larger, and hence the light is softer and more diffuse.

A small flashgun, for example, is generally considered to produce a hard light source as it is small. However, if it was placed a few inches above a tiny insect, it would be huge, and therefore would be a soft light source— remember, it's relative size that matters.

The relative size of the light source is something that often confuses photographers. If you have a flashgun that's very close to a model and you then move it farther away, the light gets harder as its relative size gets smaller. This can be confusing because this light may bounce around off floors and walls and fill in the shadows, giving the false impression it's actually softer. However, in a dark room where the light doesn't bounce around, or outdoors, it would be much harder.

So, what use is this for photographers? Soft light is generally much more flattering —wrinkles on a person's face tend to get filled in with light, rather than appearing as deep creases with dark shadows, so soft light is often used for flattering portraits. But hard light has its uses too; it's more dramatic, and gives harder-edged shadows that work well if you're photographing men, for example. It's also often used in

ABOVE AND ABOVE RIGHT

These two photos were taken with exactly the same lighting setup and exposure. However, the first is taken with a large light source—a large white beauty dish almost overhead and a reflector underneath—and the second is taken with a small, 18cm-wide silver-lined dish. The telltale signs of the hard light in the second photo are the hard shadows under the nose and chin. Soft light is more flattering, but hard light can be more dramatic—if your model has good enough skin to take it! *Canon EOS 5D Mark II; 85mm focal length; ISO 100; 1/160 sec at f/16.*

BELOW

A single, hard light source—in this case a flash fitted with a honeycomb grid to restrict the light to a small pool—can be effective and dramatic, especially for gritty portraits of male subjects. *Nikon D3X; 50mm focal length; ISO 100; 1/250 sec at f/5.*

Equipment

Camera setup

Techniques

Ambient light

Lighting

Case studies

Advanced

fashion, where porcelain-skinned young models with perfect makeup are made to look more dramatic with harder lighting.

The easiest way to make a hard light, such as that from a flashgun, appear soft, is to make it bigger in relation to the subject. This could be as simple as moving it closer, or more often, modifying it—like shining your flash through a photographic umbrella or softbox, or even bouncing it off a nearby wall. This way, the umbrella, softbox, or wall becomes the light source, which is a lot bigger compared to the original size of the flash. It's also possible to soften the light by diffusing it, such as stretching a white diffusion silk over a photographic beauty dish, or swapping a silver-lined dish for a white-lined version, for example. However, this isn't as effective as using a much larger dish!

Experienced photographers often spend lots of money on beauty dishes of various sizes and finishes, a whole array of softboxes with all sorts of different diffusing material, and lots of umbrellas of various shapes, finishes, and even colors too—all just to modify the output of their flash to get the perfect balance of hardness for each subject. In general, just remember that softer light is bigger and more flattering, filling in all the rough surfaces; harder light is smaller and more dramatic, exaggerating any imperfections or textures.

RIGHT

Soft light isn't just for women! A large soft light close to your subject gives a lovely light that's suitable for all ages and genders. It's a surefire way of getting a pleasing portrait. *Nikon D3; 150mm focal length; ISO 200; 1/250 sec at f/7.1.*

Equipment

Camera setup

Techniques

Ambient light

Lighting

Case studies

Advanced

Direction of Light

Along with quality of light, direction is another key property that will totally change the look of your images. With most stills photography, what we are essentially always doing is trying to make an object look three-dimensional when it's shown as flat and two-dimensional on a computer screen or in print.

Our brain instantly recognizes that the object is a real, three-dimensional object by the way it is sculpted by shadow. Without shadows, everything looks flat. So instead of thinking "photograph the light," as described earlier in this chapter, you can

OPPOSITE

Light coming from the left edge of the shot and from slightly above, pointed directly at this subject's face, adds mystery to the shot. The light was a flash fired through a softbox fitted with a honeycomb grid to stop it spilling onto the background. *Nikon D3; 85mm focal length; ISO 200; 1/125 sec at f/9.*

BELOW

Side lighting—in other words, light coming from the side—can give a dramatic effect to your portraits. It's often important to make sure your subject's face has some light on it, as in this case. The light was a single Nikon SB800 flashgun to the right of the camera, fitted with a honeycomb grid. *Phase One 645DF; 55mm focal length; ISO 100; 1/160 sec at f/6.3.*

Equipment

Camera setup

Techniques

Ambient light

Lighting

Case studies

Advanced

alternatively think, "photograph the shadows," as it's often the shadows that make your subject look real. Too many photographers try to get rid of shadows by over-lighting.

For example, imagine if we photographed a smooth, white pool ball on a plain white background, and there were no shadows due to the light bouncing all over the place. We would have trouble even seeing the ball was there; it would seem to be a blank white picture.

More often than not, there will be some shadows in your scene. If the same ball was photographed with a light source right next to the lens, then the shadows would fall behind the ball and we would hardly be able to see them. It would probably look like the ball was a white disc or plate, if we could even see it at all.

Now imagine if that light source was taken away from the axis of the camera

and placed higher up. We would see a lot of shadow underneath the ball, and our brain would instantly recognize it as a ball. Suddenly, the subject really would look three-dimensional. So moving your light source away from the direct axis of the camera lens is beneficial in creating interesting shadows, and true three-dimensionality. In other words, the worst place for your flash to be is close to the lens. That's exactly where pop-up flashes are, and not far off where hotshoe-style flashes usually fit. It is better alternative to get your flash away from the axis of the camera—especially if it's the main light source in a photo.

However, it's not just about getting your main light off-camera; the direction of light is important, too. Our brains are programmed to get used to light coming from above—either from the sun or in a building—so if your main light source is

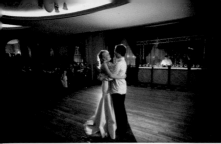

higher than eye level, it looks reasonably natural. It's a good idea to check the direction of the shadow of the subject's nose. If it goes down, all is well. If it goes sideways, or even worse, upwards, then the light position might not be the best when trying to achieve something reasonably believable.

Lighting from below looks unnatural and is called "horror" lighting. It was widely used in the Hammer horror films of decades ago—good if you want to make the viewer feel uneasy.

Side lighting can be very effective as it gives a great three-dimensional feel, and often, a deep shadow behind the subject if they're not too far away from something like a wall. Try to keep your subject's nose pointed roughly in the direction of the light source so that their face will always be at least partially lit, rather than in full shadow.

A very effective lighting technique is backlighting—where the main light comes from behind your subject. This is the exact opposite of what many people do. "Put the sun over your shoulder," was the advice

given to generations of photographers. Of course, this means your subject is squinting into the harsh sunlight.

Often, it's better to turn the subject around so that the sun provides a backlight or rim-light—lighting that gives a lovely edge to the rim around the subject. This means that your subject's face will be in shadow. Natural light photographers simply increase their exposure so that the sky and background

Equipment

Camera setup

Techniques

Ambient light

Lighting

Case studies

Advanced

blows out and goes flat and white. Armed with a flash, you can keep the exposure as before to leave plenty of detail in the sky and background, then pump some light back into your subject's face to bring in the detail. This is an easy go-to technique that almost always works. If there isn't any sunlight, put your own in by using a second flash. We will discuss this more in later chapters.

If you're lighting an inanimate object rather than a person, it's often better to only use backlighting. Think about lighting *around* the subject, rather than lighting it. That way the light streaming toward your lens adds another dimension to the photo.

ABOVE

Light coming from behind the subject often works very well. In this case, flashguns hidden in front of the two cars and aimed back toward them provide the interesting light pattern. *Nikon D3X; 34mm focal length; ISO 100; 1/200 sec at f/13.*

Contrast

If quality and direction are two basic tenets of good photography, then contrast is where it gets a tiny bit more technical.

Contrast is the difference between the bright, lit part of the scene, and the dark, unlit shadow areas. If there's a huge difference in brightness, it's high contrast; if not, it's low contrast.

If you're armed with a flash meter you can take highlight and shadow readings, work out the difference in terms of f-stops, and then determine if that range falls within the dynamic range of your particular camera's sensor. Unsurprisingly, that's far too technical for most people, especially if they're trying to work

reasonably fast, so a good way to judge contrast before you take a photo is to squint at the subject. You may get some strange looks and have to explain yourself, but it works!

Of course, the other alternative is to take a photo and check the LCD screen on the camera to see if you have managed to

BELOW

The contrast in this photo is designed to give a complete range of tones, while still offering some shadows to avoid flat, overlit photos. From the gray background to both sides of the model's face, the contrast has been carefully managed by altering the position of the main and fill light. *Nikon D3; 85mm focal length; ISO 200; 1/200 sec f/16.*

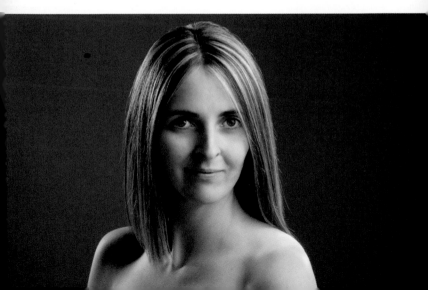

retain detail in both the shadows and highlights. You can use the histogram for this, but it's easiest just to look at the picture on the screen. It's not technically ideal, but it works for many people.

If you discover you have too much contrast, you have two options. The first is to adjust your exposure so that the most important part of the scene is captured properly. If the main area of interest is in shadow—someone's face that is backlit, for example—then by exposing for the shadows the background will be high-key, featureless, and bright. This may be the effect you're after. Alternatively, you can expose for the highlight areas and let the shadows go to black—it's a creative decision.

The other option is to reduce the contrast, usually by filling the shadow areas with some light. You could use a reflector or an additional light source to do this. This is called a "fill light" as opposed to the "main light." A word of warning: if your main light source is, say, 45 degrees to the right of your camera, many people put their fill at the other side at a similar angle, usually set at a lower power setting. However, these really are two very different light sources and will produce two sets of opposing shadows that may partially cancel each other out. It's a very old-school approach.

The new rule is that a fill light shouldn't go farther over than the axis of the camera lens. Actually, the axis of the camera is an ideal place for a fill light. An onboard flash, or a ringflash—a kind of flash that goes right around the outside of the lens—can be a great fill light. That way, any shadows go behind the main subject, so there are no conflicting second shadows. However, rules are meant to be broken, so often main and fill lights do come from different sides. That's the beauty of photography—there really is no right or wrong way to do it.

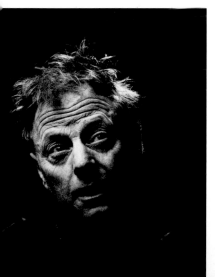

LEFT

There's lots of contrast in this photo, and it's all the better for it. The combination of a hard main light, dark background, dark clothing, and a dark studio means there is a huge difference between the brightness of the well-lit parts of the face and the darker, unlit parts. The hard light and gritty post-processing brings out the weathered face of this round-the-world adventurer. *Phase One 645DF; 120mm focal length; ISO 100; 1/125 sec at f/14.*

Equipment

Camera setup

Techniques

Ambient light

Lighting

Case studies

Advanced

Intensity

Intensity is the measure of how bright light is. In photographic terms, we usually think of this in terms of EVs, or more usually, the *f*-stop or aperture it requires for the scene to be recorded accurately at a given ISO or shutter speed.

For many years—certainly before the advent of digital photography with its instant feedback—the intensity of light was a crucially important factor. Photographers would spend a long time metering the light with handheld meters, or using their experience of their own camera and its TTL metering system, plus the sensitivity of the film emulsion they were using, to make a judgment on what camera settings to use. Then they had to wait for the film to be processed to see if they had judged it accurately.

If you add using flash into the equation, it gets even more tricky. Flash meters for the advanced or well-off photographer, and guide numbers and basic mathematics for the amateur, were the order of the day. Nowadays, it's much easier with more advanced cameras, and of course, you can view each picture on the LCD screen immediately after taking it.

To get the "correct" exposure, we can alter three main parameters on our cameras. The first is ISO—the sensitivity of the sensor. If light is low, you can increase the ISO. Of course, the best image quality is at the lowest or base ISO, so increase ISO at your peril if you're looking for the finest quality results.

The second parameter is shutter speed. Adjusting this can introduce camera shake

ABOVE

At dusk on a summer's evening, a small flashgun has ample power to light up a scene, even when fired through a softbox. In this case, the camera's ISO was put up to 400 so that the sky retained a little of its color, rather than just being overpowered by the flash. This shot is all about bright colors—the red dress, blue sky, and green leaves. *Nikon D3S; 24mm focal length; ISO 400; 1/200 sec at f/6.3.*

or motion blur if you go too low and either the camera or the subject moves. On the other hand, high shutter speeds can freeze motion unnaturally.

The final thing that can be changed is the lens aperture, or *f*-stop, which alters the depth of field. A narrow aperture—a larger *f*-stop number like *f*/22—means more of the photo is sharp from front to back. A wide aperture—like *f*/2.8—gives a shallower depth of field.

Bringing flash into the equation adds

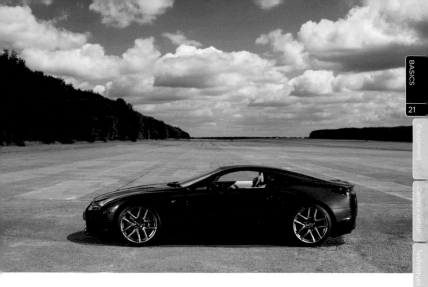

Environment

Camera setup

techniques

Ambient light

Lighting

Case studies

Advanced

another parameter. There are two ways to change the intensity of the flash: the first is by changing its power output, whether manually or by using the camera's built-in control system and exposure compensation, or by simply moving the flash farther away, which affects how brightly it will light the subject. Of course, if the camera is controlling the flash, and you move it farther away, then it automatically adjusts and increases the power until it reaches its limit.

You may run into problems when trying to mix flash with ambient light. If you're working with low light levels, then most flashguns are powerful enough to act as a main light, even when their power is sapped by shooting through a softbox.

Bright days in full sunshine can be problematic. One solution is to move the subject into the shade, but sometimes this isn't possible. In that case, your little flash

ABOVE
An amazing location for a shot, but there was no shade to speak of and the sun was blazing overhead. The ambient light intensity was very high, and the noon sun put the side of the car nearest the camera into deep shadow. Powerful flashes were used to reduce the contrast and light up the side of the car and its wheels. *Phase One 645DF, 55mm focal length; ISO 100; 1/250 sec at f/6.3.*

has to match, or overpower, the light from the sun, which is a tall order—especially if you're trying to make the light soft by using a modifier like an umbrella.

You either need extra power—from several flashes working together—or bigger, more powerful flash units. It's the intensity of the light at a given distance that you are trying to alter: you can't magically adjust the intensity of the ambient light from the sun.

Evenness and Color

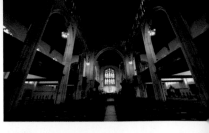

ABOVE

The orange-colored tungsten lights in this church are obvious, especially compared to the natural light coming in through the altar window. Human eyes naturally compensate for this effect, however, so anyone inside the church wouldn't perceive the light being particularly warm in hue. *Nikon D3; 14mm focal length; ISO 200; 1/10 sec at f/2.8.*

If you thought dealing with contrast and exposure in an image was challenging, then just the mention of the inverse square law may send you reeling. But fear not, it's here to help you!

In very basic terms, the inverse square law dictates that the farther away you move a light source from the subject, the less bright the subject becomes, which is pretty obvious. But what the light also does is fall off in a more extreme way the closer you get to the light source. So, for example, if you're lighting a group of four people in a line with a single flash that is right next to the end person, that person will be very bright, but the luckless soul at the other end will not be so fortunate. However, if you move the flash farther away, say another 12 feet, the relative difference in brightness diminishes. The person closest to the flash will still appear brighter, but not a lot brighter than the last person.

In practice, this means that if you're lighting a group, or want even coverage on a big subject—like the photograph of the car on the previous page—then you have to move the light farther away. However, this not only affects the brightness, but also the quality of the light. The brightness of the subject will be reduced, and the light will become harder. You can counter this by making it bigger, perhaps with a softbox or simply by increasing the power. Congratulations, you now understand the basics of light! Soon it'll all become second nature, particularly once you master the final property of light—its color.

Color temperature is measured in Kelvin, which you can accurately measure by using a color temperature meter that you can then set your camera white balance to. If you shoot Raw format then you can adjust the color balance in post-processing. You may think you can do the same if you shoot JPEGs, but you can't—not with any great accuracy or quality. Ambient light changes color at different times of the day and under different weather conditions. Bright midday light is most often thought of as "normal," and is usually marginally warmer than your camera's flash white balance setting. Low evening sunshine, like sunset, is very orange, and light in open shade or on a cloudy day is much cooler and "blue."

For artificial light, tungsten bulbs—like many typical household bulbs—are very orangey and warm, whereas fluorescent bulbs are often quite green, although they can be mixed in with some magenta. The only time it matters to get it spot-on is if you are mixing light sources—such as using a flash on a subject in a room that's lit by household bulbs, for example. If you want to match your flash to the ambient light, you'll have to change its color by putting a specially colored gel in front of it.

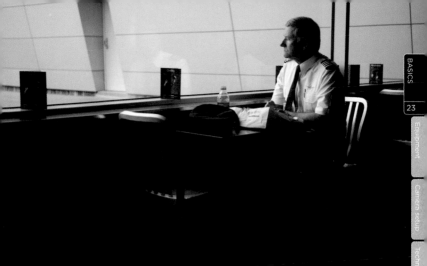

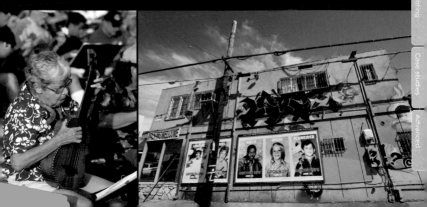

Equipment

Camera setup

Techniques

Ambient light

Lighting

Case studies

Advanced

ABOVE
A cloudy day at an airport where it's obvious the light on this airline worker is very cool and blue. *Leica M8; 35mm focal length; ISO 160; 1/250 sec at f/2.*

BELOW LEFT
This ukulele player on a Californian beachside terrace is bathed in the warm glow of the light at sunset. *Leica M8; 75mm focal length; ISO 160; 1/750 sec at f/4.*

BELOW RIGHT
Midday sunshine is perceived as being the "natural" color of light, but in reality this varies around the world. *Nikon D3X; 14mm focal length; ISO 100; 1/400 sec at f/9.*

EQUIPMENT

If you want to invest in cameras and lenses, there are lots of companies vying to take your money in exchange for some lovely equipment. However, if you want to truly invest in your photography, then you'll achieve far more by investing in lighting equipment and learning how to use it properly. This chapter will offer advice on what equipment you really need.

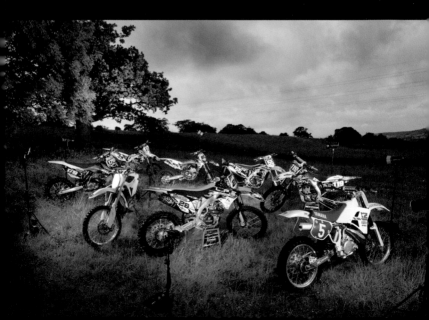

Basics

EQUIPMENT

25

Camera setup

Techniques

Ambient light

Lighting

Case studies

Advanced

Chances are, if you're reading this book, you already own some flash equipment. It may be the pop-up flash on your compact or basic DSLR, or perhaps you're looking to buy your first hotshoe-style flashgun to use on top of your camera. All these options can give good results, if you know how to use them properly. Bouncing the light can be a key way of changing the output of your flash to get a pleasing and professional result, for example.

The best thing you can do to improve the quality of your image-making is to use an external-style flashgun, but get it off the top of your camera. A whole world of photo opportunities will open up to you, and you will be amazed by how simple it is to get dramatic results.

Of course, using your flash off-camera will open up a whole new world of technical issues—such as how to hold the flash, how to trigger it in sync with your camera, how to control the output of the flash itself, and modify the light source. There are hundreds of ways of doing this, and many photo gadget companies trying to lure you to invest in their specific solution.

For many people, the journey to off-camera flash starts with a simple coiled

sync cable and a single flash held at arm's length. You are umbilically linked to your camera, which means it can be hassle-free in terms of camera and flash settings, but is also severely limiting as you can only reach so far! And with your right hand operating the shutter button, almost all shots like this tend to have the flash on the left of the camera as the gun is naturally held in the left hand. This can greatly limit your creativity.

A basic and cheap lightstand, married to a tilthead adapter that allows you to use a photographic umbrella, is a far neater and more professional solution. Wireless triggering of the flash from your camera can be very simple, as many cameras already have the technology built-in. You can also use radio triggers, which are more reliable and don't need a direct line of sight to work properly. A further benefit of using simple radio triggers is that you don't need to buy the dedicated flash for your specific model of camera; you can usually get away with a cheaper, more generic model. As long as you can control it manually, it can be a cost-effective solution.

Grip equipment, softboxes, umbrellas, triggering systems, and even the kinds of batteries that are available, will all be discussed in this chapter.

OPPOSITE

It may be overkill to use eight flash heads to light a scene with eight motorcycles, but when using battery-powered flash kit you can easily take your lighting setup to the middle of a field. One flash is even lighting the tree in the background. *Nikon D3X; 24mm focal length; ISO 100; 1/160 sec at f/13.*

Flash Equipment

Magazines and the Internet are crammed full of retailers trying to sell you the latest bit of flash lighting equipment that they claim is guaranteed to transform your image-making. Much of the equipment on offer is great and can have a real impact on your photos, but you don't need it all at once and chances are you may already own enough to start your voyage into using off-camera flash.

One of the biggest issues is whether to invest in your camera manufacturer's own system or not. If you want to use several different cameras, or think you may switch brands in the future, then you probably shouldn't. Will the manufacturer always make their clever, integrated flash systems forward-compatible, so that any new camera you may buy in the future will continue to work seamlessly with the flash kit you've already bought? Probably not. Plus, manufacturer's systems are currently reliant on infrared technology rather than radio for their triggering and control.

You don't have to spend lots of money to get you going with off-camera flash, to a point. Many photographers start by buying the cheapest equipment they can find. Although this can seem like a sensible thing to do, cheaper kit—especially pieces bought unseen from Internet auction sites—is made very poorly using components that break with time. Tilthead adapters, for example, and radio triggers are prime examples of this. If you buy cheap, then chances are it'll break very easily, stop working, or become unreliable. When you're learning, unreliable equipment really can mess with your confidence, so it makes sense to stick with reliable, known-brand tilthead adapters and radio triggers right from the start. Buying cheap can be a false saving.

Where you can save cash is on the expensive bits—the flashes themselves. If you use basic radio triggers that connect via a cable to your flash then you don't need the latest flashgun with advanced automatic modes. Basic flashes that can be controlled and triggered manually offer greater value and help you learn the art of off-camera flash.

Used flashes can be an option too, although you'll find that certain flash units have almost cult status—such as Nikon's discontinued SB800. Used versions of this model can go for almost as much as they cost when new. These flashes are prized precisely because they are small, powerful, easy to control, have a PC socket on the side, and a built-in optical slave. A lot of photographers use a bank of SB800s with Canons, Pentax, or any other camera brand.

In the next chapter we'll be looking at the kit you'll need to take your flash off-camera, control it, and successfully modify the light output.

OPPOSITE

A Nikon Speedlight mounted on top of a Manfrotto umbrella tilthead adapter on a basic lightstand is all that many Nikon users will need to start using off-camera flash. Wireless operation is built into the flash, and also into many of Nikon's modern DSLR cameras.

Basics

EQUIPMENT

27

Camera setup

Techniques

Ambient light

Lighting

Case studies

Advanced

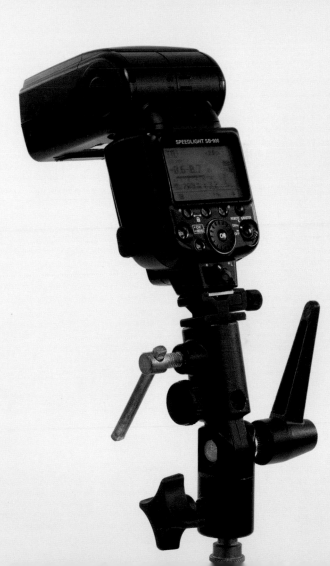

DSLR or Compact?

Only a few years ago, the question of whether to use a DSLR or a more compact camera for off-camera flash use would not have been a difficult one to answer, as virtually all compacts had small sensors and a fixed lens. However, the latest crop of mirrorless cameras, such as Panasonic's GF range, the Olympus PENs, and the Sony NEX cameras, offer sensors almost as big as those found in DSLRs, plus the ability to change lenses and to take full manual control of aperture and shutter speed. There's also a hotshoe on top so that you can fit a wireless flash trigger or bigger flashgun onto your camera, and of course they're very small.

However, for a serious strobe user, a DSLR still makes more sense. There is a wider range of lenses available, and many have built-in wireless control for dedicated flashguns. Both types of camera often boast a small pop-up flashgun, literally within inches of the lens. For dedicated image-makers these flashes are fine for a bit of fill-in light, or to put a catchlight on a subject's eyes, but not for much else. They're underpowered and in the wrong place, but sometimes can be used to trigger other flashes.

It's far better to buy a hotshoe-style flashgun, typified by the range-topping Canon EX580 Mark II, Nikon SB900, or any of a range of lower-spec models from camera makers or aftermarket manufacturers. Expensive flashguns tend to offer more intelligent triggering features, but most importantly, they give more power or a wider range of adjustment on the flash zoom head,

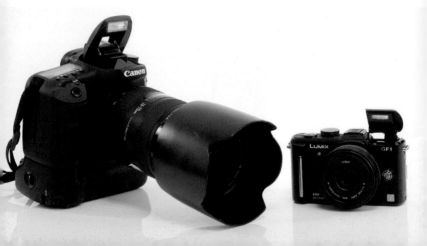

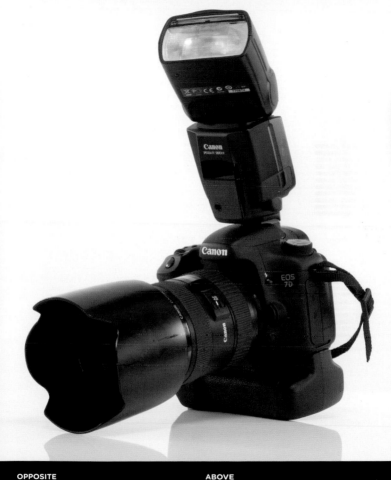

Basics

EQUIPMENT

29

Camera set-up

Techniques

Ambient light

Lighting

Case studies

Advanced

OPPOSITE

Both DSLR and interchangeable-lens compact cameras can be used with off-camera flash, but the DSLR still has significant advantages in quality and usability. Pop-up flashes on both cameras are fine for a small amount of fill light, or to trigger other flashes.

ABOVE

A Canon EX580 Mark II flash integrates seamlessly with a Canon EOS 7D and can bounce and swivel.

LEFT
A diffuser cap turns a basic flash into a mini lantern, spreading light out in all directions so it bounces off walls and ceilings. It's virtually useless outdoors.

OPPOSITE
A Honl speedstrap and bounce card can be used to make the light slightly softer, especially at close range to your subject.

so can suit lenses with a longer focal length. Other features to look for include a built-in optical slave cell, which is a feature found mainly on Nikon flashguns, but also on some others. If you activate this setting, the flash will go off as soon as it sees a pulse of flash from another unit, so an onboard or pop-up flash can trigger it.

A standard PC socket is also a bonus as it means you can plug a triggering cable directly into the flash, and either a compartment for a fifth battery—like on Nikon's popular but discontinued SB800—or a port where you can plug an extra battery pack in is very useful, too.

When a flash like this is mounted on top of your camera, you can swivel it around and tilt it at all sorts of angles to bounce off nearby walls or ceilings, thereby making the light much softer.

Some flashes come with accessory diffuser caps, which you can put on top

of your flash so that it becomes like a mini lantern. In this case, the proper use is to aim the flash upwards or tilted slightly forward so that some of the light radiates outwards at all angles, bouncing off the ceiling. Of course, this really only works if the walls are neutrally colored, or you'll be in danger of nasty color casts and it certainly doesn't work outdoors—it just kills the flash power, effectively by a half.

Larger, aftermarket diffusers such as those made by Gary Fong have some effect. An alternative is to use a strap covered in hook-and-loop fasteners to go around the outside of your flash, which is attached to a bounce card. These straps are made by companies like Honl, and are relatively inexpensive and very portable. They also work when you take your flash off the camera's hotshoe.

Basics

EQUIPMENT
31

Camera setup

Techniques

Ambient light

Lighting

Case studies

Advanced

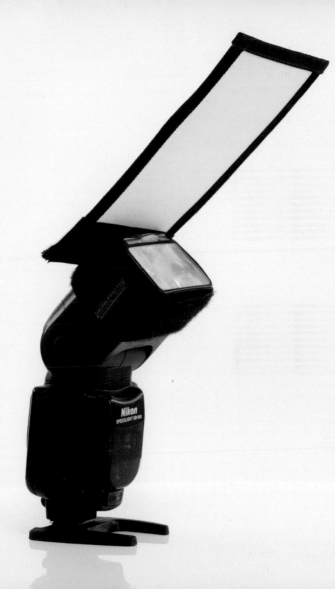

Give Me Power!

Your journey toward being a serious strobe user is very likely littered with the debris of hundreds of AA batteries! It's those little power cells that provide the juice for the vast majority of flashguns, so you'd better get used to burning through them.

Cheap lead acid ones just won't do; alkaline ones are more expensive but work far better. Lithium ones are better still, but the cost soon racks up and you'll often be throwing them out, and nobody wants to start a photo session with half-dead batteries, reluctant to change them due to the cost. It's also important to think of the environmental implications of throwing away so many half-dead batteries. Lithium batteries do have a long shelf life though, and are ideal to keep in your bag for emergency use.

By far the best option is to use rechargeable Nickel-Metal Hydride (NiMH) batteries. Although initially more expensive to buy, especially when you add in the cost of a charging unit, they can be used hundreds, if not thousands, of times. Not only that, they almost turbocharge your flash as they recycle much faster— especially the more high-powered ones such as 2500mAh types. The downside of this is that the batteries get very hot, and as they recycle quicker you're often tempted to keep on firing. Most modern flashguns have a thermal cutout to stop you melting your flash, but it can happen.

There are two types of NiMH batteries: the regular ones that need charging before use, and the ones that come precharged. The first, basic type quickly lose their charge when stored—sometimes within a matter of days—and you'll see a noticeable drop in performance. The second type hold their charge far better, and are definitely the best choice; Sanyo Eneloops are one of my favorite brands.

It's also important to invest in an intelligent battery charger such as the Maha, rather than using the free charger that some batteries come with. Proper chargers individually condition each battery and make them last far longer.

For even more power, many manufacturers including Canon and Nikon, offer a special external battery pack that you can fill with several AA-sized cells that plug right into a port on their flashguns. So, instead of running on four AAs, the flash is now using up to twelve.

As an alternative, companies like Quantum and Lumedyne also offer their own plug-in, external battery packs that offer a very real increase in performance. But if it's more light power that you're craving—especially if you're trying to fight against the midday sun—then the option most professionals go for is a separate battery pack and dedicated flash head. These are far bigger and more expensive than hotshoe flashguns, but offer a huge increase in power and faster recycle times.

Some, such as Elinchrom's Ranger Quadra system, also have built-in radio wireless triggering and offer a reasonably bright modeling light—something that hotshoe flashes don't. For that reason alone, many people like to use larger packs, as the modeling light allows you to see what you're going to get before

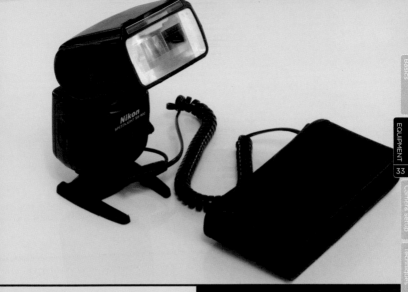

Basics

EQUIPMENT

33

Camera setup

Techniques

Ambient light

Lighting

Case studies

Advanced

ABOVE
Nikon's SD-9 battery pack takes six extra AA cells and plugs into the socket on a dedicated Nikon flashgun, while Canon's equivalent is the CP-E4, which holds eight AAs.

LEFT
Eneloop batteries and a Maha charger are clear favorites among flash users.

you hit the shutter. These larger flash units often work with full-size studio lighting attachments, so softboxes, beauty dishes, and zoom spots go right on without having to resort to DIY-style attachments, as many users of small strobes have to.

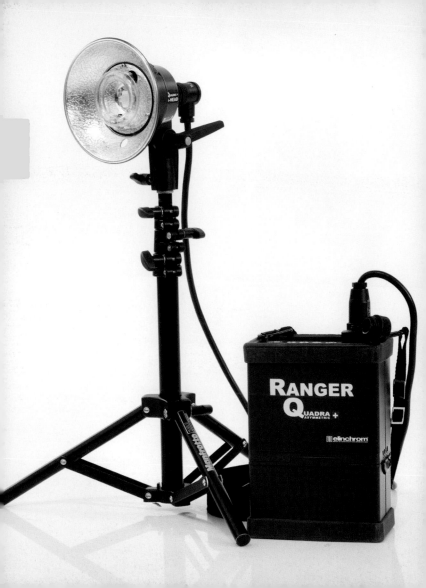

Basics

EQUIPMENT

35

Camera setup

Techniques

Ambient light

Lighting

Case studies

Advanced

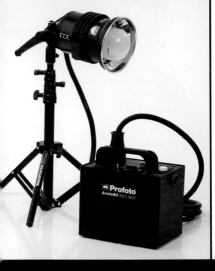

ABOVE LEFT

Profoto's Acute B Air system is very powerful at 600W, and is powered by a small lithium battery, but won't come cheap.

ABOVE RIGHT

Quantum's Qflash system is like a beefed-up hotshoe flashgun, complete with TTL capabilities and a turbo battery pack.

OPPOSITE

Elinchrom's Ranger Quadra offers 400W of power and lots of high-tech features built-in

TTL Infrared Controllers

If you already own a modern pro-consumer DSLR and a dedicated flashgun from one of the big brands, there's a chance you already have everything you need to take it off-camera and work wirelessly.

Of course, you don't have to go wireless. You can buy a sync cable that umbilically links your camera to its flash; these range from cheap, basic sync cords to expensive full-function TTL cables that retain full TTL control, as if the flash was still on its hotshoe. The cable route is not so neat, however. You're limited by the length of your cable, and there's a safety issue in having cables trailing everywhere.

Instead, triggering your off-camera flash via wireless technology is the way to go in most situations. If your camera has built-in wireless triggering, and you can navigate your way through the manual, set your camera to "Master" and the external flash to "Slave." When you push the shutter, the camera sends an infrared message to the external flash to make it fire, and also communicates lots of parameters, such as exposure compensation, so everything is worked

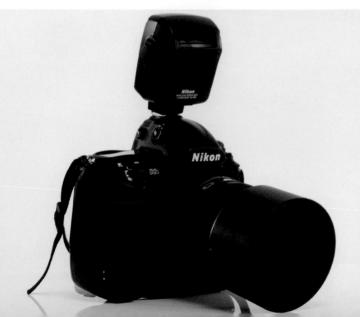

Basics

EQUIPMENT

37

Camera setup

Techniques

Ambient light

Lighting

Case studies

Advanced

out automatically. Nikon has led the way with this wireless technology using its Creative Lighting System (CLS), with Canon playing catch-up with its E-TTL system.

Most Nikon DSLRs above entry level models have built-in wireless capability, while the Canon EOS 7D, launched at the end of 2009, was Canon's first camera to be totally integrated.

Each camera and flash is different, so you definitely need to read the manual. Essentially, the camera is set to Master via a mode that is usually within the menu system, or you can use a compatible flash on the hotshoe and set that to be the Master. Sometimes, you can set it up using either method.

A third option is to use the manufacturer's own wireless radio controller, as with Nikon's SU800 or Canon's ST-E2. If your camera is one of the pro models, like a Nikon D3 series or Canon EOS 1D series, your only option is to buy one of these controllers, as the camera has no built-in flash trigger.

You can then set your off-camera flash to Slave via its own menu, and it all works automatically. If you leave it in "TTL" and use auto mode, the camera will try to get the exposure right, just as it does when the flash is mounted right on the hotshoe.

Of course, you often need to dial in some under- or overexposure, as it's hardly ever right the first time. This is made more difficult when there are any flashes aimed back toward the camera, so in this case, switching to manual control is a good idea.

By navigating the menu system on the camera or controller, you can set up different flashguns as different groups, and adjust the relative power or exposure compensation by dialing it in—you don't have to keep on walking back and forth to change settings on the flash itself. You can even alter the wireless channel so it doesn't affect other photographers' systems nearby.

Using the menus, you can disable the master flashgun so it doesn't affect the

OPPOSITE

A Nikon SU800 flash controller on top of a Nikon D3S camera is the only way for pro-spec DSLRs to control their own wireless flash systems. The SU800 is also a good accessory for lower-spec cameras, as it offers an easy way to quickly adjust your external flashes.

exposure, go into high-speed sync mode, or on some models, even change from first to second curtain sync. The remote flashes can be set to be controlled manually, or by using any of the automatic modes. You really do have complete control, and it's easy to see why you may not consider using any other triggering system.

There is important factor to bear in mind, however, and that's the fact that the camera uses an infrared signal to control everything. This means there must be a direct line of sight between the Master and Slave, and the range is limited—especially if you're outdoors on a sunny day. You can't hide a flash behind something, which is one of the main reasons for using small flashguns in the first place.

For many, this is a total deal-breaker. Poor range, high chance of interference, and the line-of-sight issue is a major headache. It means you can't put a flash inside certain softboxes, for example. You're always trying to aim the infrared receiver window on the side of the flash toward the camera, or cobble together flashes on the end of sync cords with other flashes, so they can daisy-chain relay the infrared signal to the others. Not ideal.

In certain circumstances, it will work perfectly—when you have a clear line of sight and aren't using large light modifiers, for example. However, using the camera manufacturer's flash triggering is not the whole solution.

OPPOSITE

Using a wireless controller, you can control your external flashguns from your camera position. This is set up to wirelessly trigger three groups of flashguns, all controlled automatically via TTL. Group A is set to overexpose by one stop, group B to underexpose by a 1/3 of a stop, and group C has no exposure compensation. It's set to broadcast on channel 1, and the AF-ILL display says the unit will act as an illumination aid to help the camera's autofocus system in low light.

Basics

EQUIPMENT

39

Camera setup

Techniques

Ambient light

Lighting

Case studies

Advanced

Radio-controlled Flash

If you want your flashes to be guaranteed to fire every time you push the shutter—without the line-of-sight issue of E-TTL or CLS—then radio triggers are by far the best option.

The most popular of these are made by Pocket Wizard. They have their own certified radio channel, with a range of up to a mile and they can even be configured to remotely fire your camera. They are used by the majority of professionals around the world, and work on AA batteries. They're not the smallest, but they are rugged.

Lots of other manufacturers also make their own radio triggers, from reputable companies like Elinchrom with their Skyport system, right the way down to no-name triggers, which can be bought very cheaply on sites such as eBay. Virtually all of these work on a 2.4GHz radio channel, and their range isn't quite as good as Pocket Wizard. They are also hugely variable in terms of their reliability.

In essence, you get what you pay for—the more expensive name-brand triggers do outperform the no-name cheap stuff, which often become confused by interference from fluorescent lights and other equipment.

Some of these radio triggers are powered by AA or small cell batteries and some are rechargeable, but most do exactly the same thing. One sits on your camera's hotshoe, and when the shutter is fired it sends a signal to the receiver, which is plugged into the flash and tells it go off. And that's it; it's just a basic trigger. This means that you have to set your flashgun manually for both power and zoom setting, and to change it you have to keep walking up to it, then back to your shooting position.

To plug these radio triggers into most flashes, you need a cable with a PC-style socket on the end. Most Nikon and many independent-brand flashes have a PC socket, as does Canon's EX580 Mark II. The cable is often the weakest link in the chain, as it's easy to pull out. A company called Flashzebra custom make PC cables with a screwlock end so they screw into the PC socket of suitable flashes. They're a worthwhile addition to your kit.

Basics

EQUIPMENT

41

Camera setup

Techniques

Ambient light

Lighting

Case studies

Advanced

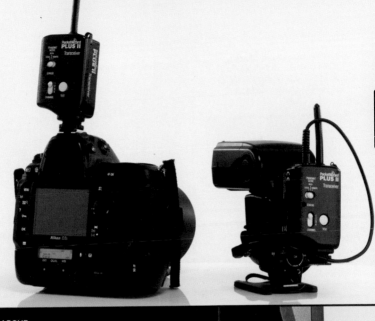

ABOVE

When the camera shutter is pressed, the Pocket Wizard Plus II transceiver on the hotshoe sends a signal from the camera to the unit mounted on the flash to fire it. To avoid interference with other photographers, there are different radio channels—from four on the basic Plus IIs, to up to thirty-two on more advanced Multimax models. The Plus II is bungeed to the flash using a Hildozone Caddy for a neat solution.

RIGHT

A good cable from Flashzebra screws into the flash's PC socket.

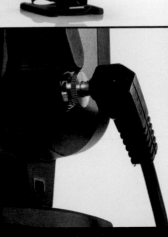

If your flashgun doesn't have a PC socket, you may have to buy a hotshoe adapter. The flash will sit on top of it. The cable plugs right into this adapter, and some adapters have a built-in cable. The advantage of using radio systems and manual control is that you can mix and match flashes and cameras with ease. They all work together and always will—even in the future.

Therefore, Canon, Nikon, Vivitar and the rest all work well together, whatever their vintage. As long as you buy a flash you can control manually, you're in business. Nowadays, however, there is another advanced option. A new breed of remotes from ingenious companies like Pocket Wizard and RadioPopper offer all the advantages of TTL, and full control from the camera using the manufacturer's own systems, but run on radio signals. The Pocket Wizard TTL remotes—called the Flex and Mini—are available for Canon and Nikon, and also let you alter the flash sync trigger timing as well as releasing the camera—clever stuff.

They're among the most expensive remotes and can be a bit daunting to set up initially, but can be made to work with old-school Pocket Wizards like the Plus IIs and Multimax radio triggers. Other manufacturers will no doubt follow with similar systems.

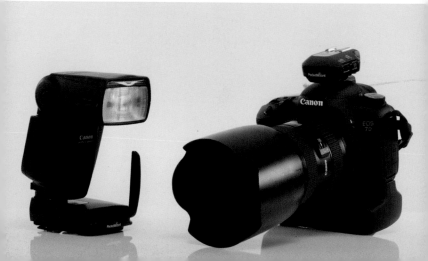

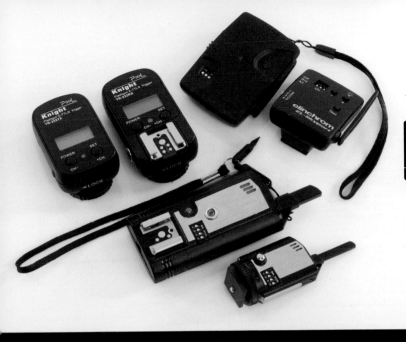

Basics

EQUIPMENT

43

Camera setup

Techniques

Ambient light

Lighting

Case studies

Advanced

OPPOSITE

The Pocket Wizard Flex and Mini offer full TTL control, but are triggered by radio signals so don't need line of sight.

ABOVE

Radio triggers from Elinchrom and Flashwave are well proven pieces of kit. Knights is the first of the budget brands to offer full radio TTL control like the proven Pocket Wizard Mini and Flex units.

Moving to Manual

Many photographers initially feel nervous about switching their flashes off automatic and taking full manual control, but once you get used to it, and understand exactly how the flash works, it's easy.

If you leave your flash on auto, there are two different ways it works. The first is the TTL setting, where the camera meters the flash output through its lens, and stops the flash when it senses the right amount of light has been emitted. The second way is the old-school "Auto" mode, where a sensor in the flash gauges how much light is being bounced back from the subject, so it knows when to cut off. This way was always thought to be inferior to the new-fangled TTL measuring, but can actually be more accurate with wide-angle lenses.

However, if you're using ordinary radio triggers your only option is to control your flash manually. There are only two things you can change on most flashes, and that's the light output, or power, and the angle of the beam.

First is the actual output or power. Most modern flashguns let you manually dial in how much power you require—from full power, often labeled as 1/1, to half power (1/2), quarter power (1/4), eight power (1/8), and right down to 1/128 power in many cases. This reducing by half every time tallies with camera *f*-stop numbers, where *f*/11 lets in half the amount of light as *f*/8, which lets half as much in as *f*/5.6, and so on.

Many flashes offer greater adjustments, including those that represent thirds of a stop. This allows you to go up from one

quarter power to 1/4 and 1/3 of a stop, to one quarter and 2/3 of a stop until you finally reach half power.

Don't worry about the numbers. Just consider that full power is full power, 1/2 is half power, 1/4 is quarter power and so on, plus you can adjust a bit between those settings—it's not rocket science. If your photo needs more light from the flash, just adjust the power a little at a time until it's right.

Once you've got the power about right, as long as the distance between the flash and the subject doesn't change, every exposure will be the same. This leaves you to focus on the subject, and is far better than worrying about exposure variation. This is precisely what can happen with any automatic or TTL systems—if you change position slightly, or zoom in or out, the camera tries its best to guess your exposure once again. It can lead to inconsistencies and a lot of checking of the LCD screen between shots to make sure the exposure is correct.

Of course, working manually means you've got to keep walking back and forth between your camera and flash to make the adjustments, but with more experience you'll be able to make an educated guess at what the power level should be. Then tweak away, but it's unlikely you'll need to adjust more than a couple of times if your first guess was pretty close.

With experience you can often just adjust the camera's aperture, especially if you're using several flashes and they are all over- or underexposing. This affects depth of field and ambient light exposure, but that may or may not be a problem,

Basics

EQUIPMENT

45

Camera setup

Techniques

Ambient light

Lighting

Case studies

Advanced

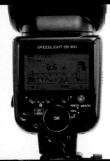 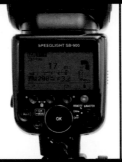 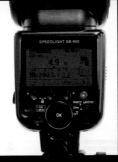

ABOVE

This Nikon SB900 flash is adjusted to provide full manual control. Its output will be a tiny 1/128 power and the zoom head is set to a very wide 17mm setting. As a guideline, the flash is telling you that when using ISO 100 and *f*/3.2 the maximum flash-to-subject range is just 0.6 meters. But, the flash doesn't know what ISO you're using or what *f*-stop, as it's not even mounted on a camera, so don't get confused by this info.

MIDDLE

Here the flash has been changed to full power (1/1) and been zoomed in to the 200mm setting. Note how the range is now up to 55 feet at ISO 100 and *f*/3.2. That's still relatively useless information unless you really are using *f*/3.2, but it at least gives a guide.

RIGHT

Finally, the flash has been adjusted to a third of a stop more than 1/16 power. That's 1/16 power +0.3EV. With the zoom still at 200mm, the range is now reduced.

depending on your individual situation. If the flashes are too bright or too dim relative to each other, then you have no other option but to change one or more of the flash output settings.

The second variable is the angle of the light beam, which is manually adjustable on most flashguns. The way this works is that when a flash is mounted on the camera, the beam adapts to fill the frame of whatever lens you're using. So the beam is narrower for a 200mm lens, but throws the light farther, for example, than a wide beam for a 17mm lens.

When using this off-camera, it means you can adjust the beam of light for creative effect, such as just creating a

small pool of light using the 200mm setting. Once again, the experience that is gained by experimenting with different settings means this isn't as difficult to get right as it may at first seem.

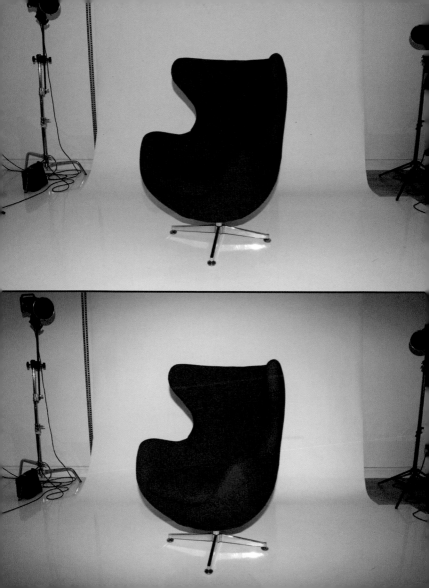

OPPOSITE TOP

With the lens set to 24mm, but the zoom head set to a wider 17mm, the flash easily covers the whole frame.

OPPOSITE BOTTOM

With the camera and lens unchanged, but the flash zoom now set to 50mm, there is some darkening in the corners of the image.

BELOW

Now with the zoom head at 200mm, there's a very obvious brighter pool of light in the center. The flash used, a Nikon SB900, actually lets you adjust the pattern of the flash from fairly even to more center-weighted, as shown here.

Basics

Camera setup

Techniques

Ambient light

Lighting

Case studies

Advanced

Lightstands and Tiltheads

You've got your camera and flash and are all set with a way to trigger it—preferably wireless. Well, unless you're going to hold the flash in your hand—which obviously limits your creativity and ability to position the flash—you'll be needing to invest in some sort of stand. There are loads of lightstands available to suit every budget. Some extend very high, some are very heavy, some are pricy and stack together for ease of transport, and others are very cheap and light. Some even have sliding leg attachments so they can balance on uneven ground.

The beauty of small flashguns is their portability, so it makes sense to buy lightweight stands that fold up very small. A popular model is the Manfrotto Nano 001B. Its thin legs are good for sticking in the dirt, and it reaches pretty high. It's not the most stable of stands, but it is compact and light. It's also black, which is good; silver or chrome stands can often be seen in reflections if you're shooting shiny objects. The flash attaches on top of the stand, which can be a problem if you want to position it over your subject: for that you'll need something bigger and sturdier. One option is a C-stand, which has three legs that swivel around to stack against each other. On top of this you can fasten a boom arm to a swivel joint, with another swivel at the end to let you move your flash into the required position. These stands—originally called Century stands—are great in a studio, or when they don't have to be moved very far, but they aren't very portable and their chrome finish isn't

reflection-friendly. They probably won't blow over in the wind, although with lightstands, putting sandbags or, at a push, camera bags onto their base helps to keep them stable.

Lightstands usually come with a standard spigot mount at the end. This often has a standard photographic 1/4 inch thread on top. Onto this you could screw a coldshoe attachment which you will mount your flash on. Many lightstands come with plastic coldshoes, or you can buy metal or plastic ones. If you use a coldshoe attachment, you can't tilt the flash around and aim it, so you will have to purchase a tilting head attachment. This clamps right onto the lightstand and has a swivel joint in the middle. Your flash coldshoe goes on the top. Now you can swivel your flash around and point it exactly where you like. The majority of these tilting heads also have a hole through them for the shaft of a photographic umbrella. A grub screw clamps down on the shaft to hold it in position, and the shaft hole is actually designed to be at a slight angle, so that the flash head can be pointed directly toward the center of the umbrella.

Tiltheads are available from many manufacturers at different price points, but beware the very cheap ones that are made from plastic as they are not very durable. You could, of course, fix a tilthead on top of a tripod, as they also offer a 3/4 inch thread.

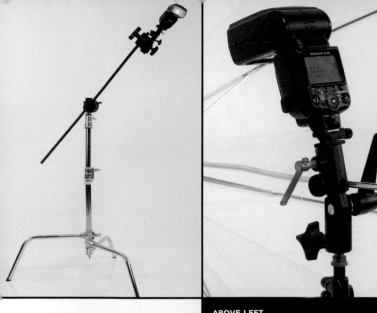

Basics

EQUIPMENT

49

Camera setup

Techniques

Ambient light

Lighting

Case studies

Advanced

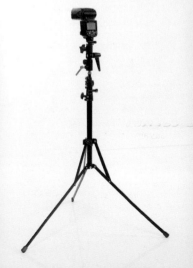

ABOVE LEFT

A larger stand like a C-stand can take a boom, which is ideal for putting your flash directly over the head of a subject. However, it's not a particularly portable option.

ABOVE RIGHT

Many tilthead attachments have a mounting hole for a photographic umbrella, like this one. It's a very worthwhile feature.

LEFT

A compact lightstand like this Manfrotto Nano is a popular choice for strobe users as it's compact and light. A Manfrotto tilting head sits on top of the stand and allows the flash to be angled at the subject.

Lighting Grip

One of the greatest benefits of using small flashguns rather than larger power pack-style lighting is their compact size, which means you can put flashes in small nooks and crannies that bigger heads wouldn't fit in.

However, shooting in a small space often means you don't have room for a lightstand, so you need to work out an ingenious way of fastening your flash to the exact place you want it to be so you can aim it in the right direction. Some flash users resort to gaffer tape, ball bungees, and Velcro, all of which are cheap, portable, and easy to set up in a hurry, but there are also several commercially available devices that can be used to clamp a flash more solidly. In the film world, the equipment to hold lights in place is called grip, and it's a term photographers often use too.

One of the most useful bits of grip you can buy is a "magic arm." This has a clamp at one end, and a standard lighting spigot at the other, so you can fit a tilthead, or even just a coldshoe. After clamping the arm to something solid, you move the flash into the desired position before tightening it all down with a single clamp in the center of the arm. Manfrotto is the best-known manufacturer of these arms.

A much smaller option is essentially a large crocodile spring clip with a small ballhead and coldshoe on the top. This isn't as secure as the magic arm, but may be just what you need if you find yourself stuck. Many manufacturers make versions of the magic arm, but Manfrotto's Justin clamp is the best known. For multiuse options, the Joby Gorillapods, which were

initially designed as tripod-style devices for lightweight cameras are popular. You can bend the device into shape like a regular, albeit small, tripod, or wrap it around things like fence posts. As it has a standard 1/4 inch tripod thread on the top, it's easy to fit a standard coldshoe and then place your flash of top of that.

If you need to clamp onto a smooth, flat, nonporous surface—for example a smooth wall or window—then a suction-cup clamp could be the answer. You press this onto the surface, then either use a clamping arm or a pumping device to create a vacuum to make it secure, and a ballhead with a tripod-sized screw thread accepts a coldshoe for your flash.

If there really is nothing to clamp your flash to, then you could always fix it to the top of a boom pole, though of course you'll need an assistant to hold it in place for you. Booms are purpose-designed to be light, with cushioned grips to ease the strain of lifting them, but you can always use a monopod for the same effect. Monopods are usually not as long and are a bit heavy, but have a tripod-sized screw on the top to fasten your flash onto.

ABOVE LEFT

The suction-cup clamp is ideal as long as you have a perfectly flat, smooth surface to mount it onto.

ABOVE CENTER

Spring clamps like these are ideal for lightweight flashguns, but you wouldn't want to rely on one in a situation where the flash could become dislodged and fall.

ABOVE RIGHT

Magic arms are solid and strong, but can be heavy and bulky, not to mention expensive. They offer one of the most secure options for clamping your flash precisely where you want it however.

RIGHT

A tripod and a clamp all at once, the light, plastic Gorillapod is versatile. It's not the most secure, but it's not very expensive.

OPPOSITE

A boom and a burly assistant can be a great asset in putting your flash head exactly where you want it to be. Think safety and make sure the flash is securely fastened before you hold it over someone's head, though!

CAMERA SETUP

Getting your camera settings right—and knowing how
to quickly change them when you're on location—is a
key element of taking top-quality photos. If you don't
know how to change your image quality, white balance,
and the like, then you're at a disadvantage.

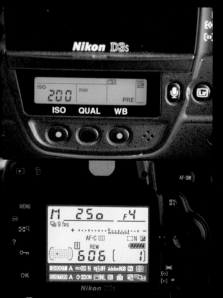

LEFT

The panel on the rear of this Nikon D3X shows the ISO
is set at the camera's "base" setting of 200 and the file
format at Raw for maximum quality.

BELOW LEFT

Amongst lots of other things, the Nikon's D3s menu
screen shows the color space set to Adobe RGB and
the picture style to NL for Neutral.

The first thing you need to do is to dig out your camera's manual and read it thoroughly. Then practice changing the settings. Some will have to be set via the camera's menu, while others can be changed by separate dials or buttons on the camera and lens. You will need to know which settings can be altered this way, as it varies from camera to camera.

Basic settings start with image quality, which really means choosing whether to shoot JPEG or Raw files. There are professionals who shoot each and both options have their merits, but in terms of quality of image, Raw is the best option. Raw files take up more memory space on your card and hard drive, can be slower to write to your camera's memory, and must first be processed via software before you can edit or use them. They are the best quality however—and crucially for flash use—they capture the greatest range of highlights and shadows compared to lower quality JPEGs. This is important when you also have hard highlights from flashguns.

You can also change your white balance in your Raw processing software, and can usually change the Raw quality too. Some cameras offer compressed Raw files that take up less memory space but are a tiny bit lower in quality, while others let you choose the bit depth. A higher bit depth means higher quality, so is many times the best setting, though you should experiment to see if there is any difference as often there is not much at all.

If you're going to be post-processing using Adobe software—like Photoshop or Lightroom—then it's best to change your camera's color space from the standard sRGB to Adobe RGB as it captures a wider range of tones. You may have to convert the final image back to sRGB for printing though.

Many cameras also let you choose a picture style: for example, Vivid or Neutral. This affects the JPEG settings, up to and including the JPEG you view on your camera's screen, even if you're actually recording Raw files. Unless you process your Raw files in the camera manufacturer's own software, then these settings aren't usually applied to your Raw files. It's often good practice to leave the color settings as Neutral on the camera and make all changes in the Raw converter.

All Raw converters process your files slightly differently and can be fast or slow, intuitive to use, or complicated. Adobe Bridge and Lightroom are both different to Capture One, or Nikon's Capture NX, for example. It's best to pick one and stick with it, learning its foibles thoroughly. For best quality, it's also good to keep your camera's ISO settings as low as possible.

When you increase your ISO, you increase the sensor's sensitivity to light, which allows you to use faster shutter speeds to avoid blur, or a narrower aperture for more depth of field. You don't get something for nothing however, and increasing the ISO does increase noise in the image, especially in shadowy areas. Although it has to be said, putting your ISO up and taking a picture that might be slightly noisy is better than having no picture at all.

Basics

Equipment

CAMERA SETUP

53

Techniques

Ambient light

Lighting

Case studies

Advanced

Automatic Exposure Modes

Automatic exposure modes—such as Program, Aperture, and Shutter Priority—are really only useful when using off-camera flash if you are using a TTL-based wireless triggering system or a sync cord. If you're using basic radio triggers, they are of limited use. You'll be controlling your flashes manually, so it's far better to control your exposure manually, too, but if you use TTL systems like Canon's E-TTL, Nikon's CLS or a Pocket Wizard, or similar TTL system with appropriate dedicated flashes, then automatic modes can make things easier.

The two most used modes are Aperture and Shutter Priority. These are called different things on various cameras. Aperture Priority is often called A or Av, while Shutter Priority is often labeled as S, Sv, T, or Tv, which stands for "shutter" or "time variable" with the exception of Tv, which is a Canon term that stands for "time value."

Essentially, you pick a mode and dial in your desired aperture or shutter speed setting, and the camera measures the light through the lens and sets a corresponding aperture or shutter speed for what it deems the "correct" exposure.

If you have a TTL-controlled flash, it will attempt to correctly expose the scene for ambient light and mix it perfectly with flash light, too. So if you're using Av, for example, you can set a narrow aperture of ƒ/16 for lots of depth of field. Then the camera will work out a shutter speed that suits. Or in Tv, you could pick a shutter speed like 1/250 sec, and the camera will work out a corresponding aperture. If you

ABOVE

Selecting Tv on this Canon-camera sets it to Shutter Priority mode. Some cameras use a push-button and menu system rather than a dedicated dial.

set it to P or Program mode, the camera will attempt to choose middle settings for both, which is not ideal if you're trying to take control and be creative.

The problem with choosing auto modes is that you have to keep a constant watch on your actual settings anyway. If you dial in ƒ/16 in Av, for example, then the camera will set a slow shutter speed to match in most situations, so camera or subject blur could be an issue. It also often won't let you go too slow on the shutter speed, so may not always expose properly for the ambient light. This is ideal for shooting at night, but this may not be the look you're after. The limit to how slow it will allow you to go is usually editable in the menu. As you can see, auto mode is more complicated than it looks.

Basics

Equipment

CAMERA
SETUP

Techniques

Ambient light

Lighting

Case studies

Advanced

55

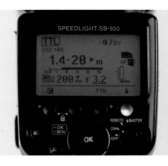

ABOVE

This Nikon D3 camera lets you dial in flash exposure compensation direct from the camera. In this case, it's set to -1 EV so it will be a stop darker than the ambient light exposure.

ABOVE

With some flashes, you set the exposure compensation on the flash itself. This Nikon SB900 is set to TTL mode but to underexpose by 0.7 EV, which is around 2/3 of a stop.

If you are using Tv and have set a shutter speed that's faster than your camera's true sync speed, it will affect flash output; the flash may automatically revert to the special high speed sync mode. Again, a mode often thought to be simple is getting more complex.

This whole process relies on the camera getting its exposure correct too, which it often doesn't. In that case, you can dial in some under- or overexposure using exposure compensation. If the ambient light is not appearing bright enough, you can dial in +1, for example. This will alter the exposure, by setting a 1-stop slower shutter speed if you are in Av, or a 1-stop wider aperture if you're in Tv.

On some cameras, dialing in exposure compensation affects the power of the flash, but on others it doesn't. Check your

manual and take some test pictures to see. You can also usually alter the relative power of the flash using flash exposure compensation, which you can access via the flash or camera menu, depending on the model.

Of course, if you change viewpoint or zoom in or out, the whole exposure can change. In reality, attempting to use auto modes can be very complicated and introduces variables between shots. For that reason, taking full control and using manual exposure is often far simpler and definitely more consistent.

Auto modes do have their place, such as in fast-moving situations or when ambient light is constantly changing.

Taking Manual Control

To truly take control of your images and effectively introduce off-camera flash, it's good practice to switch to full manual control. That way, you can set the desired aperture and shutter speed on the camera to give the right effect, and then dial in the power of your flashes to match.

This will allow a real understanding of what's going on, and once your lights are set up then every exposure will be the same. First, put your camera into manual mode either via a dial or its menu system. You are then at liberty to adjust the exposure by changing the aperture of the lens or shutter speed.

Aperture controls depth of field, with a wide aperture (a low number like $f/4$) giving a very shallow depth of field. A narrow aperture (high number like $f/22$) gives a very wide depth of field, so things close to the camera to those right into the far distance will appear sharp.

The distance from your subject and the focal length of lens you choose also affect depth of field. A wide-angle lens gives more depth of field than a telephoto at a given distance, for example, and depth of field reduces the closer you are to the subject.

Wide apertures are good for making your subject really stand out from its surroundings. Narrow apertures are good for landscapes, for example, where you want everything in focus.

At a given ISO, setting the aperture will determine the shutter speed for the "correct" exposure. A narrow aperture will give a corresponding slow shutter speed which may not be fast enough to stop blur.

BELOW

Setting the mode dial to M for Manual opens up the world of truly creative photography. It's well worth getting to know how to shoot manually, as it gives a real understanding of light.

In this case, to get a higher shutter speed you need to increase your ISO—which slightly reduces image quality. Getting the exposure right is a continuous three-way battle between low ISO for maximum quality, shutter speed fast or slow enough for the desired creative effect, and the right aperture for a required depth of field.

In some cases, you may not be able to use an ISO low enough to get the required wide aperture for shallow depth of field —especially when you consider that you probably won't want to go higher than your camera's maximum flash sync speed, which is often around 1/250 sec or lower. In this case, a neutral density filter (ND) over the lens reduces the amount of light entering the camera, meaning you have to

Basics

Equipment

CAMERA
SETUP

57

Techniques

Ambient light

Lighting

Case studies

Advanced

use a wider aperture. We'll be tackling the issue of maximum sync speed on the next few pages.

So where do you start with choosing an aperture or shutter speed? Usually you will have one overriding factor, such as wanting to avoid camera shake, for example. In this case, it's often best to set your camera to its maximum flash sync speed which is often 1/250 sec. To get a matching aperture you could use a separate handheld incident light meter and set your f-stop to match, but as your camera already has a built-in meter, you can use that to take a reading from your subject. It's a good place to start. Take a photo, check out the results on the LCD screen, then adjust the aperture. If it's too

ABOVE

Setting the camera to its maximum sync speed of 1/250 sec gave an aperture of f/11 on this bright day. So manually underexposing to f/13 made the sky slightly darker and more saturated. A single flash through a softbox—clearly reflected in the subject's sunglasses—was the main light source on the subject. *Nikon D3S; 35mm focal length; ISO 200; f/13 at 1/250 sec.*

dark, set a wider aperture and vice versa if it's too bright. Take another picture to check that your results are right, and zoom in on parts of the photo to see if you have the required depth of field. If you have, you're good to start shooting and only need to change exposure if the light on your subject changes.

Judging Exposure

Many photographers now use the LCD screen on the back of digital cameras, as a final judge of whether their exposure is correct. Take a photo, check it looks all right on the screen and you're ready to go. The introduction of LCD screens has meant that sales of handheld light meters, which previously all serious photographers used to own, have plummeted.

However, just using the LCD picture as a guide to whether your exposure is correct is fraught with problems. Firstly, if you look at the same picture on the screen outdoors on a bright sunny day versus indoors in the shade, there's often a big difference. Also, many photographers have their screens set to auto adjust to the surrounding brightness levels, so it can look different minute to minute.

It's impossible to calibrate your LCD screen in the same way you can your computer screen. All you can do is adjust its brightness manually. It's good practice to take a photo, then load it onto a computer with a calibrated screen. Put the memory card back in the camera, then adjust the camera LCD brightness until it's as close to the screen as possible. It's slightly more accurate than the auto mode, but of course a bright day outdoors really affects how your eyes see the screen anyway. As standard, many camera screens seem to come preset at a very bright level. (Cynics might say this is so that when you try it in a camera shop, it looks impressive.)

A far better way to check exposure is to check the histogram, which essentially is a graphical representation of the tones in a photo. What you're trying to avoid is the graph either clipping off the right or the left edge of the screen. It's pretty technical, and many photographers set their screens to check out separate histograms for separate red, green, and blue channels. There are whole books written on the subject, and it can be good practice to learn how it works.

In reality, when in the field and busy shooting, many successful photographers find this method a bit too technical and fiddly.

If you think this would be you, then one of the best ways to see if your exposure is right is to activate your camera's highlight warning. Set like this, any overexposed highlights in your photo blink very obviously. It's always good practice to avoid blowing these highlights, as once detail is gone, it's gone, but you can often pull shadow detail back.

Knowing if your highlights have blown allows you either to adjust your camera or flash to underexpose a little, or understand that you'll have no detail in the final shot. This may be what you want, (in a high-key shot, for example), or it may give you a vital warning you've just overexposed a bride's white dress and allow you to reshoot. Either way, the blinking is an obvious visual cue that works if you're in bright sunshine or indoors in a darkened room.

A final parameter to consider is the camera's white balance. Auto can work well, as long as you're shooting in Raw and there are no mixed light sources. A better bet is to manually set the white balance using the built-in settings like Flash or

228-9

Highlights

RGB **R G B** ⊠+◉Select R, G, B

🔲 M 1/250 F10 ISO200 85mm

🔲 -0. 7 🔲

WB PREd-2, 0, 0 AdobeRGB NL

📷 228NCD3S _D3S8964. NEF ⌁RAW
04/08/2011 15:45:04 FX 4256x2832

228-9

6/9 NIKON D3S

Highlights

RGB **R G B** ⊠+◉Select R, G, B

🔲 M 1/250 F16 ISO200 85mm

🔲 -0. 7 🔲

WB PREd-2, 0, 0 AdobeRGB NL

📷 228NCD3S _D3S8959. NEF ⌁RAW
04/08/2011 15:44:27 FX 4256x2832

ABOVE

A blinking highlight like this gives an easy graphic representation that the background of the test shot is very overexposed and lacking in any detail.

TOP RIGHT

A histogram version of the overexposed picture shows the graph disappearing or "clipping" at the right hand edge. This shows some of the tones are missing.

BOTTOM RIGHT

A histogram of a correctly exposed frame shows the graph completely within the edges of the chart.

Cloudy. Choose the white balance to suit the main light on the subject, more often than not flash if you're using strobes. A better alternative is to use a calibration target, such as the X-Rite Color Checker Passport, to make a custom white balance setting.

A NOTE ON GUIDE NUMBERS

A guide number is the power rating of a flashgun, and can be used to determine exposure when working manually. Using the guide number of your flash (as stated by its manufacturer) divide this number by your flash-to-subject distance in meters to work out an approximate f-stop to set your lens to. If your flash guide number is 33 at ISO 100 and the flash is 3 meters from your subject, then $33/3 = 11$, so you would set $f/11$. This is an old-fashioned system that hasn't been used for years, so it is far better to use a flashmeter or check your LCD histogram as a guide to your exposure.

Basics

Equipment

CAMERA SETUP

59

Techniques

Ambient light

Lighting

Case studies

Advanced

Sync Speed

The maximum flash sync speed of your particular camera is the one shutter speed that should be permanently fixed in your mind. Different cameras have different maximum sync speeds, and you'll find yours in the manual.

This speed is the maximum speed you can set while still getting full coverage with your flashgun. If you set a speed higher than this, then the flash will fire while the sensor is partially covered and you'll get a nasty dark line obscuring part of the image.

To understand why this happens you need to understand how shutters work. Think of the shutter as a pair of curtains. The first opens to let light hit the sensor, then the second curtain closes at the required time to stop the light.

At very slow speeds, the first curtain opens after a specified time—like 1/2 sec for a half-second exposure—the second curtain snaps shut. The flash, which usually has a very, very fast duration of 1/1000 sec or even less, goes off while the sensor is completely exposed.

As shutter speeds go higher, the second curtain has to move with an increasingly short time delay. There comes a point where the second curtain has to start moving at the precise moment that the first curtain reaches its fully open position. This is the fastest shutter speed you can use where the sensor is fully exposed, and is the maximum sync speed. At this speed, the fast burst of flash will fully register on the sensor and give full coverage. At speeds higher than

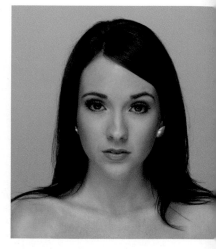

ABOVE

At 1/160 sec, within the Nikon D3X's maximum stated sync speed of 1/250 sec, the flash gives complete coverage of the frame. The Elinchrom Skyport wireless triggers used to fire the flashes reduce the camera's maximum sync speed by around 1/3 stop due to the time it takes them to operate.

this, the second curtain has to start moving before the first is actually fully open. At very high speeds, this is almost like a slit scanning over the scene. If you use conventional flash at speeds like this, you'll see an image of the shutter curtain obscuring the image. Obviously this isn't what we want, but there are high-tech ways around it, as we'll discover later.

Basics

Equipment

CAMERA
SETUP

61

Techniques

Ambient light

Lighting

Case studies

Advanced

ABOVE
At 1/250 sec, the camera's stated maximum sync, there is a clear black line showing the shutter curtain encroaching on the image.

ABOVE
At 1/320 sec, the image is more than a third obscured.

ABOVE
At 1/400 sec, it's roughly half covered.

ABOVE
By 1/500 sec, there's not much left to see.

ABOVE
At 1/640 sec, only the very top of the image is showing.

When you check your camera's stated maximum flash sync speed, here's a word of warning: don't trust the printed figure! If you're using the manufacturer's designated flash, either on the hotshoe, at the end of a dedicated sync cable, or via the CLS or E-TTL wireless system, then the sync speed will be right. If they say 1/250 sec, you can virtually guarantee it will be 1/250 sec.

If you're using an aftermarket wireless flash trigger, however, then there's a very good chance your flash won't sync quite as high as the stated figure. This is because most wireless triggers lose about 1/3 stop in shutter speed. The way to test this is to try your flash in a dark room, so that ambient light won't affect the exposure,

and see what maximum shutter speed you can set before you start to see a dark line.

There are some wireless flash triggers that offer a fast "speed" mode that can make the camera sync at, or closer to, the stated speed. Pocket Wizard's Multimax triggers, Elinchrom's new Skyport Speed, and Profoto Air Sync are three that can do this. The range or ultimate reliability may be slightly compromised however.

Slow-speed Sync

Using your camera at its maximum sync speed is a widely-used technique. It prevents camera blur, and if you're outside on a bright day trying to record both ambient light and flash, it gives as wide an aperture as possible.

It's not the only way to get creative results, though. When light levels drop, you may wish to drop your shutter speed to something much lower. This helps low-level ambient light register, and introduces an element of blur at very low shutter speeds.

If your aim is to get a sharp photo all over, and you're not using flash, you'll need to make sure the subject and camera don't move. A tripod is essential for this, as is a subject that doesn't move—like an inanimate object. Another way is to actively use blur to give a creative new dimension to your photos. Using blur—such as when panning with a moving cyclist, for example—is a well-tried way of suggesting motion. Setting a low shutter speed gives this lovely blurry effect, but your technique needs to be perfect in order to do it properly. The general idea is to keep the subject sharp, but the background blurry.

If you introduce a burst of flash into the equation, you can get even more dramatic results. There will still be lots of blur, thanks to the low shutter speed letting the ambient light register, but a burst of flash—which is super-fast by comparison—means the subject can also be partially frozen. So you get a sharp image, surrounded by a ghost image from any movement. If the subject is actually moving, then the blur will show how

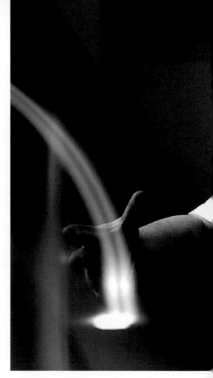

you've moved the camera to keep up with the subject. Alternatively, if the subject isn't moving very much, you can even introduce some blur by moving the camera during the exposure. Of course, this can be hit and miss, with too much blur often a problem, but thanks to digital, you can try again and again and instantly view your results.

A second consideration is what occurs when the flash goes off. As discussed in the previous section, there are two shutter curtains, and on longer exposures, the flash goes off when the first curtain

Basics

Equipment

CAMERA
SETUP

63

Techniques

Ambient light

Lighting

Case studies

Advanced

reaches its fully open state. The alternative is to change your camera settings so that the flash fires just before the second curtain starts to close. This is known as second curtain sync.

In first curtain sync, the image is frozen virtually at the point of triggering the shutter, then the blur happens afterwards. However, this does mean the subject can look like it is moving backwards.

Second curtain sync often means the subject looks like it's moving forwards, but with very long shutter speeds it's difficult

ABOVE

Just because your subject isn't moving much doesn't mean you can't use slow-speed sync for creative effect. This rapper is partially frozen by an off-camera flash, and partially blurred due to camera movement during a 0.6 sec exposure to let the ambient light register. *Nikon D3; 85mm focal length; ISO 200; 0.6 sec at f/8.*

to guess when the flash will go off. Both types of photos have their charm, so it's best to experiment with first and second curtain sync to see if one works better for you than another in various situations.

High-speed Sync

Until recently, it wasn't possible to use flashes successfully at shutter speeds higher than maximum sync speed. If you did, part of the image would not be lit by flash and you would see a black shadow from the shutter curtain, as demonstrated on page 61. But now there is an option to go even higher, thanks to some clever new technology.

Firstly, you have to know why you would want to go higher than the stated maximum sync speed. This is obviously related directly to the shutter speed, where you want to ensure there is no blur on a fast-moving subject. At the 1/250 sec maximum sync of most cameras, there is still a very good chance of some motion blur.

A second reason you may want to go higher on the shutter speed is that it gives a correspondingly wider aperture, which is often desirable for shallow depth of field effects. Of course, you can do this by fitting an ND filter to your lens to reduce the light reaching the sensor, which necessitates a wider aperture, but ND filters can be fiddly and make the viewfinder image darker. This can affect focusing speed and sometimes accuracy.

To use high-speed flash, you need a compatible camera, flash, and triggering system. Essentially this means a pro-consumer level DSLR, a dedicated flash offering high-speed sync, plus a dedicated TTL controller like a Nikon SU800. Some of the more advanced wireless triggers, like Pocket Wizard Mini and Flex, also allow high-speed sync operation. You usually need to enable high-speed sync in either the flash or camera menu, or

sometimes both. With Nikon-cameras, this is called Auto-FP mode and Canon call it HSS for "high-speed sync." The way this works is that instead of the flash firing in one big burst, it actually pulses. The eye can't detect this, as it happens thousands of times per second.

This pulsing means that the flash fires as soon as the first shutter curtain starts to open, and continues pulsing until the second curtain closes. It's like a very short continuous light source that is on precisely while the shutter is open—even if the shutter curtains do form a slit at very high shutter speeds. The flash will work at any shutter speed, right up to the maximum speed of the camera—typically 1/8000 sec.

There is one big caveat, however, and that's the power of the flash. Compared to one huge burst of flash power, lots of little pulses are nowhere near as bright, so the range and effectiveness of the flash is massively reduced. If the ambient light is very low, there won't be much of an issue, but on a bright day—precisely the time when you may want to set a fast shutter speed or wider aperture—it's not very effective.

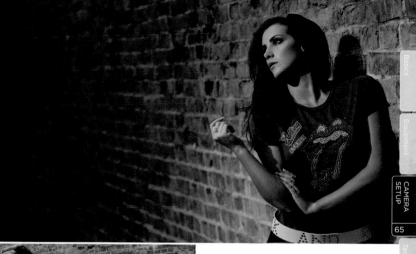

ABOVE

Not all high-speed flash is aimed at getting faster shutter speeds. Sometimes a wider aperture for narrower depth of field is the goal, like in this photo of a model against a wall. *Nikon D3X; 82mm focal length; ISO 100; 1/1000 sec at f/2.8.*

LEFT

Using Nikon's CLS system meant high-speed sync was easy, especially as low light levels and short distance between the model and the flash meant power was not an issue.

As an alternative, if there is a lot of ambient light registering in your photo, don't use Auto-FP or HSS, but simply set a shutter speed that's too high to sync properly. Of course, part of the image will not be lit by flash, but if there is enough ambient light to register it may not be a huge issue. It all depends on where the subject is in the frame. If you know that your flash at, say, 1/500 sec will only illuminate the top half of the frame, but that is in fact where your subject is—such as a skater jumping out of a half pipe—then you know that they will be illuminated by a pulse of full-power flash. It's trial and error, but it can work. Some ingenious photographers use this to darken a sky in a picture by shooting with the camera upside down! The sky goes dark but the foreground is illuminated by flash. It's not very easy to do, and it doesn't work if you hold your camera in portrait orientation!

Beautiful soft light from several flashes helped create this high-key image, full of muted tones and soft lines. *Mamiya 645AFD; 150mm focal length; ISO 100; 1/125 sec at f/12.*

Basics

Equipment

Camera setup

TECHNIQUES

67

Ambient light

Lighting

Case studies

Advanced

The direction of light is only one aspect of light that you should take into account, however, although it ranks right alongside quality of light for having a huge effect on the look and feel of your images.

Getting great images isn't just about putting light everywhere. It's often about channeling the light so it illuminates a key part of the scene, leaving less important elements of a scene to disappear into the background, or to create shadows where you need them for maximum artistic effect.

It's all about taking control of your lighting, and modifying its output to give a certain look to your images. From lovely, soft, flattering light to sharp-edged beams, all you have to do is modify the output from your flashgun.

Colored gels, grids to control spill, gobos, and specialist flash attachments can open up a world of creativity and produce amazing photos. There's been an explosion in the number of attachments you can buy for your flashes, and many give a fantastic effect. In this next chapter we look at the best techniques for modifying your light source to get the results you want.

BELOW

Even outside, a small flash can be powerful enough to balance with ambient light to give a glowing look to the skin of this bride, thanks to the use of a softbox. *Nikon D3S; 24mm focal length; ISO 200; 1/200 sec at f/14.*

Bouncing Light

Our first technique for using off-camera flash actually may not involve taking the flash off its hotshoe at all. In fact, it's not necessarily about off-camera flash at all, and is more to do with having an off-camera light source.

Probably the easiest way to do this is to use your hotshoe-mounted flashgun and aim it directly at a nearby wall or ceiling. The wall or ceiling becomes the light source, and as it's large compared to the subject, the light will be very soft.

One of the advantages of this is that it's free and easy to do. You can just aim your flash's bounce and swivel head right at the ceiling and let your camera work out its setting automatically using its TTL system. Easy. Or you can go fully manual on the flash, or camera, or both if you want to take real control.

However, it's not a perfect solution, as bouncing your flash has the effect of reducing its power. In addition, light always takes on the color of whatever it's been reflected from, so you will need a neutral-colored surface to bounce off. Bouncing off a bright green wall may make your subjects look ill. You can carry a big reflector, hold it to the side or overhead and bounce off that, instead. Large broadsheet newspapers make good bounce cards, too, as do large people in light-colored shirts!

When using bounce flash it's often advantageous to use a clip-on diffuser, as this scatters the beams of light so they bounce off even more surfaces. Some flashes come with these as standard, or you can buy aftermarket diffusers from Stofen, Gary Fong, or others.

ABOVE

Two off-camera flashes, one on either side of the room, were aimed at the white ceiling, meaning the light on this group of people is surprisingly even and soft. *Nikon D3S; 14mm focal length; ISO 200; 1/125 sec at f/9.*

They do reduce flash power, which may be an issue. They send the majority of light directly to where they are pointed, though the sides also radiate light. This is ideal for a little bit of fill light on a subject's face and can put nice catchlights in the eyes, with the diffuser cap acting like a main light and minor fill, all at once.

Low ceilings are ideal for bouncing off, as the main light comes down from above the subjects, giving a natural look. If it's too bright however, note that there can be shadows under the eyes—just like on a sunny day. It's also a good idea to reduce the camera's shutter speed or increase its ISO so that some ambient light is recorded. Of course, if the floor is white then it will act as a lovely fill light for you if you bounce light off the ceiling. Light will bounce down as a soft main light, hit the floor, then bounce upwards as a fill light.

It's not always about ceilings, as light-colored walls can work very well as a main light source. Of course, this works if your flash is on-camera, but also if you take it off-camera and bounce it. With a light-colored ceiling and a couple of off-camera flashes aimed upwards, you can put even light all over quite a large room.

ABOVE

An ISO of 400, a pretty wide aperture of $f/3.5$, and a slow shutter speed of 1/50 sec means lots of ambient light was registered in this line-up shot. The key light is a flash bounced off the low, light-colored ceiling. *Nikon D3S; 24mm focal length; ISO 400; 1/50 sec at $f/3.5$.*

BELOW

You don't always have to bounce light off a ceiling: this shot was lit by a flash bouncing off a large white wall to the right of the photographer, in a small room that was painted all white. *Nikon D2XS; 105mm focal length; ISO 100; 1/125 sec at $f/13$.*

Basics

Equipment

Camera setup

TECHNIQUES

69

Ambient light

Lighting

Case studies

Advanced

Umbrellas

When it comes to ease of use, lightness and portability, soft but adjustable quality of light, and great value for money, nothing comes close to the humble photographic umbrella. Softboxes and beauty dishes may seem more modern and certainly offer a more controllable output, but they're not as versatile and—crucially—nowhere near as cheap to replace when damaged as the umbrella.

The damage issue can be a real problem. If you put a big light modifier on top of a lightstand, sooner or later it is going to get knocked down or blown over. Umbrellas give your flashgun some protection from hitting the ground, and when and if they do go down, you can often bend them back into shape.

Using an umbrella is all about making the relative size of the light source bigger, and therefore softer. Essentially, there are two types of umbrella: those you aim the flash into so it bounces back toward the subject (reflective umbrellas), and those that you aim the flash through (usually called a shoot-through umbrella).

For portraits, it's hard to beat a plain, white, shoot-through umbrella. Although the light output from a shoot-through is marginally harder than from a reflective umbrella, it's easier to get the shoot-through close to your subject. This makes its size bigger in relation to the subject, so the light is softer and wraps around the face of the model. The key disadvantage of an umbrella like this is that is scatters light nearly everywhere. If you're trying to really control where the light goes, a white

ABOVE

A single flash, fired through a white shoot-through umbrella, provides a flattering soft light, especially at such a close distance as this. In a white room, the scattered light from the umbrella's surface bounces off the walls and floor and acts like a natural fill light.

shoot-through will be irritating as the light will bounce back from any walls, ceilings, floors, or other surfaces. It's just not as controlled as a similar-sized softbox, for example.

This uncontrolled spread can be a huge benefit on the other hand, as this scattering of the light bounces back toward the subject and provides a degree of fill light. In a light-colored environment, for example, a single shoot-through umbrella can be the only light you need for a soft, flattering portrait. Place it so that its center is approximately at the same height as the top of your model's head. That way, the majority of the light will be coming from a largely downwards direction—which always looks natural—but the lower part of the umbrella will fill in some of the shadows

70

BELOW

Aiming a flash into a reflective umbrella before it goes through the shoot-through umbrella provides an even softer light on the model. However, the black-backed reflective umbrella stops the light from spilling around the room anywhere near as much. Compare the light on the background of this photo to the one shot with a shoot-through umbrella. It's the same room as in the other image.

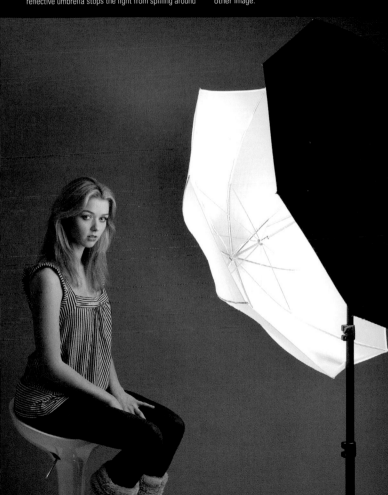

Basics

Equipment

Camera setup

TECHNIQUES

71

Ambient light

Lighting

Case studies

Advanced

ABOVE

Silver-and-gold-lined reflective umbrellas provide a sharper, more contrasted light than white. The gold umbrella really warms the light.

ABOVE

A white-lined umbrella produces a soft, even light. The black backing of the umbrella cover stops light shining through and spilling around as much as it would using a shoot-through umbrella.

that could form in the eye sockets or under the nose and chin. It's a main light and a fill light all in one—especially as the light that bounces backwards from the umbrella will bounce around the room and reduce contrast even more.

Due to their ability to spread light around, shoot-through umbrellas can also be used as very effective fill lights when moved slightly farther away or the power of the flash reduced.

Reflective umbrellas come in various different finishes and colors. The most popular is a white finish, with a heavy black cover on the outside to stop light going straight through. This means the light output from the open end of the umbrella is soft, and there's less uncontrolled spill everywhere, so it can be more effective in controlling the beam of light. Other surfaces are also available, ranging from silver to gold to a half silver/half gold

zebra pattern, or even a blue-silver.

Silver umbrellas provide a much more contrasty, sharper, and harder-looking light source, while gold-colored umbrellas give similarly crisp and contrasty light, but one that is much warmer—ideal for giving someone with a tan a healthy glow.

The half-silver/half-gold patterns are crisp and give slightly less warmth than a gold umbrella. Gold umbrellas are often much too warm for normal use.

A blue-lined umbrella is used to make a warm light source very blue and cool, though instead of using a special umbrella, it would be just as easy to put a cooling blue gel in front of your flash to produce a similar effect.

For maximum softness, some photographers actually use two umbrellas together. The flash is fired into a reflective umbrella. Instead of the light then bouncing back and straight onto the subject, it

Basics

Equipment

Camera setup

TECHNIQUES

73

Ambient light

Lighting

Case studies

Advanced

ABOVE
The white reflective umbrella gives the softest, most flattering light output.

ABOVE
At the same distance, the silver umbrella gives a slightly more contrasty look. As silver is better at reflecting light, it's also brightened up the background, too.

ABOVE
A gold umbrella provides a very warm look to the whole photo. On a pale-skinned model like this, however, it's a bit too warm.

shines through a shoot-through umbrella that is placed in the front. This usually takes a special type of tilthead clamp, but forms a softer light source that doesn't spread too much. It's more like a softbox, although the curved shoot-through does make the light bounce around.

Umbrellas usually come in a range of sizes. Of course, the larger the umbrella, the softer light output can be, though if you go too big, the umbrella becomes unmanageable. It's best to buy the biggest umbrella you can reasonably handle; a 38-inch diameter umbrella is a good compromise. If you want the harder light that you'd get from a smaller umbrella, then you can slide the shaft of the umbrella farther down into the tilthead. You can also zoom your flash head so the pattern is focused in the center of the umbrella, or let it down slightly—it doesn't have to be fully open to work. A sandbag or camera bag to weigh the lightstand down is a good idea, as with all light modifiers.

For maximum softness, it's best to insert your umbrella shaft just a few inches into the tilthead, then zoom the flash head to a wide-angle setting so the light fills the umbrella, but no more. It's all a bit of trial and error, and you should try different settings on your zoom and take a picture of the umbrella. That way, you should get a good idea of whether the whole umbrella is being evenly filled with light, or just the center.

As with many things, the more you pay for your kit the better quality you tend to get. The better umbrellas don't lose their color and are made of stronger materials in both the cover and the ribs and stretchers. Some of the best models from top manufacturers like Westcott are double-fold or triple-fold, so they collapse into a very compact size.

Softboxes

A softbox is essentially a reflective cloth material stretched over a frame that can be square, octagonal, rectangular, or long-strip rectangular. Each produces slightly different light, and some professional photographers will only work with octagonal softboxes due to the more natural catchlight they produce in the eyes of a subject.

Softboxes may cost more than umbrellas and take a little bit longer to set up, but the quality of light they produce is just about as soft as it gets. By carefully choosing the type, shape, size, and any accessories to direct the output, you can very effectively control the spread of light, too.

However, the downside is that you often have to be more conscientious in managing the contrast. You haven't got the spread-around light of a typical shoot-through umbrella to help you, for example.

Typically, the reflective material inside a softbox is silver. Some manufacturers offer white-lined softboxes for a slightly softer light, though these do reduce the power of the light slightly. Most softboxes have an inner diffuser—essentially a piece of white diffusion fabric similar to the fabric in a shoot-through umbrella. This inner diffusion can usually be removed to provide a slightly harder light source, or to make the light more efficient if power is an issue.

The front of the softbox has a second diffuser. It is these two layers of diffusion and the lack of all-around spill light that provides a soft yet directional light source. On some softboxes, the flash is totally flush with the front of the box, and on others, it's set slightly inside so that the edges of the softbox provide a small lip to stop light spilling around too much.

Some manufacturers, such as Elinchrom, offer a very deep softbox that provides a light that is slightly more focused and contrasty while still remaining soft. As you can probably imagine, there are hundreds of different versions available and each has its advocates.

Most softboxes were originally designed for full-size studio lights, so pack-based battery systems like the Profoto Acute or Elinchrom Ranger work flawlessly with the full range of softboxes designed to accept them. Many softboxes can be assembled into a circular speedring that takes the relevant mounting ring for whatever particular brand of studio flash you use. There are speedrings and adapter brackets that you can use small, hotshoe-style flashes with, though in most cases the flashes need to be set to their fully wide zoom setting, as the idea is to fill the interior of the softbox with light. It's often a good idea to also use a diffuser cap, though this does cut power output.

Softboxes that use the speedring-type system, such as Chimera, usually require assembly with rods each time you use them. It only takes a minute or so, but they're not the fastest to set up and the largest are less than portable. As these softboxes were mostly designed before the use of small flashguns exploded in popularity, it means the placing of the flashtube inside the softbox when using small strobes can be less than ideal.

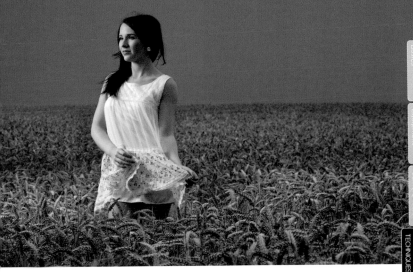

Basics

Equipment

Camera setup

TECHNIQUES

75

Ambient light

Lighting

Case studies

Advanced

ABOVE

A medium-size softbox close to the model gives a lovely soft light on her, and also partially lights up some of the wheat. The rain-heavy sky adds some drama to the scene. *Canon EOS 5D Mark II; 105mm focal length; ISO 100; 1/160 sec at f/11.*

BELOW

The setup for the shot in the wheat field. An Elinchrom Ranger Quadra is firing into a Chimera softbox fitted with double diffusion for maximum softness.

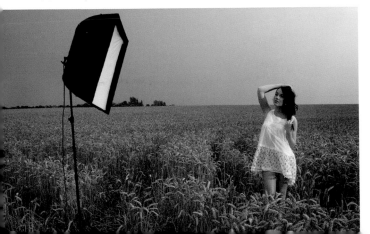

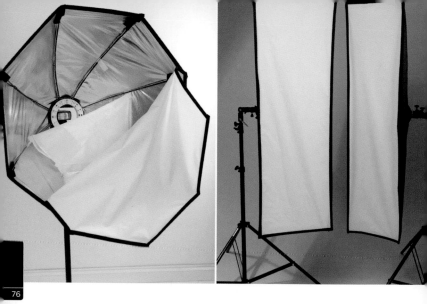

Softboxes are usually expensive due to the costs of a speedring, adapter ring, inner and outer diffusers, and rods, as well as the cover itself. They are perfect for use in a studio or outdoors when there's little chance of them being damaged.

Luckily, there are other options for users of small flashes, and new products are regularly coming onto the market. One of the most popular is from Lastolite, the manufacturer famous for its pop-up reflectors that use fabric stretched over spring steel. They've used this technology to build a range of softboxes that just spring up when you take them out of the bag.

The strobe sits on a special adapter device that just pushes into the back of the spring steel softbox frame. They are light, portable, and fast. The downside is that they are available in a limited number

ABOVE LEFT

The inner diffuser, outer diffuser, and reflective interior of the softbox are clear to see in this shot of this Lastolite softbox designed to be used with flashes.

ABOVE RIGHT

Some manufacturers are starting to offer strip softboxes for flashes. There is a limit to the length of a strip box that a flash can adequately fill, so it's best to stick to ones built by reputable manufacturers. Poor-quality strip boxes have a very hot spot in the middle, but the light is less bright at the extreme ends.

of shapes and sizes, and the spring steel pop-up frame isn't sturdy enough to hold very large softboxes. Because of this, the range has now expanded to include larger octagonal and even long, strip-style softboxes especially for small strobes, though these larger units do use a speedring and rod-type system.

Basics

Equipment

Camera setup

TECHNIQUES

77

Ambient light

Lighting

Case studies

Advanced

TOP

This is how a flash fits into Lastolite's Ezybox Hotshoe softbox. Due to its simplicity of use, it's been hugely popular worldwide.

ABOVE

Inside the Westcott Apollo, the flash is totally obscured, and also sits very high inside the unit.

Most softboxes leave the flash unit itself exposed at the back. This is useful, as you can change power settings easily, but if you are using an infrared triggering system like Nikon's CLS, then the softbox itself can easily obscure the receiver window, which is a huge headache. Some softboxes are set so you can sit the flash at 90 degrees to the softbox, then twist the head round 90 degrees so it points inside the box. This leaves the infrared sensor more exposed, but it's still a problem. Radio triggers are the best to use with any softboxes or light modifiers that in any way obscure the flash.

The final type of softbox is typical of those made by Westcott. Theirs is called the Apollo and is a square softbox that's based on an umbrella-type device. Essentially, it's like a square reflective umbrella that opens up, with a diffuser fastened to the front with hook-and-loop fastening. The flash itself sits on a tilthead inside the softbox, completely obscured. This makes it unusable for infrared systems and changing settings is tricky if you're using radio triggers. In addition, the flash sits high inside the softbox so it is difficult to get it to point toward the center of the box. It is compromised, but very portable—and not a lot more bulky than a regular umbrella.

Many people point their softboxes directly at their subject, but the way a softbox works is that the light falls off gradually at the edge. You can use the light in this fall-off zone for a softer effect, which is called "feathering the light."

Beauty Dishes

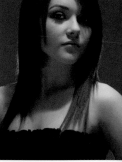

It would be wonderful if when taking a beauty shot, you could simply fix a beauty dish to your flash, start shooting, and automatically achieve instant gorgeous light that would give you cosmetics-campaign-perfect photos. Sadly, it's not that easy.

A beauty dish is usually shaped like a large metal dish, resembling a Chinese wok, with the flash head poking through from the back. If the dish were used just like this, the light would be very hard. Instead, the light from the flash hits a reflector cap fastened right in front of it, which bounces back into the dish. It's then reflected back toward the model so there is actually no direct flash hitting them.

Beauty dishes are available in a variety of sizes and finishes, the most common being either white or matt silver. As with reflective umbrellas, white gives a softer look, while silver gives a crisp, harder look.

There are other factors at play to govern the quality of the light output. The first is the size of the reflector cap, its finish, and its distance from the flashtube. Some dishes come with replaceable caps, so you can buy a kit of three or four various types, from white to silver or gold, and even semi-translucent. Each gives a slightly different effect.

Some manufacturers, like Mola, even make dishes in a variety of shapes. Some are relatively flat, while others have a pure parabolic shape to focus the light a bit more. Mola even offers some that have a stepped shape, all to offer a slightly different quality of output and, crucially, to alter the fall-off at the edge of the light

ABOVE LEFT
A silver-lined beauty dish fitted with a silver reflector cap can give a very crisp light.

ABOVE RIGHT
A beauty dish overhead lights the model's hair and face, but leaves her eye sockets and under her nose and chin in deep shadow. Fill lights are used to reduce the contrast. *Nikon D2XS; 105mm focal length; ISO 100; 1/125 sec at f/16.*

pattern. If this sounds a bit technical, that's because it can be. One critical point is the exact placement of the flashtube in relation to the dish. Different manufacturers have different mounting rings, so this has to be taken into account. It's fine if you're using them on studio-style pack heads, for example, as they have fixed circular flashtubes, but for small strobes, it's a compromise.

There really isn't a proper beauty dish that works perfectly with hotshoe flashes. The flash heads are rectangular and fitted with a moving Fresnel reflector in front of the long, thin flashtube, which is never going to properly fill a scientifically-designed parabolic beauty dish.

In reality, however, it doesn't hugely matter. Manufacturers that make mounts to fit small strobes into whatever

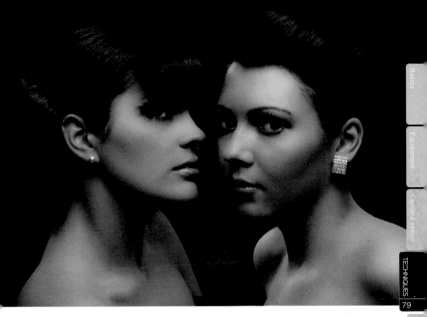

beauty dishes they offer know that their potential user isn't an obsessive perfectionist, and the kits themselves can work really well.

Having said that, the light from a beauty dish is far harder than many people realize, especially if the dish is small and the finish inside is silver. A dish like this produces quite hard shadows in eye sockets and under the nose, which often need careful management with a second fill light or a reflector at the least. Most of the time dishes are used on a boom held in front of, and slightly higher than, the model's face. While they can be quite hard to use, the results are good when you get it right.

Dishes are very useful for shooting portraits of men, where you are often much less concerned about hiding flaws.

ABOVE

A larger, white-lined beauty dish gives a slightly softer light, but reflectors are still used to stop the shadows on the models' faces going completely dark. *Phase One 645DF; 80mm focal length; ISO 100; 1/125 sec at f/18.*

The light from a beauty dish can be made softer by stretching a diffuser over the top. Many dishes come with these as standard. Some dishes also come with optional honeycomb grids to channel the light in a particular direction. This makes the light harder, but more controllable. Using a dish like this takes practice and requires attention to be paid to the management of fill light and contrast in order to get beautiful shots with a good tonal range.

Honeycomb Grids and Snoots

If umbrellas let lovely soft light spill out everywhere, then right at the other end of the scale are honeycomb grids and snoots. These devices are a means to channel the light into controlled beams so you can put little pools of light precisely where you want them.

Of course, these small shafts of light are hard, contrasty light sources that make very defined shadows. This is probably not ideal if you're trying to take a flattering photograph of an elderly aunt, for example, but can be fantastic when you are projecting tight pools of hard light for dramatic effect.

Honeycomb grids are accessories that fit onto the front of your flash and look like metal or plastic honeycombs. The light comes out in very parallel beams which, as we have discovered, is what makes light hard.

The depth of the honeycomb and the size of the holes in it have a very real effect on how tightly a beam of light is projected through. A deeper grid or one fitted with smaller holes gives a smaller,

tighter beam. Some grids are measured by the actual size of each of the holes, and some are measured by the angle of light beam they project—different manufacturers do it different ways.

Another way of producing a controlled pencil beam is to use a snoot, which is essentially a tube that channels the light as it leaves the flash head. Again, these are available in different sizes—which usually differ in length. Users of power pack heads most often have a full range of snoots and grids to choose from, but flash users have to use slightly more makeshift solutions.

Most snoots or grids fasten to the flash using hook-and-loop fasteners, or a speedstrap, which is a rubberized strap that fastens around the flash. The snoots or grids are then fastened to this via hook-and-loop.

These methods are obviously not 100 percent secure, but as the attachments are quite light and portable they do the job pretty well. Some snoots are simply pieces of stiff fabric that you stretch around the flash head, while others take a bit more assembly.

The biggest difference in the light output between a grid and a snoot is to be found right at the edge of the pool of light. A grid usually has a softer edge where the light goes from bright to shadow, while a snoot is generally more hard-edged, which

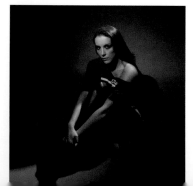

LEFT

A Honl honeycomb grid on a Nikon SB800 was the only light used for this moody shot of a model on a floor. The deep shadows show how hard the light is. *Nikon D3X; 31mm focal length; ISO 100; 1/200 sec at f/9.*

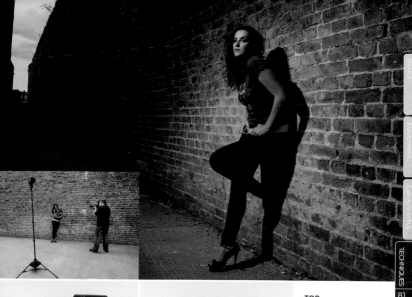

Basics

Environment

Camera setup

TECHNIQUES

81

Ambient light

Lighting

Case studies

Advanced

TOP

A single strobe fired through a Lastolite honeycomb grid puts a pool of light on the wall where our model is standing. *Nikon D3X; 24mm focal length; ISO 100; 1/250 sec at f/9.*

might well be the look you're after. The light from both sources is pretty hard.

The biggest problem with using grids and snoots is accurately aiming them without the aid of bright modeling lights. Often you have to just take aim, take a shot, then tweak the angle of the flash to suit. A good tip is to put yourself in the subject's position and look back toward the snoot or grid. If you can see the flash head through it, it's aiming in the right direction.

ABOVE LEFT

A Honl honeycomb grid is a great addition for anyone who uses hotshoe-type flashes.

ABOVE RIGHT

A typical snoot, this one made by Lumiquest, produces a harder-edged pool of light than a grid.

TOP INSET

This shows the relative position of the flash, model, wall, and camera position. We swapped to a wide-angle lens for the actual shot, though.

Softbox Grids

Softboxes give lovely soft light. Flashes fitted with grids give hard, directional light. Combine the two —a softbox with a honeycomb grid— and you get something that shares the best properties of both types of light modifier.

The light is soft—not quite as soft as an unmodified softbox, of course, as the beams of light are forced to be more parallel, but it's very directional, so you can put pools of soft light precisely in areas where you want them.

Softboxes fitted with grids are ideal for lighting subjects with soft light when you don't want the light to hit the whole scene and kill the atmosphere. They are also very useful if you are using a softbox as a rim-light where it is aimed back toward the camera. In cases like this, flare can be a huge problem, and a gridded, directional softbox can cure it in an instant.

It's not all perfect, however, as grids do drain power from your flash. This may or may not be an issue, depending on what you're trying to light, how far away the subject is, how bright the ambient light is, and, of course, how powerful your flash is. However, not every softbox is made to accept honeycomb grids. Unlike the metal or plastic grids that fix directly to flash heads, grids for softboxes tend to be made of flexible fabric. Typically, they only fit to softboxes with recessed front panels—that is, where the front diffuser screen is set a short distance back from the edge of the softbox.

More often than not, you have to buy a softbox that is purposely designed to

82

ABOVE
A Chimera softbox fitted with a fabric honeycomb grid can give soft light that's very directional, especially when it is used quite close to a subject. Using it at close quarters means the fall-off from the subject is greater, which enhances the effect of a controlled pool of light.

accept these fabric grids rather than trying to find an aftermarket manufacturer that makes one to fit your specific softbox. Some manufacturers do make them, but they can be expensive.

The high-end softbox manufacturers like Chimera actually sell grids in different sizes to fit their different sizes of softboxes, and just like a grid for a flash head, you can buy Chimera grids in different degrees to match the different angles of beam they put out.

Basics

Equipment

Camera setup

TECHNIQUES

83

Ambient light

Lighting

Case studies

Advanced

ABOVE

A normal softbox here would have lit up not only the subject but also the shiny background of the subject. A softbox with a grid kept the light soft but prevented it spilling everywhere. *Nikon D3; 85mm focal length; ISO 200; 1/160 sec at f/11.*

The tightest angles give the most highly-defined pool of light, but as it gets more defined it becomes harder and the efficiency of your flash is hit pretty hard. It's often essential to remove the softbox's inner baffle, as this will have minimal effect on the light quality, but will affect the relative power of the flash.

Masks and Gobos

Putting some sort of obstruction between your light source and the subject in order to cast a shadowy pattern may not seem like a natural thing to do, but if done right, the pattern cast can add an interesting new element to the image.

Placing an obstruction between the light and subject has been used in film and theater for years, and manufacturers of film lighting equipment produce an amazing array of accessories to do just this. These are often in the form of masks or gobos, which is an old-fashioned term for something that "goes between" the light and subject. While these aren't really available for photographic lighting, this is no bad thing, as it's far better and more fun to use everyday objects to cast shadows, such as plants or shrubs. Actually, the practice is so widespread in the film and TV industries that using plants in this way even has its own term—it's called "dingle"!

Whatever you use, the idea is to obstruct part of the light source. When using softboxes, this is easily done with masks that fasten on to the front of the diffuser using hook-and-loop fasteners.

An alternative is to remove the front and inner diffuser so that the light source is far more hard-edged, then to use strips of fabric to create interesting patterns—you are only limited by your own imagination. A popular option to use is masking tape, but this can leave residue.

Some manufacturers, like Lastolite, now offer a whole range of masks and strips, complete with hook-and-loop fastener, so you can experiment to your

ABOVE

A softbox with its diffusers removed but fitted with some strips of fabric means the light output is in distinct stripes. Moving your model into one of the pools of light gives a dramatic effect, far more attention-grabbing than the shot would have been if the softbox was used in its normal configuration. *All pics Nikon D3X; 85mm focal length; ISO 100; 1/250 sec at f/8.*

heart's content. Using a softbox with strips like this can be a trial and error process if you are using it to light a person, as you will have to move the light around so that the important parts—the face of the model, for example—are adequately lit.

An alternative is to use two lights. That way, you can use a light fitted with a gobo to project an image onto the background, and a plain softbox to light the foreground, containing your subject.

To do this, you need to make sure there is enough separation between the subject and the background or else the flash used to light the model will spill onto the background and reduce the effectiveness of the gobo-equipped background light. Using a softbox with a grid to light the model is an ideal way to do this.

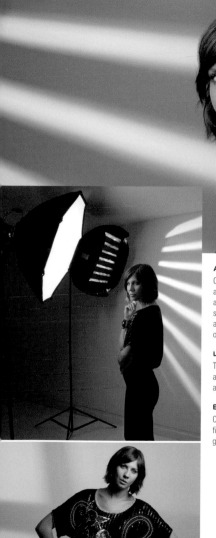

Basics

Equipment

Camera setup

TECHNIQUES

85

Ambient light

Lighting

Case studies

Advanced

ABOVE

Changing the pattern of fabric strips and their angle, and then using the light just on the background, gives an interesting effect. The model is then lit with a separate softbox. Model and softbox are far enough away from the background to avoid the light spilling onto it and ruining the effect.

LEFT

Two softboxes, one with fabric mask strips and another in conventional pattern, were used inside a plain white room.

BELOW

Changing the strip pattern into a cross formation, and fitting the strobe with a light-blue gel, is subtle and gives a different pattern and color shift to the background.

Gels

For something so simple and inexpensive, a pack of multicolored gels can really give your images a whole new funky edge. A splash of bright color can change the mood of your photos and is used by editorial and commercial photographers to take some highly creative images.

A gel is simply a colored piece of acetate that is fastened in front of the light source so that the light output takes on the color of the gel. Gels initially were thought of as highly technical bits of kit, designed for color correction when you were trying to accurately balance light sources of different color temperature— a crucial step in the days of transparency film where you couldn't adjust white balance on a computer. Gels have also been used to change light sources into bright colors, which can give a very definite effect on your photographs.

Gels used to only be sold in huge sheets that you would simply cut with scissors to the required size, and gels for small flashes only needed to be a few inches long. Gel manufacturers used to offer free swatch books containing hundreds of gels in different colors that just happened to be the right size for many small flashes, and as the interest on off-camera flash exploded, so did the numbers of people requesting free swatch books without any intention of buying the huge gel sheets.

The gel manufacturers soon cottoned on and supply of gel swatches got tighter, many now sell packs of popular gels for flashguns, but at very reasonable prices. Instead of having just one of each

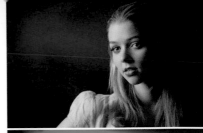

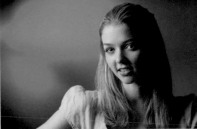

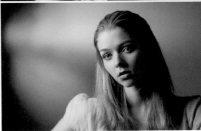

TOP

A blue gel and funky gobo mask produces a deep blue mottled pattern on a pure white wall behind the subject. The main light on the model is a softbox, so the subject is moved around 15 feet away from the background to stop pure white light spilling onto it.

ABOVE

Just swapping to a green gel totally changes the look and takes a matter of seconds.

ABOVE

A yellow gel gives a whole different feel again. Gels are cheap and can have a great effect. *Nikon D3X; 85mm focal length; ISO 100; 1/200 sec at f/4.*

Basics
Equipment
Camera setup
TECHNIQUES
87
Ambient light
Lighting
Case studies
Advanced

ABOVE

A sheet of blue gel acetate is slipped inside a Lastolite filter holder.

ABOVE

A Lastolite honeycomb grid fitted with a blue gel produces a hard-edged pool of blue light.

color, these strobe-specific packs have fewer colors, but several copies of each. This is good in case you lose or damage the gel, or want to match up the light on several flashes.

Fastening a gel to a small flash can be as simple as slipping it under the pull-down diffuser, but this will set the flash to its widest zoom setting. You can use a rubber band around the flash to hold gels in place, though it's better to fasten some hook-and-loop fasteners to the end of each bit of gel and fasten it to a speedstrap fixed around the flash head. Alternatively, you can use self-adhesive hook-and-loop fittings to stick a patch right on the side of your flash head, though make sure it doesn't interfere with the area where your diffuser cap fits.

Some manufacturers also make specific gel holders for small flashes, which can look a bit more professional than the above solutions and allow the gels to be combined with other modifiers, such as grids.

Using gels is as simple as aiming them at whatever subject you want to take on their color. Adjusting the power of the flash affects how bright the color appears on the final image, as does the color that you are projecting onto. When you start to

mix in ambient light, they can help you affect color shifts in your whole image and can make a blue sky look even more blue, especially as light levels start to fall.

One trick to make a sky take on a really electric blue color is to change your camera's white balance from flash to tungsten. The camera is "expecting" the light to be very warm-colored, and so it makes everything look cool on the final image, thus the sky goes from blue to a very much more saturated blue. However, the light on the subject is also very blue, so if you use an ungelled flash as your main light source, the subject will end up being a really very saturated blue, so what you have to do is change the color temperature of the main light source by gelling it to match the white balance. First fit an orange-colored gel to your flash, which the camera will see as natural. That way, the skin tone should be correct, but the background—or anything that's not lit by the gelled flash—will stay cool and blue.

Gels like this are called CTO—Color Temperature Orange, and you can also get CTB—Color Temperature Blue—to convert warm light sources to daylight color. These aren't much use for flash, though. However, a green filter designed to color correct for

fluorescent lights can be used. If you are in a room that is predominantly lit with green-tinged fluorescent lights and want to use flash, you must make your flashes the same color as the ambient light. This means fitting a color temperature gel—a green gel in this case—and setting your white balance to fluorescent to match.

Likewise, if you are introducing a flash into a room lit by orangey tungsten lights, you will gel your flash to orange with a CTO and set a white balance to match. However, half CTO and quarter CTOs are also available. By using this, your flash will not be as warm as the ambient light. If you do a custom white balance and set it for the main half-CTO light, then the

background will be warmer, which can often be a nice effect.

Some photographers leave 1/4 CTO or even 1/8-strength CTB on their flash at all times to leave a flash white balance. This warms up the output of the flash slightly so can be flattering for portraits.

ABOVE

A green gel combined with a funky mask provides an interesting, green-tinted directional light.

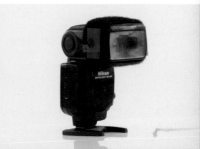

ABOVE

You don't need a fancy gel holder. This gel is fastened to a speedstrap using self-adhesive hook-and-loop dots. You can even just stick the hook-and-loop fabric right to the side of your flash.

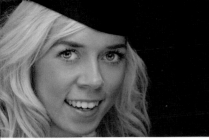

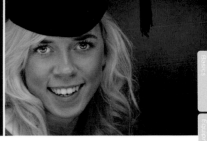

Basics

Equipment

Camera setup

TECHNIQUES

89

Ambient light

Lighting

Case studies

Advanced

ABOVE

This shot of a graduate is lit by flash in front of a plain, dark background. Her dark headgear almost disappears into the background.

BELOW

A single flash on the model and a second aimed at the bush in the background gives a natural look to this early evening shot. Note how her dark jeans melt into the darker background.

ABOVE

Putting in a flash fitted with a blue gel and grid aimed at the background gives a brighter feel to the photo and highlights her headgear. *Nikon D3X; 105mm focal length; ISO 100, 1/160 sec at f/22.*

BELOW

Changing camera white balance to tungsten and fitting a CTO gel to the main light means the model's skin is kept at its natural tone, but the sky goes electric blue. A third flash, aimed from behind the model, separates her from the background. It's ungelled, as is the light on the bush, so these lights have a very blue color cast to them. *Nikon D3X; 31mm focal length; ISO 100; 1/50 sec at f/4.5.*

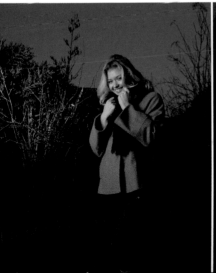

Ringflash

ABOVE

A ringflash right up close to this Lucha Libre wrestler shows the shininess of his costume. Note the telltale ring-shaped highlights in the subject's eyes. *Mamiya 645 AFD II; 80mm focal length; ISO 100; 1/125 sec at f/16.*

What started out as a specialist lighting device for medical, dentistry, and scientific use has taken the world of creative photography by storm. The ringflash is a flash device where the flashtube itself goes around the outside of the lens. This provides virtually shadowless lighting.

Ringflash quickly became the darling of the fashion photography world, as its shadowless light output meant it was fantastic at filling in and therefore masking any imperfections on a model's face. Former *Baywatch* star Pamela Anderson insisted that any photographer commissioned to shoot her had to agree to use a ringflash. It may seem counterintuitive to combine this shadowless lighting with off-camera flash, where it's the shadows created that give a subject form and true three-dimensionality, but a ringflash does cast some shadows, especially when the subject is placed near a background wall. The ringflash gives a very signature shadow that goes all around the outside of the subject like a halo. It's a very distinctive look, and one that some photographers think is overused nowadays. It's overused because it gives good results.

The very first ringflash units were quite small, and were designed for close-up work. They didn't really have enough power for anything more than close-ups. After these, manufacturers produced a range of large-size ringflash units, powered by studio-type pack systems. For many of these, you can buy a range of light modifiers to make the ringflash larger and therefore softer, but ringflash remains expensive when you take into account the cost of the unit, its power pack, and its accessories, though some more economical ringflash units for packs like Elinchrom's Ranger Quadra have started to appear on the market.

For users of hotshoe flashes, the biggest shift has been the availability of far more affordable units that you can clip your strobe into. The Rayflash and the Orbis are two examples of this new breed of flashes. On some, the flash stays in its hotshoe on top of the camera, so full TTL control is retained, while on others the flash has to come off the hotshoe. Either way, a TTL cord is an ideal way to control it.

These flashes aren't perfect, as the lighting coverage isn't perfectly even, and the power is far less than with studio-style packs. But as a budget alternative, they are great fun and offer a distinct look that many people might have thought was out of their budget. They are also useful as a fill light, as their shadowless nature means they are perfect for use as an unobtrusive way to reduce contrast when teamed with a more directional light source.

Basics

Equipment

Camera setup

TECHNIQUES

91

Ambient light

Lighting

Case studies

Advanced

ABOVE

Ringflash is most effective when used in front of a background that reflects the light. This shot of a tattoo artist shows the shiny wall and chair well, plus the typical ringflash shadow around the subject. You can also see the ringflash reflected in the subject's spectacles, but it's not too obtrusive. *Nikon D7000; 25mm focal length; ISO 400; 1/125 sec at f/11.*

LEFT

A shiny leather jacket makes an ideal item of clothing for a close-up ringflash shot. This kind of light can also be very flattering. *Phase One 645DF; 80mm focal length; ISO 100; 1/200 sec at f/14.*

And finally, just because it's called a ringflash doesn't mean it always has to stay around the outside of your lens. It's very possible to move it off-camera and use it as a regular light source too, as it's a bigger light source than a bare flash and acts like a mini beauty dish.

AMBIENT LIGHT

The key to successful flash photography is carefully balancing the output of the flash with the existing ambient light. By ambient light, I don't necessarily mean natural outdoor light.

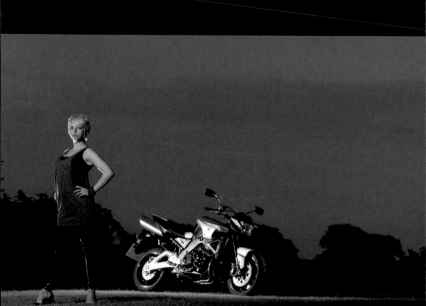

Streetlights, interior lights inside buildings, candles, and even light from television screens are all sources of ambient light.

Getting the balance between flash and ambient light right is not only about the intensity of the light, but also about its color temperature. Cool colors in areas of shade, or scenes photographed at night, mixed with the warm glow of tungsten household bulbs, can create a wonderful image. When you mix in a burst of flash, (which is usually slightly cooler than daylight), you really have to think about what you want your final image to look like.

In all cases, it's the intensity of your flash that really matters. You can use flash as a fill light to reduce contrast in a scene that's predominantly lit by daylight by filling in the shadows. It can be subtle, to the point where it's hard to tell a flash has been used at all. At the other end of the scale, you may wish your flash to totally overpower the ambient light in a scene. You can, if you have enough flash power and low ambient light, rely completely on the flash output to light the subject. This means the ambient light

OPPOSITE

The low, cool-colored ambient light of a summer's evening was underexposed so just the sky registered. The main light on the subject, the model, and the bike was cast by flashes. A tungsten white balance makes the sky go very blue, and the main light on the model is gelled with a CTO to provide a natural skin tone. Two more lights—one to light the bike and one to provide a rim-light on the model—were ungelled so look blue-tinged. *Nikon D3X; 70mm focal length; ISO 200; 1/125 sec at f/5.6.*

has virtually no effect on the overall photo as it's overpowered by the flash or flashes.

It's often good practice to work out what you want your main light to be, and go from there. Usually, the ambient light is the one overriding factor to take into account as most times you can't affect it unless it's a case of turning the house lights down, for example. You can control how this ambient light registers on the final image by using your aperture and shutter speed. Change one or both and the effect changes. How you want this to register is the key factor in your exposure—for example, whether you want the ambient light and background to be underexposed and moody, or to be the main light source.

You then introduce your flash, which, as discussed in earlier chapters, is very fast. So fast, in fact, that altering your shutter speed doesn't affect the brightness of the flash on the final image. That's because the shutter is open for a longer time than the flash unit, which provides a tiny burst of intense light. To affect the intensity of the flash on the final exposure, you can alter its power or your camera's aperture.

Essentially, shutter speed affects the ambient light, while aperture affects both ambient light and flash. If you close down your aperture by a stop, for example, the ambient light and flash light exposures are both underexposed, too. If you use a fast shutter speed—as long as it is within your camera's sync speed—then only the ambient light is affected. If you can master this relationship, balancing flash will become second nature.

Basics

Equipment

Camera setup

Techniques

AMBIENT LIGHT

93

Lighting

Case studies

Advanced

Fill-in Flash

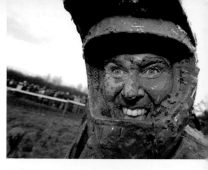

Fill-in flash is a term often used to describe a technique where your flash is used to literally "fill in" some of the shadows cast by the main light. In most cases, this main light is the ambient light, usually outside.

Fill-in flash can also be used as a fill light along with other flashes, reducing the contrast to a range that's easily recorded by the camera's sensor. It can also be used indoors, for example if you are trying to reduce the hard shadows caused by overhead household spotlights. (In this case, you'd want to gel your flash CTO to match the output of the main light, the household tungsten bulbs.)

With fill-in flash, you are usually just filling in the shadows and therefore don't really want the output of the flash to be noticeable by causing its own, secondary shadows. That's why it's the one time where the best position for the flash is to be as close to the camera as possible. This on-axis flash is best typified by a ringflash unit. Second best, and not too far behind, is to use a flash as close to the lens as possible. This means a pop-up flash—if it has enough power—or else a hotshoe flash can be ideal. This is because it's just filling in the shadows rather than acting as a directional light source in its own right.

The most typical use of fill-in flash is in a portrait where the subject is backlit. If you leave the camera on automatic, chances are it will expose for the strong backlighting and render the subject as a silhouette. You could, for example, meter off the subject's face and either use manual settings or dial in some exposure compensation, which

ABOVE

A hotshoe-mounted Nikon SB800 flashgun was ideal for lighting up the face of this muddy motorcycle racer as well as putting a catchlight in his eyes. *Nikon D3; 17mm focal length; ISO 400; 1/250 sec at f/5.6.*

would leave the subject's face exposed correctly, but the background would probably blow out to white, and you'd lose a lot of detail in the background. Often a better option is to expose for the background ambient light, so it retains some detail rather than going white. This, of course, would leave the subject's face in darkness, so a burst of fill-in flash would reduce the contrast. If the subject's face was truly in silhouette, then an off-camera flash to give some three-dimensionality would be preferable. In many situations, a burst of on-axis fill flash does the trick and has the added benefit of putting a catchlight in the subject's eyes.

Many cameras will automatically work out the flash exposure for you, but you may have to dial in some flash exposure compensation to get it exactly right. Or if it's inconsistent, try controlling the flash manually.

On certain flash systems, like Nikon's SB800 and 900, you can set the flash itself to balance with the ambient light using a special mode called BL. In practice, it's just

Basics

Equipment

Camera setup

Techniques

AMBIENT
LIGHT

05

Lighting

Case studies

Advanced

ABOVE

With the sun coming from the left side of this photo, the red and white helter-skelter was well lit, but the gold roundabout was in shadow. A burst of flash from a Nikon SB800 was enough to make sure the gold details were recorded. *Nikon D1X; 17mm focal length; ISO 125; 1/125 sec at f/13.*

LEFT

Three men in caps and white overalls in the midday sun provided too great a contrast to accurately record. A burst of fill-in flash reduced the shadows under the brims of the caps and luckily didn't wake them up. *Nikon D1X; 19mm focal length; ISO100; 1/200 sec at f/16.*

as easy to leave the flash in standard mode and tweak the flash exposure compensation.

Fill-in flash isn't just for close-up portraits, though. It can just as easily be used for groups of people or even to reduce the shadows in a building. In these cases, the overriding factor is the power of the flash, the brightness of the ambient light, and of course, its distance from the subject. On bright days or at narrow apertures, a single hotshoe flash may not be sufficient, and you may have to use a second flash or a more powerful unit.

Flash as the Main Light Source

Fill-in flash is generally flash that fills in shadows and reduces contrast from the main light, but you don't always have to use your flash this way. In fact, one of the best uses of flash is to underexpose the ambient light so that your flash output becomes the main light source.

When you work this way, it's as if the ambient light is acting as the fill light to reduce the contrast from the main light, which is the flash.

Unlike on the previous pages where the idea was to place your flash on-axis with the lens so it didn't cast its own shadow, when using your flash as a main light source you want the flash to create shadows for an impression of depth and three-dimensionality. That means taking the flash off your camera.

In order to use your flash as a main light source, it's important that you accurately understand the intensity of the ambient light. In our picture of a model posing in a yard full of wooden pallets, the ambient light gives an exposure of 1/200 sec at $f/2.8$ on a setting of ISO 100.

This combination was carefully chosen. The ISO was 100 as that's the camera's base setting for the best quality. A shutter speed of 1/200 sec was selected as this is the fastest the Nikon D3X camera can reliably sync at using standard Pocket Wizard Plus II radio triggers. This combination gave an aperture of $f/2.8$ for the "correct" exposure, as seen in the natural light photo seen here.

For a bit of drama, and to make a flash the main light source, we will need to reduce the effectiveness of the ambient light. This means underexposing it, though by how much depends on the precise situation and the results you are looking for. A couple of stops is usually a good amount to start with. To do this, either take control manually or set exposure compensation if you are using an auto mode like Shutter Priority.

To underexpose the ambient light by two stops I could drop my ISO by two stops, but as the camera was at its base, this wasn't an option. You could also increase your shutter speed by two stops, but as this would take the speed up above the regular flash sync speed you could then run into serious issues. Thus the only option is to close down the aperture by two stops.

If you are using an auto mode with exposure compensation, it is best to stick to Shutter Priority mode. Using Aperture Priority mode could see the camera setting too high a shutter speed for your sync. If you are using a dedicated wireless system like CLS or E-TTL, your camera will avoid errors, but if you're using conventional radio triggers, sync speed is a real issue, so stick to Tv.

For my shot on the right, I stuck to manual mode and actually underexposed by 2 1/3 stops, reducing the aperture from $f/2.8$ to $f/6.3$ for a moody, dark background. I then introduced a Nikon SB900 flash as a main light. It was held on a boom over the model, and aimed down at her, and the beam of light was channeled through a honeycomb grid so it would act like a spotlight. The flash was controlled manually, and the power adjusted until it correctly exposed the

AMBIENT
LIGHT

97

Basics

Equipment

Camera setup

Techniques

Lighting

Case studies

Advanced

ABOVE
This natural light shot of our model in a wood yard is correctly exposed, but lacks any real drama. *Nikon D3x; 18mm focal length; ISO 100; 1/200 sec at f/2.8.*

ABOVE
By underexposing the ambient light by 2 1/3 stops, the background becomes darker and more moody. Introducing an overhead flash fired through a honeycomb grid as the main light on the subject creates a pool of light and an instant improvement in the image. *Nikon D3X; 18mm focal length; ISO 100; 1/200 sec at f/6.3.*

most important part of the shot—the model's face.

In this case, the overcast day meant the power of a Nikon flash was easily sufficient to overpower the ambient light, especially at such short distances. On a very bright day, and if the flash was used through a power-sapping softbox, for example, the flash might not have been bright enough. On very bright days you either have to somehow bring more flash light in by either using a more powerful unit, reducing the flash-to-subject distance, removing light modifiers like softboxes, or moving your subject into an area of shade.

Using a Second Flash

On many occasions, a single off-camera flash unit can provide all the light you need in order to create a great image. A particular favorite technique of mine is to turn the subject so that their back is facing toward the main ambient light source, such as the sun. This provides a nice rim-lighting effect, good for highlighting the hair, for example.

This little rim of light is also great for making the subject stand out from the background, especially if it is dark and the subject is wearing dark clothes. Essentially, you are using rim-lighting as a separation light, making the subject stand out from the background and using the direction of light to give real three-dimensionality to your image.

Of course, doing this usually means that the subject's face will be in shadow, so this is where an off-camera flash is used as the main light on the subject. If there is no natural rim-lighting, all is not lost. With a second off-camera flash hidden behind the model or out of view of the camera, you can introduce an element of rim or separation lighting. As you are often trying to mimic the hard light of the sun, a bare flash works well, or to avoid the backlight potentially flaring into your lens, or to control its pool of light, a strobe channeled through a honeycomb grid or snoot can be useful.

As with all images that mix flash with ambient light, it's the ambient light that initially controls the exposure. In our shot of the model in the doorway, the leaf-lined door was in the shade of a building on a blazing hot summer day, so the ambient light was subdued and soft. An ambient light reading, taken at a base ISO of 100 and the camera's maximum sync speed of 1/160 sec, gave an aperture of f/5.6. Thus to keep the speed at 1/160 sec and ISO at

BELOW

This shot looks like it was taken on a bright sunny day—and it was! The doorway was located in the shade of a building. An off-camera flash to the left of the subject, and a second hidden behind her though the door, mimics the look of bright sunshine but without forcing the model to squint. *Nikon D3X; 62mm focal length; ISO 100; 1/250 sec at f/13.*

ABOVE

A flash fired through a softbox from slightly left of the camera position is used as the main light on this fashion shot. A second light, a flash fitted with a honeycomb grid, was positioned behind the model, out of frame to the left side. This puts a rim highlight on her legs and arms. *Canon EOS 5D Mark II; 50mm focal length; ISO100, 1/160 sec at f/20.*

BELOW

This setup shot shows how the doorway was in shade, and the position of the first flash unit that provided the main light on the model. The second flash has not yet been introduced, so the lack of rim-lighting on the model is quite obvious.

100, the aperture was reduced by two and a third stops to *f*/13 to underexpose the shot. It's best to do this manually, though Shutter Priority with -2 1/3 exposure compensation would work.

A bare Nikon SB800 flash was then used off-camera to act as the main light, as shown in the setup photo. The power was adjusted manually until the exposure on the model's face was correct. This is because a Nikon camera was used to fire Pocket Wizard transmitters to trigger a Nikon flashgun, but equally, any brand of camera could be used. The Pocket Wizard is a basic radio trigger, requiring full manual operation of your flash and camera. Alternatively, if a TTL system was used you could tweak the exposure using flash compensation.

The resulting image was fine, but could be improved upon. A second flash unit— another bare Nikon SB800—was mounted on a lightstand and hidden behind the model on the other side of the doorway. This provided an element of rim-lighting on the model and also put some light on the bushes you can see behind her.

The power of this flash was adjusted manually until the right level of output was achieved. If you were using CLS or E-TTL, this shot would have been close to impossible as these systems need to have direct line of sight from the camera to the flash. Furthermore, if the signal had managed to bounce around and trigger the second flash, the TTL system would be easily confused by flash that comes from behind the subject. This is a huge benefit to working manually using radio triggers.

Basics

Equipment

Camera setup

Techniques

AMBIENT LIGHT

99

Lighting

Case studies

Advanced

Hiding a Flash for Rim-light

Brides with veils are the perfect subject for rim-lighting, especially because having a light source behind a veil really lights it up and provides a lovely frame for the face. Of course it's not particularly natural looking, unless you are blessed with a glorious day and can use a stream of sunlight to highlight the veil. Even then, chances are you'd be using a flash to light the bride's face anyway—hardly an unobtrusive, natural look.

If the day is overcast and the light is flat, you're not going to get that naturally rim-lit veil that brides often love, so you're going to have to fake it.

One of the biggest advantages of using hotshoe-style flashguns is that when used off-camera, they are both portable and small, so can be easily hidden behind a sitting bride, for example.

For this image, a Nikon SB800 was placed on a lightstand hidden directly behind the bride, and aimed back toward the camera position. In this case, using a manufacturer's own infrared wireless system wouldn't have worked, mainly because of a line of sight issue. It would have been hopelessly unreliable to attempt to trigger an obscured flashgun, especially at a wedding, when time is paramount. For this kind of situation, a super-reliable radio trigger is the only way to go.

Using a radio trigger also makes it easy to mix and match different lights. In this shot, the main light was a powerful Elinchrom Ranger Quadra, fired through a large softbox to the right of the camera position.

RIGHT

A dull, overcast day wasn't going to stop this bride from getting brightly lit photos. A main light through a softbox provided a lovely soft key light, and a second flash—a hotshoe-style Nikon SB800—was hidden behind her veil for some rim-lighting. *Nikon D3; 24mm focal length; ISO 100; 1/250 sec at f/11.*

The Ranger was chosen as it is more powerful than a hotshoe flash, and is perfect for filling up a large softbox with light. It also recycles far faster than a hotshoe flash—an important consideration for events like weddings.

To give an even spread of light not only on the model, but also on the rocks in the foreground, the Quadra was moved far enough away from the subject so fall-off wouldn't be a huge issue—thanks to the inverse square law—and the big softbox that was used kept the light reasonably soft. The camera was controlled manually,

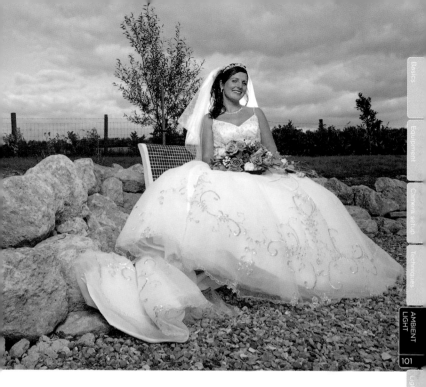

Basics

Equipment

Camera setup

Techniques

AMBIENT LIGHT

101

Lighting

Case studies

Advanced

and a setting of base ISO 200 was used for best quality. The exposure was manually set at the 1/250 sec sync speed and $f/11$, roughly a stop and a half under a true ambient light exposure. This gave a bit of detail in the sky rather than it going to white.

It would be a very big ask of a flash the size of a Nikon SB800 to send enough light through a softbox at roughly 15 feet from the subject to give an exposure of $f/11$. This isn't impossible, but would be very hard on both batteries and recycle time. This is where larger flashes come into their own, and the Quadra's power was manually

adjusted until the exposure on the subject was right.

The second light, an SB800 triggered by a Pocket Wizard, was then placed behind the subject's head and its power manually adjusted until it cast just the right amount of light on the veil. As this flash was bare and very close to the subject—the veil—it had plenty of power.

It is often easy to light the subject too much from behind and for the effect to be very obvious and unnatural. Getting it right is a balancing act, and with weddings, depends on the tastes of your client too.

Mimicking Existing Ambient Light

You don't always have to put bursts of flash light in places that it naturally wouldn't occur—like behind a bride's veil. Sometimes a great image results from creating a natural-looking shot where the flash mimics the existing ambient light.

So why not just use the ambient light? Well, in many cases the ambient light is too variable, not bright enough, or has too much contrast. In these cases, carefully using off-camera flash can not only mimic the natural light, but help you improve on it by managing contrast and giving you a workably high shutter speed to avoid blur.

The key to a more natural-looking shot is to look at where the ambient light is coming from, and work out how hard or soft it will be. This could be light streaming through a window, or from an overhead lightbulb. You can then mix this light with flash by subtly adding in fill lights, gelled to the same color temperature as the main light. However, quite often balancing with ambient light this way can give a low shutter speed, so you'll need a tripod, and your subjects will need to be still.

An alternative is to replicate the ambient light with a burst of similar-quality flash, which will be at a much higher intensity. This means you can usually set a higher shutter speed, often right up to your camera's maximum. Now your subjects and camera don't have to remain perfectly still when the shutter is triggered.

In my shot of a team after training, the ambient light was predominantly daylight coming in from two frosted windows high

OPPOSITE

Two flashes fired through softboxes were used to replicate the low-level ambient light in this changing room shot. The power of the flashes gave a working shutter speed of 1/250 sec and an aperture of f/9, enough to make sure all the players are in sharp focus. *Phase One 645DF; 55mm focal length; ISO 100; 1/250 sec at f/9.*

up on the right side of the room. The light from these windows was very low in intensity, and relatively hard in quality as the windows were quite small. The clients wanted to replicate the light they saw when they went into the room, not realizing that it had far too much contrast, which their eyes had automatically adjusted for.

The way to replicate the light initially seemed easy. Two small softboxes were placed in exactly the same position as the windows, but they actually ended up replicating the issues of light fall-off and contrast. The player on the right of the image was nearest to the lights, and was too brightly lit compared to his team

Basics

Equipment

Camera setup

Techniques

AMBIENT LIGHT

103

Lighting

Case studies

Advanced

mates. The answer would have been to move the lights farther away, but the wall was in the way. The light on the player furthest to the right also cast a shadow on the player to his left, compounding the problem.

My solution was to move both lights. The first was placed in between the two windows, and fitted with a grid to make it directional and harder. This light was aimed at the two players on the left of the image, and you can see the telltale shadow from the light source on the wall directly behind them. This softbox was moved so that the edge of the light also partly illuminated the player right in the corner.

The second softbox was now moved to the left of camera and aimed at the player on the far right. Essentially the beams of light from both boxes crossed each other at 90 degrees. This second softbox was aimed so that it illuminated the face of the player on the far right, and feathered off to partially illuminate the player in the corner, too. As the walls are quite bright they acted as a reflector, and went some way to reducing the contrast, too.

Using a Parabolic Umbrella

There's a theory that if you want to evenly light a person for a full-length shot, then you need to use a full-length light source. It is true that a very large light source will give more even illumination than a smaller one when they are relatively close to the subject.

Of course, any light source will give pretty even illumination if it's moved far away from the subject, thanks to the inverse square law, but the distance will affect its quality, and make the light harder. So for an even light source that's not really hard, you want a big light source, but the larger the light modifier—like a big softbox or umbrella—the more powerful the light you'll need to fill it. You need to make sure the flash "fills" the modifier, which often means using a wide-angle diffuser and the flash at its widest setting to avoid creating a hot spot in the center of the modifying device.

This, of course, drains the flash of its power. If you're trying to use it outdoors, mixing the light from your flash with the ambient light, then you may run into problems. You may not have enough power, and if you can get enough light output then your recycle time between flashes will be quite long. That's not great if you're shooting people, as the delay can feel like an eternity and ruin the mood of the shoot.

What is ideal is a large light source that can be easily controlled in terms of spill, and is very efficient. A silver-lined parabolic umbrella is an ideal tool for this. While a shoot-through umbrella scatters the light everywhere, a silver-lined parabolic actually reflects it and produces much more of a focused source. In that way, it works more like a controllable softbox.

Proper parabolic reflectors are specially designed so they focus the light in a very precise way. These reflectors are designed to work with very specific studio-style heads where the placement of the flashtube is critical.

For other types of flash, like hotshoe flashes, then a parabolic umbrella—which has a much shallower shape than a real parabolic dish—works well. It isn't as focused as a true parabolic, but this can be an advantage, as the fall-off of light will be more gradual. The silver lining is very efficient, giving up to four stops more power than a white-lined reflective umbrella. That variance in power can make a very real difference to your shots, and is why parabolics are having a surge in popularity. They can also be great at throwing light a long distance, and are ideal for lighting big groups. The only downside is that they are physically large and can be difficult to control outdoors if there is wind. Also, their size makes any lightstand very unstable, so a helping hand to steady the rig or a sandbag for stability is strongly advised.

Using a silver lining gives a crisper edge to the shadows in your images, but as the light source is large, the light wraps around the subject more to reduce some of the inherent contrast. It's a look that is not too hard and not too soft, and useful for taking pictures in many situations, or in genres such as fashion photography.

ABOVE LEFT

A parabolic umbrella gives a sharp-edged look to this shot of a model posing in an underpass. It was positioned slightly behind her, to give some rim-lighting to her legs. Note the Rembrandt-style lighting pattern on her face also. A second, bare flash was positioned behind the wall she's leaning on and casts a rim of light on her raised arm. *Canon EOS 5D Mark II; 82mm focal length; ISO 200; 1/160 sec at f/5.6.*

ABOVE

A helping hand holds the silver-lined parabolic reflector to stop it from toppling over. A single Nikon SB800 provides plenty of power thanks to the light-efficient lining.

BELOW

By changing the position of the model, and by moving the light source more toward the direction of the camera, the light on the model's face is far more even. All of the rim-lighting is provided by the hidden flashgun behind the wall she's leaning on. *Canon EOS 5D Mark II; 70mm focal length; ISO 200; 1/160 sec at f/5.6.*

Basics

Equipment

Camera setup

Techniques

AMBIENT LIGHT

105

Lighting

Case studies

Advanced

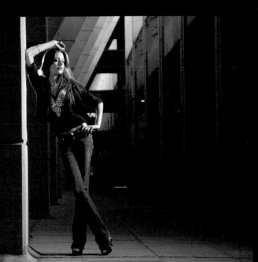

Flash With Slow Shutter Speeds

Using a slow shutter speed to let low-level ambient light register, (combined with a burst of flash to get a well-lit and sharp central point of focus), is a well-used technique for nighttime, dusk, or interior shots.

The same technique can also be used outside on a bright day to capture a moving subject. Instead of using a slow shutter speed simply to let the ambient light register, you can use it to get a degree of motion blur for creative effect —for example, to create an impression of speed or movement. A burst of flash light provides a sharper edge to the image, and of course reduces the shadows as it acts as a fill light. Taking the flash off-camera can also provide a degree of modeling. This means creating some shadows of its own to give the photo a pleasing three-dimensional look.

Attempting to use a slow shutter speed when the ambient light level is relatively high can be difficult. To succeed, you need to set your camera's ISO to its lowest figure, and then, either by using Shutter Priority or manual, set a shutter speed low enough so that some blur will register. This could be from 1/125 sec down to one second or more, depending on the effect you want and the speed of the subject.

Such a slow speed will mean the use of a very narrow aperture like f/22. However, if it really is bright, your camera's aperture may not go down small enough. At very narrow apertures, the problem of diffraction can also occur, and this will impact on the quality of your image. Also, at very narrow apertures the depth of field

can be huge. This may be a benefit, as a large amount of the image will be sharp, or it may be a hindrance if you want to control depth of field for creative effect.

To get the aperture to a more manageable level, the amount of light reaching the sensor needs to be reduced. This could be done by moving the location of the shoot to somewhere in the shade, for example, or you could physically reduce the amount of light reaching the sensor by using a filter on the front of your lens. An ND filter is useful for this. It looks like a gray filter and all it does is cuts down the amount of light hitting the sensor. ND filters are available in lots of different strengths—usually one or two stops, but go all the way up to ten.

Another alternative is to use a polarizing filter, which usually cuts down a couple of stops, but can reduce reflections and darken skies, too. You can even stack filters on top of each other to cut the light down even more, but you have to be careful that the edge of the filter doesn't start to appear in the corner of your image, especially if you are using a wide-angle lens. Another factor is that the

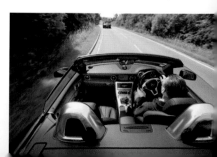

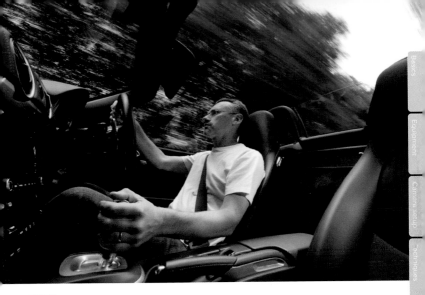

Basics

Equipment

Camera setup

Techniques

Lighting

Case studies

Advanced

ABOVE

To get the whole inside of the car in shot, the camera was mounted on a mini tripod in the footwell, and fitted with a Nikon 14–24mm $f/2.8$ lens. This lens can't take filters, so a shady location under trees was found so that the shutter speed could be dropped to 1/4 sec to add some real blur. A flash was mounted to the inside of the passenger door with a superclamp. The photographer stood at the roadside, and used a Pocket Wizard to trigger the camera and remote flash. *Nikon D3X; 14mm focal length; ISO 100; 1/4 sec at $f/20$.*

OPPOSITE

Here a camera was mounted to the back of the car using suction cups and triggered by a Pocket Wizard remote radio release by the photographer, who was being driven behind in another car. A shutter speed of 1/60 sec blurred the side of the road, and a polarizer reduced glare and brought the aperture to $f/3.5$ for less depth of field. A flash unit was hidden in the passenger seat, and fitted with a dome diffuser so it would spill around and fill the car's cockpit with light. A second Pocket Wizard triggered this. *Nikon D3X; 17mm focal length; ISO 100; 1/60 sec at $f/3.5$.*

more glass you screw in front of your lens, the more the image gets degraded. They may only be slight, but lots of extra layers of glass can cause internal reflections, which is never a good thing.

For the flash to match with the ambient light, it is likely that you will need lots of power, and if you use an ND or polarizer to reduce the light for a wider f-stop, the flash still has to work hard. The balance between the ambient light and the flash itself is what's important, as governed by the aperture. The flash burst is so quick, that having a longer shutter speed has no effect on how bright the flash appears in the image. Aperture controls flash exposure, not shutter speed.

Overcast Day Flash Balancing

Overcast days often produce flat, lifeless skies and soft overhead lighting for your subject. If you are shooting outdoors and expose for your subject's face, there is a danger that the sky will melt away into an insipid wash of off-white.

However, if you're armed with a flashgun or two, this needn't happen. Gray days mean a lower level of ambient light than on bright days, so it can feel like your flash has been super-charged with power. It's easy to overpower the ambient light if you want to, and you can use an array of lighting modifiers without worrying they'll be draining power.

As with any situations where you are mixing flash with ambient light, it is the ambient light that is the overriding factor in deciding your exposure. You should take this into account first, and then dial in the power of the flash to suit your scene.

On a gray day, take an ambient light reading at or near your camera's maximum sync speed. Then, to bring some detail into the sky, dial in some underexposure. You can do this by using exposure compensation or by using a narrower aperture if you're shooting manually.

The key to this is working out how dark your background needs to be. If you like, you can go mad and vastly underexpose the background by, say, four stops. This makes the sky go dark and moody, and can be very dramatic. It works well if the subject is solely framed by the sky, but if the shot has any other foreground or background in it, that will also be very dark. This can give a dramatic effect, albeit one that looks very

unnatural, but if that is the look you want, then my advice is to go for it.

If you're after a more natural look, but one that still has a dramatic edge, then you need to carefully work out the level of underexposure you need for the background to work effectively in your image. This may be as little as half a stop, or as much as two stops.

With the background light being soft and the sky being gray, it is much more believable to have soft light on the model rather than the hard-edged light you will find on sunny days, so softboxes or shoot-through umbrellas can be ideal.

As flash output is not hugely critical in this situation, you can use softboxes with two layers of diffusion to make the light as soft as possible. You can even feather the light, which means that you use the light at the edge of the softbox where it starts to fall away, rather than in the center where it is brightest. Feathering the light can give an even softer look. A second softbox can be used behind the model to give a little edge of rim-lighting or hair lighting, though again, this should be reasonably subtle to give a more natural look.

When using a softbox in this way you have to watch out for flare bouncing back into the camera lens. Using a softbox with a grid could be ideal, or placing a flag between the light and lens can be useful, too.

LEFT

By zooming in and framing the model against the sky, you don't need to alter any camera settings to get a different shot from the same location. *Nikon D3X; 70mm focal length; ISO 100; 1/200 sec at f/10.*

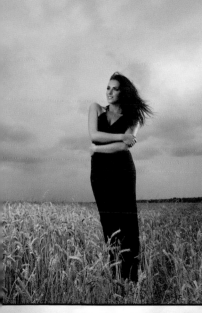

MIDDLE

A dull day means you have the flash power to alter the key of the image—going low-key and dark, for instance, by vastly underexposing the ambient light, although this can look very unnatural. Careful balancing of the exposure of the ambient light for the background and flash for the subject is the key to getting a natural, authentic-looking shot. *Nikon D3X; 29mm focal length; ISO 100; 1/200 sec at f/10.*

Basics

Equipment

Camera setup

Techniques

Lighting

Case studies

Advanced

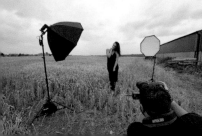

LEFT

This setup shot shows the main softbox is not pointed directly at the model. The light on her face is "feathered" for a softer look, and the softbox also illuminates the foreground of the shot.

Low-light Flash Balancing

Many people end up hating their flash—especially if it's a pop-up unit or a hotshoe-mounted gun—after using it indoors. The flash can overpower the ambient light to give horrible harsh lighting with nasty, dark shadows. It gives no modeling for three-dimensionality and totally kills the atmosphere, and finally, there's the age-old problem of red-eye.

As when using a flash outdoors on a bright day, the key in low light—either indoors or outdoors—is to balance the flash with the ambient light, both in intensity and color.

The flash can act like the main light source, with the ambient light acting as fill light to retain the atmosphere and fill in any shadows, or the ambient light can be the main light, with the flash just picking out a detail of the scene. Alternatively, you can carefully blend the two so that the flash does very little apart from seamlessly adding to the mix and lifting the brightness of the scene to a higher level.

You will need to take into account the color temperature of the lights present, as there are several different types of indoor lighting, all of which cast different colors.

Some common light you will likely find yourself working with includes cool, blue light coming in through windows, green/magenta light from fluorescent tube lights, orange from tungsten lights, and a very warm orange from candles and the like. If you then mix in a flash that's balanced to slightly cooler than daylight you can have an interesting mix. Sometimes a burst of natural-looking flash light can give a

RIGHT

The only lights in this room were the lightbulbs around the mirror, and a few ceiling-mounted spotlights dotted around the room. The ambient light exposure of 1/25 sec meant a tripod was used to keep the image sharp. A flash was shot through a beauty dish fitted with a honeycomb grid to stop the light from spilling outside the frame, and the light was aimed to the right down at the subject's face. The pool of light from this ungelled flash can clearly be seen on the wall behind the subject, but actually replicates the look of the downward-facing spotlights in the rest of the room. The actual power of the flash was set very low as the camera's aperture was a relatively wide f/4. *Nikon D3X; 28mm focal length; ISO 100; 1/25 sec at f/4.*

more pleasing skin tone to a subject, while the rest of the room is bathed in warm ambient light. Other times you may wish to gel your flash so it's the same color as the dominant ambient light and blends in seamlessly. You can also gel your flash so it's not fully matched, but is some way there, such as using a half CTO gel in a room full of tungsten lights, for example. There really isn't any one-size-fits-all method, just trial and error to see what works and what doesn't.

Whatever the color, it's the ambient light intensity that's crucial. Just as if you were outdoors, take a reading for ambient light and set your camera to that, then experiment with underexposing. The biggest difference will be the light levels, so you may have to drop to slow shutter

Basics

Equipment

Camera Setup

Techniques

AMBIENT LIGHT

111

Lighting

Case studies

Advanced

speeds, wide apertures, or high ISOs to get an acceptable background exposure. For ultimate quality, keep your ISO as low as possible whenever you can. This often means shutter speeds are low and necessitates the use of the tripod. You will also need a subject willing to keep reasonably still to avoid a ghost image showing where they have moved. Toward this end, it's often good to give them something to lean on as it aids in keeping them still.

Now you should introduce your flash, and increase or decrease its power so it gives the correct exposure on the subject. Just like working outdoors, a larger light source gives a softer light, but be aware that it's easy for the flash to overpower the scene and become the dominant light

source, especially if you're using modifiers like umbrellas, with their scatter-gun approach. Softboxes or lights fitted with grids can be better used to put small pools of light where you require them, and nowhere else. Used this way, they can often replicate the look of a spotlight highlighting just part of the scene, and of course, a larger-size fill light can be used to raise the ambient light level. A light can also be bounced off the ceiling to provide fill light. If that light is gelled to match the ambient light, it can be quite subtle, too.

Bright-light Flash Balancing

Contrary to popular belief, it's when the light is at its brightest and most harsh, rather than when it's overcast or dull, that you really need to use your flash.

Bright days and overhead sun create loads of contrast, with deep shadows in all the wrong places. Eye sockets go dark, your subjects end up squinting into the blinding light, and the harsh light shows up every lump and bump.

Faced with light like this, many photographers go running off in the quest to find shade to shoot in, but sometimes you simply can't do that— for example, in the middle of the wide open outdoors, or at a wedding when a bride wants to be photographed in front of the church.

In these cases, you need to be able to use your flash to get the shot you need. You should also be able to use the bright colors and glorious light to get a more dramatic shot than any natural-light photographer could ever achieve.

The biggest problem with working outdoors on a bright day is the intensity of the ambient light. My tried-and-tested technique is to take a reading for the ambient light, then underexpose a little for more saturated colors. Then, place your flash as the main light and increase or decrease the power until the light level on the most important part of the subject is correctly exposed.

On a bright day, even at ISO 100 and a 1/250 sec shutter speed, your ambient light exposure will typically be around $f/11$. So to underexpose by a stop, you're looking at $f/16$, and some cameras don't sync as high as 1/250 sec, like Canons such as the EOS 5D Mark II. This is also a problem if you're using radio triggers, and

To make sure the colors remained deeply saturated, this shot was underexposed by a stop, and the light on the subject bolstered by an Elinchrom Ranger flash through a beauty dish directly in front of him. It came from the same direction as the sun, but lower in height, reducing the hard shadows on his face. The flash acts like a main light, while the sun is the ambient light fill. *Nikon D3X; 32mm focal length; ISO 100; 1/200 sec at $f/10$.*

Basics

Equipment

Camera setup

Techniques

AMBIENT LIGHT

113

Lighting

Case studies

Advanced

if you're using both, then you will need an aperture of around $f/20$. So to recap, your flash will have to put out enough power for an exposure of $f/20$, or even $f/22$ or $f/32$, if you want real drama.

In practice, using a bare flashgun reasonably close to the subject at full power will do the trick, but you can't modify for softness with an umbrella or softbox, for example, as it will drain the power. You will also be shooting at full power, which causes havoc with your batteries and recycle time, and in worst cases can even melt your flash.

One option is to use more than one flashgun. Two flashguns is double the power and gives one more stop of light. To get another stop you need another two flashes, though, and then another four! This can get expensive as you

ABOVE

Bright sunshine and a bright white salt lake mean the ambient light levels at Bonneville in Utah are higher than just about anywhere else on the planet! A two-stop polarizer reduced its intensity by two stops, but underexposing the ambient light by a stop still gave an exposure of 1/250 sec at $f/10$. An Elinchrom Ranger Quadra pack-type head was used through a beauty dish as the main light on this rock'n'roll couple. *Nikon D3X; 50mm focal length; ISO 100; 1/250 sec at $f/10$.*

will need flashes, triggering devices, grip, and more.

Another option is to use a more powerful flash, like one of the pack-powered studio-style flashes. These can give a lot more power so you can actually modify the light for softness. In some situations, there really is no substitute for power.

Cross Lighting

Setting up flashes quickly and getting everything to work fast is often a key requisite of photography. It's great if you can spend ages measuring, moving, and tweaking your lighting setup, but more often than not time is of the essence. In addition, the more time you spend playing with and altering your lights, the less genuine interaction you will have with your subject—and getting the best out of your subject is really the secret to a great picture.

It's good practice to work out a simple go-to formula for taking a successful picture pretty fast. After that, you can move on to more creative options.

My most-used setup is to use a cross-lighting technique, where there are two lights on the subject that are set up as the main light, placed at 45 degrees from the camera. The subject faces toward this light, which has the benefit of turning them slightly sideways—this is often more flattering than facing the camera straight-on.

Their face will be lit in the style of short lighting, with some shadows on the side nearest the camera. This is very flattering, makes the face look thinner, and gives a very three-dimensional look.

A second light is then used behind the subject, aimed straight at them. Thus, the main light, subject, and rear light are all in a straight line. This line is at roughly 45 degrees to the camera.

This rear light provides some rim-light or hair light, and separates the subject from the background. In an ideal world, you can use sunlight for this rim-lighting

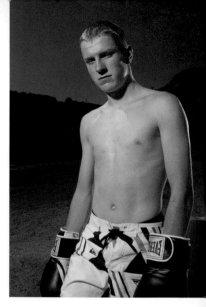

ABOVE

A young boxer in the desert under a midday sun is lit by a bare flash from the left of the camera. The rim-light comes from the same direction as the sun, but is actually a second bare flash. The rim-lighting effect of the sun was reduced as the ambient light is vastly underexposed to get a darker sky. *Nikon D3X; 38mm focal length; ISO 100; 1/250 sec at f/20.*

effect, which would look natural, and the model wouldn't be squinting into the sun. You can then use a main light, probably with some sort of modifier like a softbox umbrella, to make the light more flattering. Harder light, such as that from a beauty dish, can be used on suitable subjects like smooth-skinned models or rugged men.

The rear light can be as hard as you like, as you're using it only for a hard-edged rim

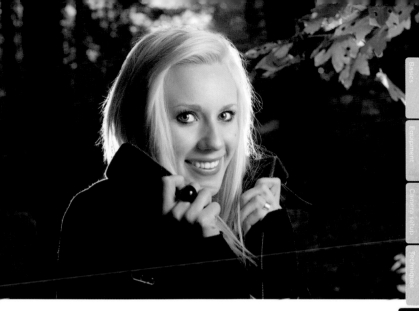

Basics

Equipment

Camera setup

Techniques

AMBIENT
LIGHT

115

Lighting

Case studies

Advanced

effect. Bright sunshine or a bare or gridded flash is ideal for this. If the sun is doing this rim-light for you, great. If not, put one in via a flash.

If you're outside on a bright day and want to underexpose the sky so it's really dark, then you can bolster the sun's rim-light by putting in a flash coming from the same direction.

If you're using the sun as a natural rim-light, then set your exposure for that. Then introduce the main light and adjust the power until the brightness on the subject is correct. If you're using a second flash as a rim-light, then you can underexpose the ambient light so the background goes as dark as you wish, and adjust the power of the backlight until it gives the rim effect you want.

ABOVE

A flash though a large white umbrella provided the main light on the model's face, and a second light behind not only provided the rim-light on her jacket, but also on her hair, with some light spilling onto the bush next to her. *Nikon D3; 70mm focal length; ISO 200; 1/160 sec at f/7 1.*

Multi-flash Setups

Once you have mastered balancing flash with ambient light, then it's easy to start to build up a picture using more than one flash. Flashes can be used to pick out parts of a scene that would normally be in shadow or are darker than you would like. By altering the effect of the ambient light exposure using your ISO, shutter speed, and aperture, you can change the overall look of the scene, and by introducing one flash at a time (with a variety of different modifiers, power settings, zoom positions, and color temperatures) you can highlight the important areas and leave some unlit.

The idea is to build up the exposure one light at a time, so that you can see the effect of the each change. As the light from the flash is likely to bounce around the scene, it will affect how other parts of the image appear, too.

The key is setting the ambient light first, so that the base exposure is how you'd like it. Typically, the way to do this is to underexpose slightly by around a stop or more, so that the effect of your lighting is noticeable.

Next, start to build up the scene with your flashes, ideally starting with your main light first. Some photographers prefer to start with a backlight and can come up with a compelling argument why that way is better, but it doesn't make a huge difference. It only matters when you are trying to light a pure white background and want to avoid the light bouncing from the background spilling forward onto the subject too much, but that is quite a

specific situation. A good idea would be to use cross-lighting with a soft light on the subject, and a harder light from behind to separate them from the background. It's a starting point that often helps massively.

Your next step should be to look around the scene and see which parts, if any, need picking out with light. This could mean an overall increase in light levels on a distant part of the image, so a softbox or

ABOVE

Four flashes were used to light this car designer posing with his latest project. One flash with a small gridded softbox provided the main light, aimed from right of the camera and higher than eye level. A second flash with a grid picked out the unlit right side of his face. A third bare flash was aimed to light the white pillars of the building, and a fourth was aimed at the front end of the car the subject is seated on. All were set up before the subject arrived at the scene and controlled manually. *Phase One 645DF; 110mm focal length; ISO 100; 1/125 sec at f/8.*

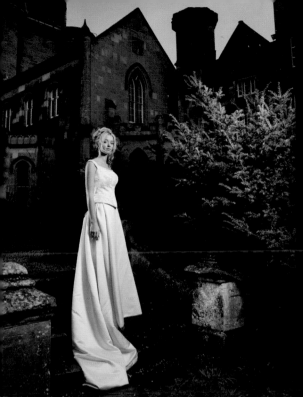

Basics

Equipment

Camera setup

Techniques

AMBIENT
LIGHT

117

Lighting

Case studies

Advanced

LEFT
A wet, grim day is no excuse for flat, lifeless wedding photos. In this shot the ambient light was underexposed so the castle was quite dark, then a flash fitted with a small softbox was fired from the right of the shot. It lights up the bride's face and also the bush next to her. A second light—a flash fitted with a honeycomb—was aimed from the left of the shot to cast a rim-light on the subject's arm and hair
Canon EOS 5D Mark II; 32mm focal length; ISO 200; 1/160 sec at f/8.

umbrella could be used, or you might want small pools of light from a flash fitted with a grid or honeycomb. This technique can work very effectively with colored gels, as these pools of light can be very brightly colored.

You can also hide small flashguns in places that you couldn't fit a bigger light, such as the footwell of a car, for example, or on a bookshelf behind a subject's head. Use small flashguns to place light where it can create a bit of three-dimensionality or

interest—you're only limited by the number of flashes you have access to.

When working like this, it's far better to control the flash output manually. Letting the camera's TTL system attempt to work out the exposure is almost guaranteed to frustrate: change one flash output and it will change all the others, seemingly at random. Stick to manual and you'll see the changes you make on your LCD screen. If you're setting up multiple lights you can't try to cut corners and do things in a rush anyway.

LIGHTING

Controlling the power of the flash, carefully balancing it with ambient light, and modifying the quality of the light source are all key skills in successfully using your flashgun. In this chapter we'll be taking a closer look at all aspects of shaping the light.

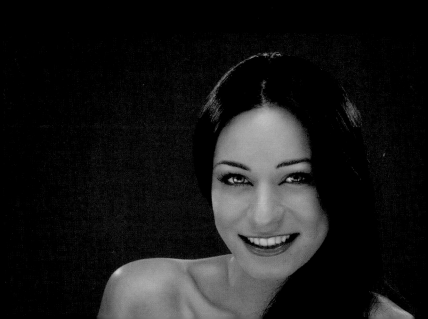

The real art of photography is in where to place your lights in order to bring out the best in your subject—be it a pretty girl, a weather-beaten oldie, a still life, or someone or something in action. All can be lit in lots of different ways, and some methods are more successful than others.

There's nowhere that it is more important to learn the "rules" of lighting than in portrait photography. If you know these rules and have an understanding of how they work, then you can work out how to break them when you need to.

Many of the traditional portrait lighting patterns evolved from the world of painting where, for years, masters of the art of controlling light studied the best ways to create their desired effect. Nowadays, we've modified their use for photography, and given them new names in a few cases.

Though taking "people pictures" is by far the most common use for additional light sources, flash is so much more versatile—it's not just for use on portraits. Flash is ideal for action shots thanks to its super-fast duration that can really freeze an image, and can sometimes be combined with blur for artistic effect.

Or consider product still-life shots, where the power of the flash means a narrow aperture can be used to get the final image pin-sharp, or to highlight certain key parts of the subject. Vehicles are ideal subjects for flash, combining the detail of still life with action, and interiors are great places for careful use of flash, which can mix subtly with the ambient light to create an atmospheric look. Flash really is as exciting and versatile as you make it.

Basics
Equipment
Camera setup
Techniques
Ambient light
LIGHTING
119
Case studies
Advanced

LEFT

When using a dark background and a dark-haired model, a single-light setup means the model's hair disappears into the background. So two rim-lights—flashes fitted with grids—were placed behind the model and aimed toward her. You can clearly see the rim-lighting effect on her shoulders and her hair. *Nikon D3X; 85mm focal length; ISO 100; 1/125 sec at f/11.*

Traditional Lighting Patterns

The three basic lighting patterns for a portrait are known as Rembrandt, loop, and butterfly lighting. In these shots of a model in front of a white wall, only one flash was used. It was, fitted with a large white shoot-through umbrella to soften the light.

As the room was painted white, the light from the umbrella bounced around the walls and ceiling and filled in a lot of the shadows, and a reflector positioned under the model filled in some more. All that was moved in each photo was the position of the main light.

The first look is the classic Rembrandt style, as seen in many of the paintings by the great master artist. In his work, Rembrandt used soft window light from a north-facing window. In our shot we used a big umbrella for a soft light, positioned to the right of the frame and slightly in front of the model. The key look that Rembrandt lighting gives is a small triangle of light on the opposite cheek of the model to the light source. Purists say that this triangle should be no longer than the subject's nose and no wider than their eye. Rembrandt lighting gives a very three-dimensional look, thanks to the side of the face nearest the camera being darker than the "lit" side, and tends to make a face look slimmer as some of it is in shadow.

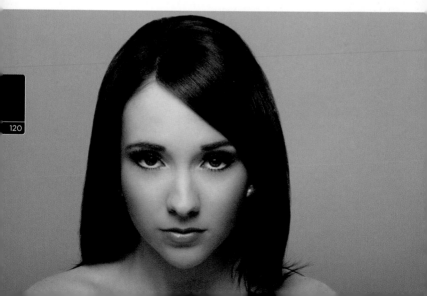

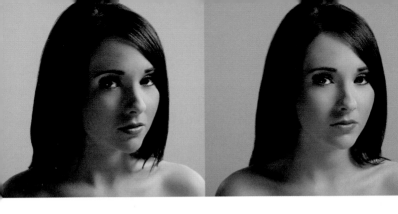

Basics

Equipment

Camera setup

Techniques

Ambient light

LIGHTING

121

Case studies

Advanced

OPPOSITE

With the light now in line with the camera, the shadow of the nose is said to resemble a butterfly. Butterfly lighting is often used for beauty shots, especially with young girls with flawless skin and great bone structure.

ABOVE LEFT

A triangle of light under the eye furthest away from the light source is a giveaway that Rembrandt lighting has been used. Much of the side of the face that faces towards the camera is in shadow.

ABOVE RIGHT

With the light moved back toward the camera, more of the face is lit. The shadow of the nose is said to resemble a loop, hence this style is often called loop lighting.

All pics: Canon EOS 5D Mark II; 85mm focal length; ISO 100; 1/160 sec at f/11.

If you move the light around the model to 45 degrees, the shadow thrown by the nose goes downwards toward your model's top lip in a sort of loop shape. Hence, this is known as loop lighting, probably the most popular lighting pattern. It lights the face well, and typically offers less contrast than Rembrandt lighting.

If we continue to move the main light back around toward the camera position, until eventually it's directly in line with the camera but higher, then we end up with butterfly lighting. This is so called because the shadow made by the nose on the upper lip is said by some to look like a butterfly. This lights the whole face, and can make it look wider than it really is. This sort of lighting is popular in beauty shoots as it really shows off the contours of the face.

Broad and Short Lighting

Learning the difference between broad and short lighting can make a huge difference to the look of the subjects in your photos, and can certainly make a difference in how much your subjects like them!

Broad lighting often emphasizes width, particularly of your subject's face, but often their whole body. The general view nowadays is that, for the most part, people don't want to appear at their widest, so using short lighting is usually far more flattering.

Broad lighting does have its uses however. It's widely used in fashion photography, where it doesn't matter if your lighting seems to add a few pounds to very slim models with angular, thin faces. It can be effective in lighting many men, who tend not to mind if they don't look as slim as they could, and is also useful if you want to really emphasize how wide someone is, for example, to highlight the blooming figure of a pregnant woman. It's no coincidence that the famous pregnancy portrait of Demi Moore was shot by Annie Leibovitz in broad lighting style.

The key to identifying whether broad versus short lighting has been used is by looking at where is in where the shadows fall. In short lighting, you are essentially shooting the "unlit" side of a person, like in the Rembrandt and loop lighting patterns on the previous page. The shadows are aimed toward the camera position.

If your main light is off to one side of the camera, get your subject to stand facing directly toward that light. You'll essentially be shooting the side of the face that has the most shadows falling on it. With the subject turning to face the light, you have decreased the apparent width of the shoulders as seen by the camera. This is the key to short lighting and can be quite slimming in effect.

The opposite—broad lighting—is where the subject faces the opposite direction to the light. So if the main light is off to the camera's right, the subject faces to the camera's left. The light then illuminates the whole of the side of the face, as presented to the camera. This has the effect of making the face look wider, and can make the whole body look wider, too.

Compare the two shots opposite of a model in front of a gray background. The lighting is exactly the same in both photos. The main light is to the right of the camera, at roughly 45 degrees to the model, and is a Nikon SB800 shot into a large white umbrella. To the left of the camera and behind the model is a second flash, another SB800 fitted with a Honl honeycomb grid. This is to give some light on the hair and separation from the gray background to make the gray-clad model stand out.

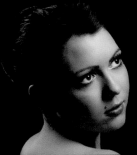

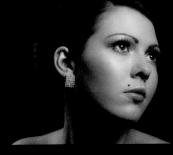

ABOVE LEFT AND ABOVE

Compare these two shots of a model in front of a dark background. The lighting is similar in both photos, except the direction of the main light has changed. The main light is a flash fired through an umbrella, and to the left of the camera and behind the model is a second flash fitted with a honeycomb grid. This is placed to give some light on the hair and give the model some separation from the dark background.

In the first shot, the model is facing toward the main light, which is to the right of the camera. The side of her face presented to the camera is therefore partly in shadow. This has the effect of making her face look slightly slimmer.

In the second shot, the model has turned around 90 degrees but is still facing in the same direction as before. The light has been moved much nearer to the camera position so it now illuminates the whole side of her face, as presented to the camera. Note how her face looks wider than before. *Phase One P40+;120mm focal length; ISO 100; 1/125 sec at f/16.*

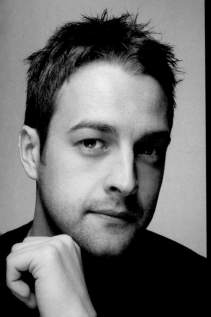

LEFT

In this shot of a photography student, the main light is lighting the broad side of his face, but this doesn't really matter. Men tend to be easier to light using broad or hard lighting. *Nikon D7000; 45mm focal length; ISO 100; 1/160 sec at f/18.*

Basics

Equipment

Camera setup

Techniques

Ambient light

LIGHTING

123

Case studies

Advanced

A Soft Light Portrait

If you look at a well-lit portrait that was clearly shot using multiple lights, it's easy to feel confused about where to begin to replicate the look. It may sound obvious, but for best results, build up light-by-light until you have the desired effect. Each light will have some effect on the others, so by building up one at a time, you can isolate any problem areas and go some way to solving them.

Don't be afraid to change things around—you don't always get it right first time, as this series of photographs proves. These images were shot in front of a plain black wall using only three flashes. The ambient light was from overhead tungsten bulbs that were warm-colored and not very flattering, so the exposure was set at 1/125 sec at ƒ/9, which meant it didn't register at all. All the light you see in the images was provided by the flashguns.

In the top left image of the four presented on these pages, the model was lit using a flash fired through a softbox to the left of the camera at slightly higher than eye level. In fact, the bottom of the softbox was roughly at her eye level so that the majority of the shadows were cast downwards, which looks natural. The model faced toward the softbox, so she is lit using a short lighting technique that introduces shadows on side of her face nearest the camera. This is often flattering.

The problem with this photo is that the model's hair simply disappears into the blackness behind her. Therefore, a second light was used, this time a flash fitted with a honeycomb grid. This was on the opposite side to the main light and

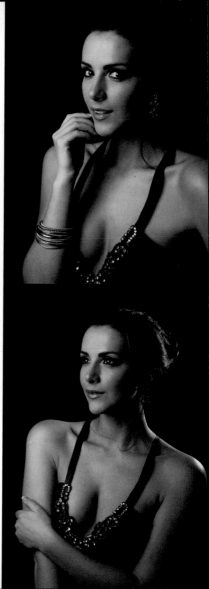

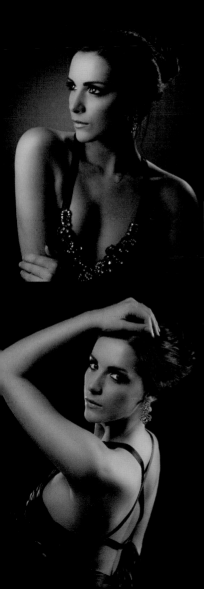

BUILDING A SHOT UP LIGHT BY LIGHT:

TOP LEFT The first shot is just lit by a single softbox to the left of camera.

BOTTOM LEFT A second light, behind and to the right, provides a hair and rim-light.

TOP RIGHT A third flash puts a pool of light on the background, but it doesn't look very good.

BOTTOM RIGHT Using the third flash as another hair and rim-light gives a far nicer look.

All pics: Canon EOS 5D Mark II; 50mm focal length; ISO 100; 1/125 sec at f/9.

behind the model (see bottom left image). It was aimed at her hair and left shoulder, and you can see these are now lit, separating her from the background.

In order to make the model truly stand out, a third flash was used, also fitted with a honeycomb grid (see top right image). This was positioned directly behind the model, and aimed at the background. Even though the background was pure black, by using the light at full power the tone was lifted to a pool of mid gray. This shot worked reasonably well, but the light on the background shows a strange pattern that I disliked, so there was a change of plan.

By turning the light around and using it on the side opposite to the first hair light, I now had a setup of two hair or rim-lights, one on either side (see bottom right image). This allowed the background to stay completely black, but put a rim of light around both sides of the model so she didn't blend in to the background—which could have easily happened, considering she is wearing a dark dress. With the model turned, the harder rim-lights highlight her back and put a soft rim of light around the edge of her face.

Basics

Equipment

Camera setup

Techniques

Ambient light

LIGHTING

125

Case studies

Advanced

Beauty Lighting

Beauty lighting is designed to show off the kind of perfect skin and makeup typically used in cosmetic advertising. It is essentially butterfly pattern lighting from the previous pages, with a second fill light or reflector added to reduce some of the shadows.

You may be tempted into thinking that beauty lighting is a surefire way to make anyone look beautiful, but it isn't a one-stop solution. Short lighting or Rembrandt lighting is often a better solution.

If your subject has flawless skin, fantastic bone structure, perfect makeup, and no issues about her face appearing as wide as possible, then beauty lighting is the way to go. If not—as in the case of many subjects—it's best either avoided or modified

The main light is almost always an overhead light—often a flash in a beauty dish or through a softbox. The harder the

ABOVE

A single Nikon SB800 flash fired through a Lastolite Ezybox hotshoe provides all the light in this beauty setup. It lights the hair and the face, and also the background as it is set up very close. A three-sided reflector underneath bounces some light back up into the face. As the photographer shoots through the gap between the reflector and the light source, this is called "clamshell" lighting.

LEFT

This simple beauty setup was shot using just one light. A main light in a softbox provided the illumination of the model and the white background, and a three-sided reflector lifted the shadows under the model's chin and eye sockets. *Canon EOS 1DS Mark III; 85mm focal length; ISO 100; 1/125 sec at f/8.*

light, (from a silver-lined, small beauty dish, for example), the more dramatic the look, but the more perfect your subject has to be and the more rigorous the post-processing retouching. This overhead lighting has strong light falling on the forehead, bridge of the nose, and cheeks. It's not for everyone.

The beauty dish needs to be high enough so the hair is lit and the shadows go predominantly downwards, but not so high that the eye sockets are in deep shadow. You need some light in there.

You will also need to reduce the contrast by either introducing a second light—at a reduced power—or a reflector

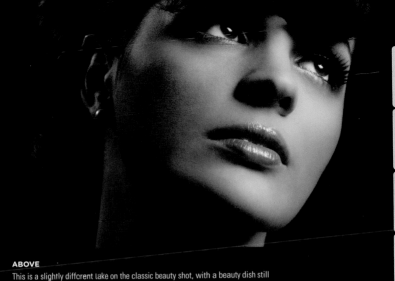

Basics

Equipment

Camera setup

Techniques

Ambient light

LIGHTING

Case studies

Advanced

ABOVE

This is a slightly different take on the classic beauty shot, with a beauty dish still used, but moved slightly to the right of the camera position to cast some shadows on the side of the face. No reflector was used underneath in order to make the shaded areas darker for a bit more of a contrasty look. *Phase One 645DF; 120mm focal length; ISO 100; 1/125 sec at f/16.*

directly underneath the model's chin. Lastolite make a three-sided reflector called the Triflector especially for this use.

You can vary the power output of the flash, or experiment with the height of the reflector, or even different reflecting materials, to change the look. Shooting through the gap between the two light sources or light source and reflector give this lighting its "clamshell" moniker.

Many professional beauty lighting setups then use a whole armory of extra lights. A typical example is a hair light directly above the model and pointed downwards to light up the hair. Two backlights—one on either side aimed

toward the camera position—are used for some rim-lighting effect. Often these have grids fitted, or are blocked off by huge boards to stop them flaring into the lens.

Finally, another flash can be aimed at the background, either to light the whole of it, or parts of it using light-controlling devices like a snoot or a honeycomb grid.

However, that's a fully professional and complicated setup. If you are using just one flash and a reflector, get in close to a light-colored background and the main light can illuminate it, too. Add in a couple of rim-lights to highlight the hair and you're in business at a fraction of the expense and complication.

Hard Light Portraits

When shooting a portrait, the default position for many photographers is to instantly reach for a soft and flattering light using the largest light source possible.

This diffuse light nicely fills in any wrinkles or imperfections, and is an easy, but often overused, form of lighting. Alternatively, you can use hard light to get some great portraits. A good rule of thumb is that the harder the lighting, the more dramatic the picture. Of course, it's always a compromise. You wouldn't use hard light to shoot a flattering portrait of an elderly lady, for example, but you would use it for a gritty photo of a similarly aged, weather-beaten fisherman.

Hard light often comes into its own when photographing male subjects who are either too young to have any wrinkles, or are too experienced to care about them.

There is a fine line between truly hard light—such as from a bare flash bulb—and that from a small beauty dish, for example. The transition from highlight to shadow will be much less severe when using a larger light source, even if it is a shiny silver dish. The contrast in full shadow may be exactly the same, but it's the subtle gradation from highlight to shadow that makes the hard light from a small beauty dish look good.

Of course, one technique often used in fashion photography is to use a hard light as a main light, and a large, soft light source right next to it to fill in the shadows and reduce contrast. This gives a more subtle effect than hard light alone, giving you a hard, dramatic source without too much

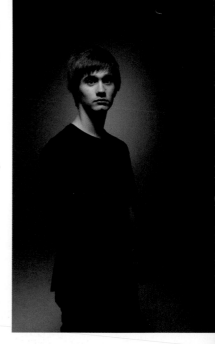

contrast. If you choose to use just a hard light source without a fill light, you will get quite a stark result.

If you combine a small beauty dish with a honeycomb grid, this makes a pool of light that's controllable and reasonably hard, but still has a more subtle gradation from highlight to shadow than a bare flash, or a flash with just a grid, would have. Both our examples use a gridded, small beauty dish as a main light.

The second image, of a man in a chair, uses just this one light. This is where knowing your traditional lighting patterns

Basics

Equipment

Camera Setup

Techniques

Ambient Light

LIGHTING

129

Case studies

Advanced

RIGHT

A single gridded beauty dish was the sole light for this shot of a film director in pensive mood. *Phase One 645 DF; 80mm focal length; ISO 100; 1/200 sec at f/16.*

LEFT

This young man was in a totally white room, but the light from the overhead, gridded beauty dish didn't illuminate any of the background. A second gridded flash put a pool of light on the background instead. *Nikon D3X; 50mm focal length; ISO 100; 1/200 sec at f/18.*

helps. The light here was placed off to the right side and aimed downwards at the subject to just illuminate him in his funky chair. The shadow of the nose is a telltale sign of the direction, quality, and pattern of lighting. It's quite a hard light, above and to the right, in a loop lighting pattern (see page 120).

For the shot of the young scooter rider, the same gridded beauty dish was used. This time it was placed above him, aiming almost downwards, and gives a true butterfly lighting pattern that you can clearly see in the shadow just under his

nose. The floor behind him is lit by the fall-off from this light. As he was in a dark T-shirt, he blended into the background, so a second flash, fitted with a honeycomb grid, was aimed at the background to create a pool of light behind his head. This made sure he stood out.

Dealing With Glasses

There's one easy solution to the problem of nasty reflections in spectacles, and that's to ask your subject: "Do you always wear your glasses?" If they don't, then ask them to remove them. This is by far the easiest way of avoiding any reflections.

The reality is, however, that sooner or later you will have to deal with problematic reflections from a subject's glasses. To understand why you see the reflections, think back to the basic physics you may have learned at school, specifically the angle of incidence and the angle of reflection.

The angle of incidence will always equal the angle of reflection, which basically means that a photon will hit an object, then bounce off, at the same but opposite angle. If the photons hit a smooth surface, like a sheet of metal or glass, then you get what is known as a specular reflection. What you're seeing is a direct reflection of the light source, and if you're using large light modifiers like umbrellas or a softbox, then the reflection will be even bigger and more obtrusive.

If your flash has a modeling light, this is a good time to use it. Ask your subject to lower their glasses on their nose a little, or tilt their head slightly until you can't see a reflection of the light source. Often, a subtle movement will do the trick, though of course this can be slightly annoying for the subject, who might have some trouble keeping in position.

A second technique is to always broad light your subject (see page 122). Broad lighting is usually not the most flattering light, but it at least means the reflection of the light bounces away from the camera rather than toward it. However, if you are lighting large groups of people, you can't use broad lighting for all of them. To get even coverage, the flash would have to be huge, powerful, and distant, and they'd all have to stand facing the same way, so it would be very limiting.

In a case like this, try using a smaller light source so the reflection will be smaller, and try to set the light above the subject's eyeline, so the reflection is aimed downwards. Unfortunately, this is a compromise without an elegant solution.

LEFT

An umbrella provided the main light in this shot, and can be clearly seen in the huge reflection in the subject's sunglasses. This can be very distracting. *Nikon D3X; 14mm focal length; ISO 100; 1/200 sec at f/11.*

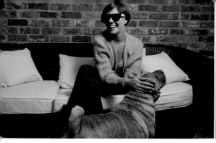

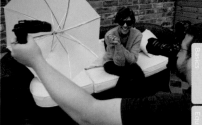

ABOVE

In this shot, the model is now facing away from the light source—hence broad lighting her, but the reflections of the light source have now disappeared. The light source is on the right of the camera, and the model faces slightly to the left. *Nikon D3X; 28mm focal length; ISO 100; 1/250 sec at f/5.6.*

ABOVE

Short lighting a subject with glasses, like in this setup shot, is a surefire way to get nasty reflections.

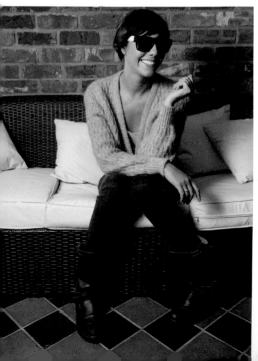

Basics

Equipment

Camera setup

Techniques

Ambient light

LIGHTING

131

Case studies

Advanced

LEFT

Once again, the model is lit using a broad lighting technique to get rid of reflections. This time, the light has been moved to a different side. It's now on the left of the camera position, and the model faces to the right. *Nikon D3X; 32mm focal length; ISO 100; 1/250 sec at f/5.6.*

Environmental Portraits

Balancing the output of your flashes with the existing ambient light becomes absolutely crucial when you are trying to include some surroundings in your images. This is important in environmental portraiture, where you use the location to tell a story about the subject or to create a certain look.

In these circumstances, the ambient light falling onto the background becomes a vital governor in your shots. You have to decide how much—if any—of the ambient light is going to register in your photo, and then build up the main light using your flashes to get the desired effect.

It doesn't always work that way, though. Sometimes, if the ambient light is poor in terms of quality, direction, or intensity, you can light the environment yourself using your flashes. Done sympathetically, this can work well and nobody viewing the images would know that every part of the scene was lit by you and your flashes!

In most cases, it's about using what's already there and augmenting it with your flashes. Often, this is done by taking an exposure reading for the ambient light, then underexposing it by anything from half to three stops. Then use your own flash to put enough light back onto the key parts of the scene to get them exposed correctly.

In some cases, it's about matching the color, direction, and quality of light to what is already there, so that the scene looks totally natural. In others, you can use a mix of lights that don't attempt to

ABOVE

A frosty but bright winter's day, with the sun just setting and providing a warm glow to the clouds, the fence, and our models hair, was a great start to this shoot. The exposure was set so that the car park in the background was underexposed in order to move attention away from the cars, and the sky was rendered a nice mid-blue. The exposure was not set so dark that the lovely rim-lighting on the model's hair, hat, and knitwear disappeared. That warmth is a key part of the shot.

A single small flash was used inside a small beauty dish, to the left of the camera and higher than the model's face.

This hard light source really picks up the texture in the chunky knitwear. As it was just out of frame, the light falls off relatively quickly so it doesn't illuminate the fence or the ground. *Nikon D3X; 24mm focal length; ISO 100; 1/250 sec at f/10.*

emulate the natural conditions, but whose function is solely to provide a dramatically lit shot. When you are in low-light situations, hotshoe-style flashguns are ideal, as they can be adjusted to output a very small amount of light, usually down to 1/128 power. Larger flashes often can't go as low as this, so you may end up using neutral density filters. ND gel is sold in large sheets so you usually have to cut them to fit.

Often, the problem is not having to cut the power down, but squeezing more power from your flashes, especially if you

Basics

Equipment

Camera ratio

Techniques

Ambient light

LIGHTING

133

Case studies

Advanced

are working outdoors on a bright day. Moving the flash close, removing any light-killing modifiers, or using more flashes is sometimes the only option, or you can invest in more powerful units.

One of the key bits of equipment you will need is a tripod. Often if you're trying to capture some of the ambient light, you will be using slow shutter speeds—especially if you need a relatively narrow aperture for a decently wide depth of field. If you're doing this, your subject may have to stay reasonably still. The flash is instant and will provide a sharp main image, but any movement will cause a ghost image. This can be used for creative effect, but in many cases is off-putting and makes your shot look less than intentionally sharp.

ABOVE

A totally cloudless, bright day under full sunshine meant lots of flash power was needed to light these three tattoo-sporting youths. They were posed so that the sun acted like a huge back-light—you can see this from the hard shadows cast on the ground. This, of course, left the subjects as silhouettes, so a single Elinchrom Ranger flash was added just to the right of the camera position. It was on a lightstand slightly higher than the subjects' heads, and was pointing down at them.

You can see a reflection of this flash going off in the shades worn by the two subjects on the right side of the photo. This could have been retouched out, but is not very obtrusive anyway. *Nikon D3; 24mm focal length; ISO 200; 1/240 sec at f/18.*

ABOVE

A 1960s-inspired black-and-white background perfectly matches the black-and-white clothing worn by the model, and the red lining of the jacket matches her red lipstick to provide a small accent of color.

This photo was taken was in the basement of a house with virtually no ambient light apart from tungsten-colored household bulbs, so an Elinchrom Ranger Quadra provided the whole light, shot through a 100cm softbox. This was positioned to the right of the camera position and level with the model's face.

The room was quite small and painted white, with a low white ceiling, so the light from the Quadra bounced around all over the place and filled in most of the shadows. *Canon EOS 5D Mark II; 50mm focal length; ISO 100; 1/160 sec at f/9.*

TOP

This is a case where the flash is used totally sympathetically with the ambient light exposure. It's not supposed to look like a flash was used at all.

A wide 17mm lens was chosen to shoot this mechanic inside his cave-like garage. Highlights of the scene included the very rare Bristol car on the ramp, an old toolbox complete with Mopar decals, and the grinder in his hand.

The lighting was totally mixed, with the green-magenta fluorescent tubes providing some of the light. A large, high window put a splash of natural light on the front of the car, but the mechanic himself was in shade, as the window light didn't reach that far. To make it look like the mechanic was also lit by the window, a flash was shot into a very large umbrella to the left of the camera. The exposure was 1/125 sec at f/2.8, governed by the ambient light in the scene. The power of the flash was also very low so as not to overpower the whole scene. *Nikon D3; 17mm focal length; ISO 400; 1/125 sec at f/2.8.*

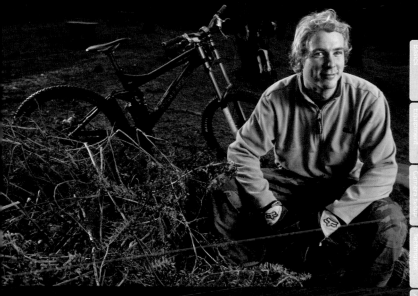

Basics

Equipment

Camera setup

Techniques

Accessories

LIGHTING

135

Case studies

advanced

OPPOSITE BELOW

Light streaming in through some venetian blinds provided the main light on this college lecturer quietly working alone.

However, the difference between the lit and unlit parts of the scene was huge, leaving the subject with a distinctly stripy face, so a single flash was used in order to subtly reduce the contrast and fill in the dark shadows slightly.

The fill light was on the right side of the camera. Usually, a fill light is a large light source, but in this case a large source would have filled the whole room with light and ruined the effect. A gridded light was used, directed just at the head of the subject to slightly reduce the contrast there.

In this case the dramatic light was provided by the ambient light, but a gridded flash put in just the right amount of fill to get back some detail in the shadows, but not enough to lose the overall look. *Nikon D3S; 85mm focal length; ISO 200; 1/250 sec at f/4.*

ABOVE

Low, late afternoon sun streaming through the trees, a couple of bikes in the background, a log to sit on, some bracken in the foreground—these are the visual clues adding context to this portrait of a keen mountain biker in his own environment.

The key to the exposure was the ambient light. Setting ISO 400 and f/6.3 at 1/100 sec meant enough depth of field and a shutter speed high enough to handhold thanks to a 27mm wide-angle focal length.

The main light on the biker was a Nikon SB800 fired through a white umbrella just out of frame to the right.

Out of frame to left and behind the subject was another SB800, fitted with a honeycomb grid. This put a nice rim of light on his right side and is relatively sympathetic to the backlight of the sun. *Nikon D3, 27mm focal length; ISO 400; 1/100 sec at f/6.3.*

Action Shots

You will find many amazing photos where the super-fast flash duration of a strobe has been used to freeze action small enough to be invisible to the naked eye. For example, a water droplet splashing onto a surface and making an amazing crown pattern, a piece of fruit being smashed by a hammer, or a bullet piercing an apple are all potentially wonderful shots, with much of the specialist work to capture the motion being done by highly technical pieces of equipment with amazingly short flash durations.

If you have a regular flashgun, which can have a very short flash duration at lower power settings, you might think you'd have all you need to totally freeze fast action, and you'd be partially right.

If you are shooting in a dark room or outdoors in very low light, then the flash itself can freeze action very well. You won't need lots of flash power, so the flashgun can be set to a low setting like 1/32 power, which gives a tiny, fast burst of flash. Of course there are lots of other technical problems that come alongside shooting in near-darkness, such as accurate focusing, but armed with a torch you can shine the light onto the subject so you can focus. Then you're ready to go.

In the real world shooting action is usually done in bright or moderately-lit surroundings; you don't often get people participating in action-packed sports in near darkness. This means that the ambient light will register and play a crucial part in the exposure. The flash may go off at 1/4000 sec, for example—

ABOVE

Caught at the top of his backswing, this golfer was hardly moving when the shutter was fired, so the image is very sharp. One flash was used to the left of the camera position and another to the right. *Nikon D3X; 36mm focal length; ISO 100; 1/250 sec at f/11.*

fast enough to freeze most motion—but typically the shutter will be open for 1/250 sec—the maximum sync speed you can set. This means that the movement will register too, so you will often get a sharp central image with a ghost image surrounding it. The faster the flash duration, the sharper the central image, and the faster the shutter speed, the smaller the ghost image. Also, the more that the flash affects the exposure compared to the ambient light, the sharper the shot. These are the reasons why top pro sports photographers

who use flash to freeze action invest in super-fast flashes, and sometimes a few of them to group together in order to sync at high speeds.

Even if you only have one or perhaps two small flashes, they still work pretty well: the key is to get the flash to overpower the ambient light as much as possible. That means that the main part of the image is as sharp as possible, and the ghost image as small as it can be. You need to get your flashes in as close as you can and aim to underexpose the ambient light. A second key element is your timing. If you take the shot when the movement is at its peak—as a golfer hits a ball, for example—then you'll get maximum blur. If you take it when he's at the top of his backswing, then there's less movement and the shot will be sharper.

TOP

Using wireless triggers meant the sync speed of this Nikon-camera was reduced to 1/200 sec, but two fast flashes helped create a relatively sharp image of our trampolining subject. By timing the shot so she was at the highest part of her jump, she actually is motionless for a fraction of a second. You can still see some ghosting blur on her feet, though. *Nikon D3X; 24mm focal length; ISO 100; 1/200 sec at f/16.*

BOTTOM

Two flashes—one slightly behind the subject for rim-light and another to the right of the camera for the main light—were used to take this shot. A low camera angle framed the subject against the sky mid-leap.

Vehicles

There are more similarities to shooting vehicles, still life shots, and people in glasses than may first appear! The common denominator is that when working with anything shiny—like a car, chrome kettle, or pair of shades—you are essentially photographing a reflection of the light source.

This is why pro still-life photographers often use large light tents to get rid of nasty reflections where they don't want them. Professional car photography studios are like that, but even bigger.

Often a floating ceiling is lowered over the car and all lights bounced off that, and then huge black cloths are draped around the floor to create reflections in exactly the right places. It's highly scientific, takes years to learn, and entails a big, expensive studio and lots of lights.

However, that's for big, commercial or editorial studio shoots. Many car and motorcycle shoots are done outdoors using nothing more than small or medium-sized flashes and modifiers that many photographers will already own.

In many ways, shooting static shots of motorcycles can be slightly easier as they often don't have a huge expanse of large bodywork panels that can be a nightmare to light. You can treat motorcycles almost like any other outdoor subject and use the sun to rim-light them—or put in your own lights for rim or separation. Rim-lighting tires can work really well, making them stand out from the background and giving them a texture—much like using a hair light on a model.

Next, use hard lighting from small flashes to put light into the important areas, such as the engine or bodywork. You can use large softboxes up close, but watch for the reflections from these as they can be off-putting. Often it's better

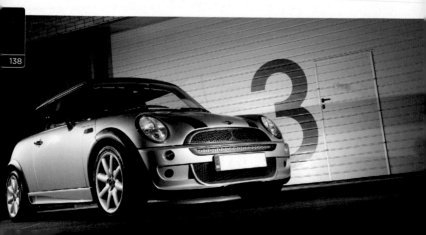

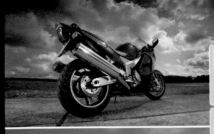

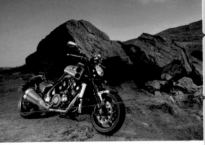

RIGHT ABOVE

The bright red motorbike contrasts well with the storm clouds, especially as they were deliberately underexposed by two stops to make them look darker and more brooding. To punch some light back onto the bike, two off-camera flashes were used.

Both flashes were mounted on lightstands and used totally bare—in other words, without any modifiers. The first is to the right of the camera position and aimed to light up the right-hand side of the bike. If you look at the ground under the bike you can see the shadows caused by this flash.

A second flash was off the left of the camera and slightly behind the bike. It's aimed at the rear of the bike, lighting up the bike's tail and rear tire *Nikon D3; 17mm focal length; ISO 200; 1/250 sec at f/14.*

RIGHT

With the sun coming from the right of this picture, the side of the bike nearest the camera was in shade. So two small flashes were used—one toward the back of the bike and one near the camera. They were far enough away to provide an even pool of light. There is one specular highlight on the bike's front fender but it's not too distracting. It could be cloned out if an exacting client demanded it. *Nikon D3X; 24mm focal length; ISO 100; 1/100 sec at f/9.*

OPPOSITE

Shooting at night means even small flashes, like Nikon SB800s used here, can be powerful enough to light a car at distances great enough to avoid light fall-off. This Mini was lit by four small flashes. Two are to the left side of the camera and used to light the whole right side of the car. They are around 20 feet away, so the light output is pretty even when it reaches the car itself. A third is to the right of the camera and lights the front of the car. A final flash is behind the car and is lighting the big industrial doors behind it. All were used totally bare, without any modifiers. *Nikon D3; 35mm focal length; ISO 200; 1/60 sec at f/11.*

to have small specular highlights from a point light source like a tiny flashgun. These can be less obtrusive, and can be easier to Photoshop out if you really don't like them. On something like a motorcycle though, where there is often lots of chrome and shiny bits, you'll never get rid of all the reflections.

Cars can be treated in a similar way. Unless you have a massive softbox, you can use hard light sources. However, you need to get these quite far away from the car so the light is even. If it's too close, there's lots of fall-off and the light can look patchy.

That means you either need hugely powerful lights, or to shoot when the light levels are low—such as at night.

Basics

Equipment

Camera setup

Techniques

Ambient light

LIGHTING

139

Case studies

advanced

Interiors

Shooting interiors can be a highly technical process, and experienced photographers use complicated technical cameras complete with tilt-and-shift capabilities to ensure the perspective is correct and has no converging verticals.

The lighting can be equally as complicated. Some tricks used by experienced interior professionals include cutting whole sheets of colored gels to fit perfectly inside windows so that the light coming in from outside is of a certain color, or layering lots of different exposures in post-processing to create a photo with the highest-possible dynamic range. Sometimes the room can be lit in sections, with every part exposed to perfection and the whole lot stitched together later on in Photoshop. Interiors shooting is an art and science mixed into one.

However, armed with a few small flashes, a tripod, and an understanding of light, it's very possible for you to take good-quality shots of building interiors. Purists may say they're not perfect, but even editorial clients nowadays prefer shots that have a more realistic atmosphere, rather than an overlit and highly manufactured look.

It's been said that 90 percent of interiors photography is moving furniture, and that's not far from the truth. Once you've chosen your viewpoint—ideally somewhere where your camera isn't tilted downwards or upwards too much to avoid converging verticals—it's best to tidy everything up as best as you can. Move the bits of furniture that can be moved into aesthetically pleasing compositions.

Tidy away phone or electricity cables, if you can. Of course, dressing the room with accessories like magazines or vases of flowers is the job of professional room stylists, but you can always have a go yourself.

As with all flash photography, the key to a successful picture is balancing the ambient light with the light you introduce yourself. In a room set, there are usually already at least two light sources—daylight coming in through windows and the light from the interior domestic fittings such as lamps.

In most cases, the time of day you shoot at is crucial to the feel of the photo. If you shoot at noon on a bright day, daylight will overpower the whole room and artificial light will have no effect. The light will be very contrasty. If it's nighttime, the house lights will register, but there will be no light coming in from outside. Again, it will be very contrasty and dark in patches.

Picking the right time of day, or even time of year, so that there is a good balance between the daylight and the artificial light inside is key to a good exposure. You'll also need a sturdy tripod and a cable release so the camera can be fired without introducing significant vibration. If your camera has a mirror lock-up facility, use that, too.

Chances are you'll want to use a narrow aperture to get a wide depth of field, so a slow shutter speed will be the order of the day, especially as you should be aiming to shoot at low ISOs for the best quality. Take a test shot, and evaluate the frame to see

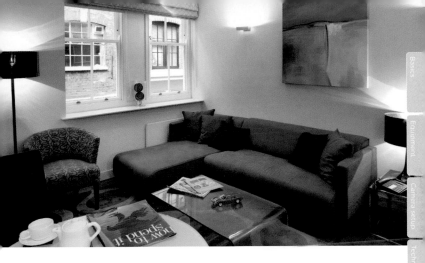

Basics

Equipment

Camera setup

Techniques

Ambient light

LIGHTING

141

Case studies

Advanced

where light needs to be introduced to reduce contrast or boost low-light areas. Often, if you have a white or plain colored wall or ceiling a flash bounced into it can provide a suitable fill light to subtly lift the whole level of light in the room. If the walls are strongly colored, a high flash fired through an umbrella or lantern-like softbox can work, too.

The beauty of using small flashes is that they can be hidden in various places in the shot, such as in lampshades or behind cupboards. The key is to make the light look like it should actually be there, which means thinking about the direction, quality, and color of the light. If you put a flash inside a household light, then you'll need to gel the flash to at least half-strength orange (half-CTO) for the light to be believable.

It's worth experimenting with different colored gels on your flashes for either dramatic effect or to shift the color balance compared to the ambient light.

ABOVE

This room was shot in the morning, before the sun got bright enough to make the light from outside overpower the interior lights in the room. To lift the level of ambient light in the room, four flashes were bounced off the white ceiling from behind the camera position. They were aimed into the corners of the room to the left, right, and behind the camera to make the light as even as possible. Their relative intensities were adjusted until the desired effect was achieved and the room looked as naturally lit as possible. The white balance was set for flash, so the room lights still had a warm glow and the open shade outside the building looked slightly blue. *Phase One 645 DF; 28mm focal length; ISO 100; 3 sec at f/12.*

Often, our eyes perceive daylight as being cool and blue and tungsten as being warm, but they do not pick up as great a difference between the tones as will show in photographs. Experiment and see what looks good and, most importantly, natural.

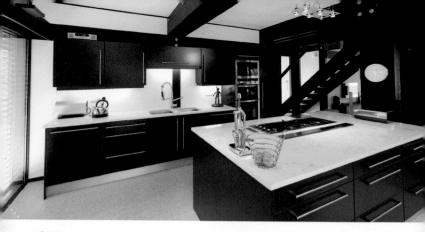

ABOVE

Lots of natural light flooded in from the left side of this scene, and from big windows behind the camera position, but the rest of the room in the distance was far darker. To even it all out, two flashes were fired into the ceiling over the kitchen to give an overall boost to the light, and another flash was fired into the ceiling in the room you can just see past the stairs. This gave some depth to the shot. *Nikon D3X; 14mm focal length; ISO 200; 1/5 sec at f/13.*

OPPOSITE

This shot was taken at night, with no ambient light entering the room. A decision was made to fake a bright, daytime feel. A white balance to match the tungsten downlighters was set in-camera so that the light there looked as natural as possible. The end of the corridor had two flashes hidden around the corners, fitted with dome diffusers. Initially, these were gelled tungsten orange to go with the downlighters so everything matched, but it looked better when they were ungelled and gave off a slightly blue color. This looks like some natural light flooding in through windows. *Phase One 645 DF; 28mm focal length; ISO 100; 2 sec at f/11.*

LEFT

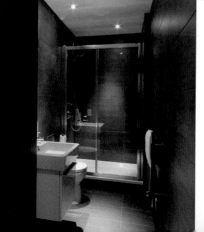

This bathroom had no natural light, so the main light was from the halogen downlighters, which made a very contrasty, patchy scene. The white balance was set to match these lights to give a more natural look. A flash was fitted with an orange CTO gel to match the color of the lights, and fired from behind the camera toward the ceiling. This provided an adequate fill light to reduce the overall contrast but still retain the ambience and true colors of the room. *Phase One 645 DF; 28mm focal length; ISO 100; 3 sec at f/11.*

Basics

Equipment

Camera setup

Techniques

Ambient light

LIGHTING

143

Case studies

Advanced

Products

If you have a flashgun and, ideally, a large light modifier such as a softbox or umbrella, then potentially you have a whole world of product photography at your fingertips.

Of course, while some product photography, like macro close-ups of jewelry, is very technical, there are still lots of still life shots you can take using just one flashgun. You could just bounce it off a wall or ceiling if you don't have any modifiers.

One of the biggest advantages of shooting products is that you can usually do it inside, so there's not normally a problem with trying to balance your flash

ABOVE

Just like the motorbike shot, the highlights on these strawberries are actually a reflection of the light source used. In this case, a small softbox. *Phase One 645 DF; 120mm focal length; ISO 100; 1/115 sec at ƒ/29.*

BELOW

A large softbox near the front of this custom bike makes the paintwork almost look like it's liquid. The very light highlights on the bodywork and chrome are reflections of the softbox used to light the bike. *Nikon D3X; 58mm focal length; ISO 100; 1/160 sec at ƒ/22.*

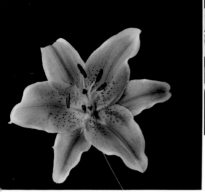

Basics

Equipment

Camera setup

Techniques

Ambient light

LIGHTING

145

Case studies

Advanced

ABOVE

This shot uses the main light from a softbox—the reflection of which you can clearly see in the knife—along with a degree of ambient light acting as fill. It was taken next to a large window of a restaurant. *Nikon D3X; 35mm focal length; ISO 100; 1/160 sec at f/22.*

LEFT

Just two lights were used to create this mono study of a lily. The main light was a softbox to the left of the camera, which gives a lovely wrap-around effect. The second was shot through a grid behind the flower to provide a bit of rim-lighting on the very edges. The flower was held in front of a piece of black paper taped to a wall. *Nikon D3; 105mm focal length; ISO 200; 1/100 sec at f/29.*

with powerful outdoor sunlight. Even the most humble flash can usually provide plenty of light at close quarters, and if you have an armory of reflectors—which can be as simple as pieces of card or bits of tin foil—then you have a top lighting rig already!

The best thing about small flashes is that they are very portable. With a couple of flashes, an umbrella, and a grid for some rim-lighting, you can shoot lots of top-quality product pictures.

As with shooting cars, the key to photographing shiny objects is to manage the reflections. A reflection is actually a mirror image of the light source. So shooting juicy strawberries with a big softbox means the shiny bits of skin reflect an image of the softbox that can look great. Just remember that at very close distances, the fall-off from your lights can be extreme. Move the flash away, and the light becomes more even, but harder. Of course, if you're using a big softbox this is hardly a huge issue!

The main instances when you will use ambient light to balance with the flash is when you're shooting food. Lots of modern food photography is shot using predominantly natural light, enhanced by a splash of light from the flash. It's a more natural look that's a world apart from old-fashioned studio-style shots of food using totally controlled lighting.

This natural look can lend itself very well to shallow depth of field. With large flashes you'd struggle to do this, unless you resorted to neutral density filters. By using small hotshoe flashes, you can adjust the power to very low level, which is ideal for balancing with low light and using a shallow depth of field. If you're shooting a fully dedicated system, you can also go even higher on the shutter speed—past your sync speed—to choose whatever aperture and shutter speed combination you desire.

CASE STUDIES

Of course, an understanding of the theory behind flash use is a great thing to have, but seeing how it is used in practice on real shoots is an invaluable learning experience. In this chapter we explore the use of flash in a wide variety of situations, from forest to desert, studio lighting to natural. We also explain, with the help of diagrams and behind-the-scenes photos, exactly how each shot was achieved.

Basics

Equipment

Camera setup

Techniques

Ambient light

Lighting

CASE
STUDIES

147

Advanced

There's no one-size-fits-all lighting solution for every photographic assignment. If you're very fortunate, you might have a bank of expensive pack-style lights and lighting modifiers, all lovingly tweaked by an army of assistants. With your camera tethered to a large computer screen, you could have instant feedback for you, your client, and the subject.

But more often than not, the kit you will use is a compromise between how much room you have, how portable the equipment is, how quick you have to be, and how bored your subject might get waiting for you to change your lights around.

Sometimes, you can use smaller pack-style lights like Elinchrom Ranger Quadras with full-size light modifiers. Other times, you have to travel light and just use one or more hotshoe-style flashes with the smallest modifiers you can get away with. It's a constant balancing act.

With the portability of small flashes comes the ability to hide them in little nooks and crannies, or clamp them to fixings. They have super-fast flash durations, which can help freeze the action, and can be adjusted to put out very low levels of power, so you can run wide apertures for shallow depth of field.

Sometimes, though, you need more power in order to either match or overpower the ambient light, use large light modifiers, or to get the light far enough away from the subject so it's output is more even. Everything is compromise.

In some instances, fast flash durations are needed, allied to super-fast sync speeds from medium-format cameras with leaf-shutter lenses, for example. Other times, you need slow duration flashes to hack the sync speed, as seen in previous chapters.

Each photographer works differently from the next, and also may alter their kit and techniques on different shoots based on the subject matter of the image, the atmosphere, working conditions, and, of course, the kit they have available to them.

In this chapter we will take a look at how a range of different and challenging photographs were created and the equipment that was used to capture the image.

LEFT

A shot of a promotional model next to a motorbike inside a gloomy indoor show called for two Nikon SB800 flashes. The first was to the right of the camera and was a silver reflective umbrella to provide the main light on the model and the front of the bike. The second was to the left of the camera and slightly behind the model, to light up the side of the bike and put some rim-lighting on the model. Using Pocket Wizard TTL controllers, the shot was set up and done in seconds. Sometimes you have to work very fast. *Nikon D3S; 32mm focal length; ISO 200; 1/250 sec at f/3.5.*

Use Depth of Field for Creative Effect

Many portrait photographers use shallow depth of field for creative effect when using natural light and reflectors. Some use wide apertures simply because they have to in order to get a shutter speed high enough to hold the camera by hand.

This wide aperture makes the background go soft and out of focus, putting the viewer's attention right onto the subject. When using flash, however, the power of the light often leads photographers to stick with small apertures so that everything is in focus. You don't have to do this, however, especially if you are using small hotshoe-style flashes that can put out very low power.

If you're using bigger flashes, some can go very low—like Elinchrom's Ranger Quadra series. Others require you to use neutral density filters, which can be a bit fiddly. The important thing to watch if you are going to use a wide aperture is that the ambient light doesn't start to creep in and register too much.

For these pictures the setting was a small room with bright patterned wallpaper and not much natural light.

The first shot was taken with a Quadra at a high power setting, shot through a softbox. This softbox was close to the model so that a narrow aperture of f/16 could be used. This made the wallpaper relatively sharp, even though an 85mm lens was used and the model was around ten feet from the wall. A second light— another Quadra fitted with a grid—was aimed at the wall to add a pool of light, but the wallpaper is still quite distracting.

In the second shot the power of both lights was dropped hugely, so that an aperture of f/4.5 was used. The rear light was also turned around to use as a rim-light. This aperture, and a tighter crop, made the model stand out far better than in the original shot.

LEFT

The original shot was at a narrow aperture, so the wallpaper was relatively sharp *Canon EOS 5D Mark II; 85mm focal length; ISO 100; 1/200 sec at f/16.*

LEFT

Using a much lower power setting on the flash required a far wider aperture, which made the background much softer and therefore less obvious. *Canon EOS 5D Mark II; 85mm focal length; ISO 100; 1/200 sec at f/4.5.*

Basics
Equipment
Camera setup
Techniques
Ambient light
Lighting

The Effect of Rim-light

This dramatic photo may look like it was taken in a darkened studio or against a black backdrop, but in reality it was taken in the middle of a bright sunny day on a playing field and the background behind the sportsman is a bright blue sky.

To get the background so dark, an element of contrast-boosting post-processing was involved, though the "heavy lifting" was provided by vastly underexposing the background and using powerful flashes up close to provide the light.

Using a medium-format Phase One 645DF camera fitted with a matching 40-megapixel P40+ back and a Schneider 110mm leaf-shutter lens, this combination can sync with full power flash right up to a staggering 1/1600 sec. With an aperture of f/11, the sky was underexposed by almost four stops, so it went from blue to virtually black.

The lights were four Elinchrom Ranger Quadras at full power—giving the fastest flash duration for the light required. They were all fitted with small beauty dishes and honeycomb grids. Two were in front of the player, and two directly behind him. This lighting pattern essentially rim-lit the player, and picked out any flying water drops in mid air.

Although the image was taken outside on a February day, and the player had just finished a match so he was able to repeat the spray around ten times before he started to get too cold. Luckily, we had the shot already in the bag.

Basics

Equipment

Camera setup

Techniques

Ambient light

Lighting

CASE
STUDIES

151

Advanced

ABOVE

This shot was taken outside against a blue sky
background, but lots of underexposure and rim-lighting
from flash make it look like it could be night. *Phase One
645DF; 110mm focal length; ISO 100; 1/1600 sec
at f/11.*

Working With Harsh Sun

If you're going to attempt to use your flash to fight the sun, then the most unlikely place you could try is probably Bonneville salt flats in Utah. The sun here is relentless and harsh, and the pure white salt of the lake acts like a huge reflector.

Visitors to the annual Speed Week competition are advised to wear a second pair of sunglasses on top of their regular shades in a bid to beat the glare. If you're wearing shorts, you need sun cream on your legs as much as on your head, as the ground reflects the light at almost the same strength.

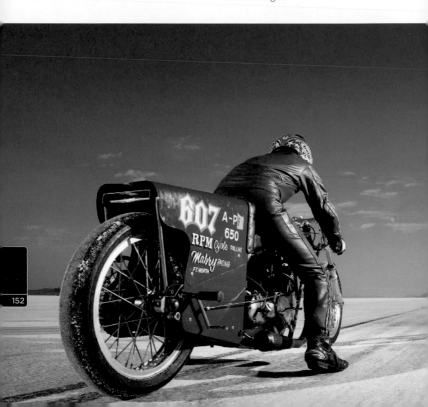

Basics

Equipment

Camera setup

Techniques

Ambient light

Lighting

CASE STUDIES

Advanced

All of this light bouncing around makes it easy to get great pictures, especially of the brightly-colored bikes and cars. Just point your camera, and the huge natural reflector fills in lots of the shadows. It is really pretty hard to take a bad picture at Bonneville. This also means that many photographers' shots look very similar, so

I decided to use my favorite technique of underexposing the background and using powerful flash to fill in the shadows and put strong highlights on the subject.

Well, getting out a Ranger Quadra flash unit on the brightest place on earth does get a few confused glances from onlookers, but what it did was allow me to underexpose the sky for saturated colors, and use the flash to really bring out the color and texture of the rider's leathers and bright red bike.

A polarizing filter was used on the lens, which cuts light down by around two stops. Even then exposure was still $f/9$ at 1/250 sec, which shows just how bright it was. The Quadra was at full power and shot bare, as close to the rider as I dared to get before he blasted off at high speed.

LEFT

If you want some odd looks, try getting out a big flash in one of the brightest places on earth! But a flash gives real saturation to a shot that you just can't get with natural light alone. *Nikon D3X; 24mm focal length; ISO 100; 1/250 sec at $f/9$.*

Camper Van Shot Multi-light Setup

A lovingly restored split-screen VW camper van is parked on the edge of a beach, and stormy clouds are rolling in. However, the lighting is anything but gloomy.

Bright light from a set of super-bright flashes really show off the van's green paint job. The shot was lit by two Elinchrom Ranger packs—the powerful, 1100Ws full-size heads rather than the smaller 400Ws Quadra units. These heads were fitted with standard reflectors and moved far away enough from the van to provide nice, even lighting. With an output of 1100Ws, they were powerful enough to enable me to use an aperture of $f/11$ at ISO 100.

One light was to the left of the camera, aimed to illuminate the front of the van and the legendary VW logo. It was around 20 feet from the front of the van. A second light was to the far right and lit the left side of the van, as well as the bush in the foreground. This was also around 20 feet away.

Inside the van was a third light, a small Nikon SB800 flashgun. This was fitted with its dome diffuser, so it put some light inside the cockpit. All three were fired by Pocket Wizard Plus II transceivers. The shot was post-processed in Photoshop with a gritty, bleach bypass-style effect to make the most of the apocalyptic clouds.

OPPOSITE

Bright lights show up the bright paint of the VW bus as the storm clouds roll in. It's not a natural look, but it is certainly dramatic! *Mamiya 645AFD II; 35mm focal length; ISO 100; 1/125 sec at f/11.*

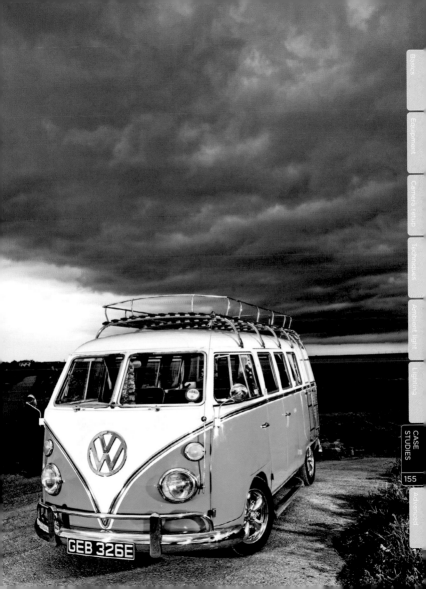

Basics

Equipment

Camera setup

Techniques

Ambient light

Lighting

CASE
STUDIES

155

Advanced

Creating Drama in a Stormy Field

The key to this shot was using lighting that was relatively sympathetic to the ambient light, which was shafts of sunlight piercing through dark clouds over a wheat field.

The ambient light was underexposed by around a stop and a half to make the sky go even darker than it really was, and make the distant wheat a darker tone, too.

The flashes were set up to approximate pools of light from the sun breaking through and illuminating the model. The main light was a flash through a softbox to the right of the camera. It was an Elinchrom Ranger Quadra fired through a small Chimera softbox. (Chimera's sizes run large—their small softbox is about as big as many manufacturer's medium or large boxes.) A second bare flash was also to the right but behind the model. This puts a rim of light on her face, arm, and leg.

The key is having the main light and rim-light on the same side as the sunlight to make it look a little more natural than if the lights had been on the other side.

Two flashes were set up to look like shafts of sunlight bursting through the clouds and creating a halo of light around the subject. The main flash on the model was a softbox moved in as close as possible to make it as soft as it could be. A second flash put a rim of light on her face and leg. *Canon EOS 5D Mark II; 28mm focal length; ISO 100; 1/160 sec at f/16.*

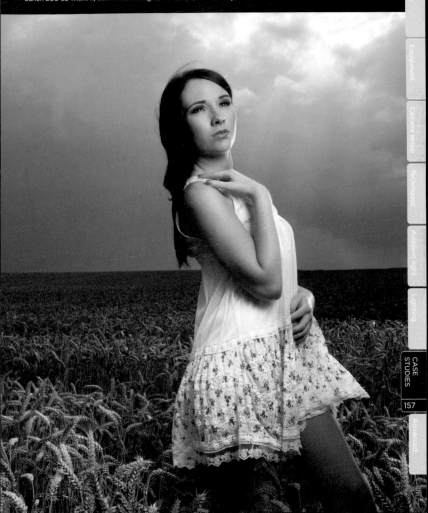

Basics

Equipment

Camera setup

Techniques

Ambient light

Lighting

CASE
STUDIES

157

Advanced

Making Three Flashes Look Like Thirty

If you were fabulously wealthy and owned 45 flashguns and matching flash triggers, as well as more than 15 lightstands, then a shot like this would be easy. You'd just set everything up as in the picture, surround the subject with lights and take a single photo with every flash set to the same setting—no problem.

Most people don't have access to that kind of equipment, however, so some trickery is necessary in this strobe technique. What is involved is fastening three flashes to a single lightstand with elastic bands, complete with flash triggers. The camera is mounted to a tripod so it doesn't move, and a wide aperture of $f/16$ set in a bid to cut down on all the ambient light. Even though this was a pitch dark night, you can still see some red light in the sky. This is light pollution from a town around five miles away.

The flashes are then set in the first position, and the shutter is triggered using the camera's B (Bulb) setting so that it stays open. Using a flash trigger in his hand, the photographer fires off all three flashes, then moves them a pace to the right and does the same again. This is repeated, with the flashes moved in a semicircle around the back of the bike.

Care has to be taken to ensure the flashes are charged up between pops or else one or more won't go off and the effect will be ruined. The flashes also need to be moved around the front of the bike so that it is illuminated properly or else it will be a virtual silhouette. Next, the shutter is closed. This is a real trial and error

technique, where the exposure time varies depending on how quick you are to get around the back of the bike.

Of course, another way would be to take a series of exposures with the lights in different positions then somehow merge them together in Photoshop, but it's so much more rewarding getting it right in-camera.

A muddy, wet floor complete with puddles complements the dirt bike too, and provides some lovely highlights.

Basics

Equipment

Camera setup

Techniques

Ambient light

Lighting

CASE
STUDIES

159

Advanced

BELOW

No, there weren't loads and loads of flashes used in this picture—just three that were moved several times. Note the flashes produce star-shaped highlights. This is due to a narrow aperture of ƒ/16 being used. *Nikon D3X; 24mm focal length; ISO 100; 142 sec at ƒ/16.*

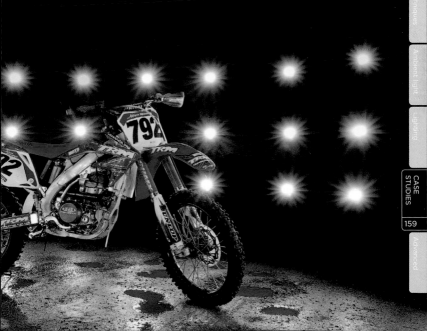

Creating Contemporary Portraits

A look that appears totally natural is a contemporary style popular with many magazines. This style is often about finding a slightly unusual location and making it look like the subject has been captured unawares, or is perhaps holding a stiff pose that makes the viewer identify with the awkwardness of the situation.

These portraits were carefully constructed to look as if they were naturally lit by the ambient light inside the café, though they were not. The ambient light from overhead skylight panels was underexposed slightly, and to put more of a highlight on the subject, a flash fitted with a small softbox (which had a honeycomb grid), was used.

For this shot, the flash was positioned out of frame to the right and cast some shadows of its own. To fill in this light and reduce the contrast, a second flash, fitted with a large umbrella, was used right next to the camera.

For the shot where the subject is making eye contact with the camera, the gridded softbox was used to the left of the frame. The second flash (once again fitted with a large umbrella) acted as a fill light and was placed next to the camera.

This style of portraiture is excellent for modern-looking fashion shots and edgy editorial or commercial clients, but it's not for everyone.

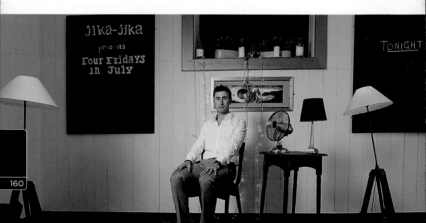

Basics

Equipment

Camera setup

Techniques

Ambient light

Lighting

CASE
STUDIES

161

Advanced

OPPOSITE

A slightly awkward pose and deadpan look somehow suit the slightly surreal café location. The odd bent-over lamps and raised stage complete with carpet are slightly freaky, too. *Nikon D3X, 29mm focal length; ISO 100;1/100 sec at ƒ/4.*

BELOW

Unusual artwork on the walls, old-fashioned school-style chairs, and a cup of tea make this odd portrait come alive. The lighting may seem totally natural, but is enhanced by the careful use of two flashes. *Nikon D3X; 29mm focal length; ISO 100; 1/50 sec at ƒ/3.5.*

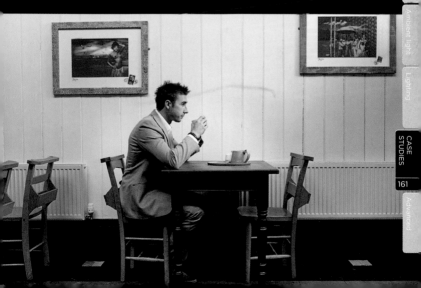

Using Blur for Creative Effect

You don't need to put the camera away just because light levels have dropped—even if you're shooting action. There are many sporting events that take place at night, from cycling and skateboarding to BMX, and if you are armed with a flashgun, there's a whole world of creative options available to you.

In fact, using your flash in low light can give results that you simply wouldn't get during the bright daylight. A partially frozen subject combined with some lovely artistic blur can make for stunning shots thanks to a real impression of movement and bright colors that only a flash can produce. Fortunately, it's not that difficult to do. The key is to carefully manage your shutter speed to get some blur, and to use a burst of flash—which is always very, very fast—to freeze part of the image.

On bright days outdoors, the camera is often set to its maximum sync speed. This prevents blur, and if you're trying to record both ambient light and flash, it gives as wide an aperture as possible. This also means the flash won't be working quite as hard and will have enough power to make a difference to the scene.

However, when light levels drop, lowering the shutter speed to something much longer helps low-level ambient light register, and introduces blur, which can be a great way to showcase motion in your photographs. Adding a burst of flash—which is lightning-fast compared to the slow shutter—means the subject can be partially frozen, and you can achieve a sharp image surrounded by a ghost image of any movement. This shot used two bare Nikon SB800 flashguns on either side of a jump the mountain biker was practicing on. A speed of 1/25 sec gave abundant blur, but not too much—it's very easy to go a bit too far and record nothing but blur.

A word of warning: this biker was jumping specially for the camera and was aware the flashes were going to go off: without this precaution, taking this shot could have been dangerous. The biker's green shorts and red top were chosen as bright, clashing colors.

Basics

Equipment

techniques

Ambient light

Lighting

CASE
STUDIES

163

Advanced

BELOW

A slow shutter speed gives loads of blur and hence the impression of speed. An instant burst of flash light from two strobes freezes the biker mid-jump. *Nikon D3; 23mm focal length; ISO 250; 1/25 sec at f/6.3.*

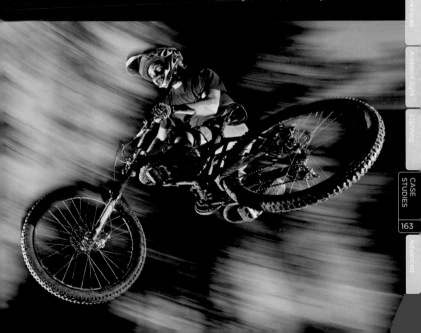

Freezing Motion

Flash is ideal for freezing fast movement. Some flashes can be as quick as 1/10,000 sec or even faster, though the majority peak at around 1/6000 sec, which is still more than fast enough for most applications.

The problem occurs when you add ambient light into the equation. Unless you can use a high enough shutter speed and narrow enough aperture to virtually eliminate the ambient light, you will see a slight ghosting of the image.

This photo of a soccer player was shot at dusk on a bright day, so there was still plenty of ambient light around. By using a Phase One 645DF medium-format camera with matching P40+ digital back and a 55mm wide-angle Schneider leaf-shutter lens, the flash can sync as high as 1/1600 sec.

In this case, a sync speed of 1/1000 sec and an aperture of f/6.3 was used so that some blue still registered in the sky. If you look closely you can also see the vapor trails of two passing planes, which almost seem to radiate from the player's foot toward the ball! The player was surrounded by four Elinchrom Ranger Quadra lights, all fitted with small beauty dishes complete with honeycomb grids to control the pool of light.

Two of these lights were by the sides of the player, pointing directly at him, and two others were slightly behind him to create a form of rim-lighting. You can clearly see the pool of light these flashes put out on the grass. The player did this kick several times—always in exactly the right position—to guarantee the shot, and then the shot was post-processed to create a grittier atmosphere and increase the contrast. This was from the same series as the athlete with the water bottle on page 151, hence the similar processing.

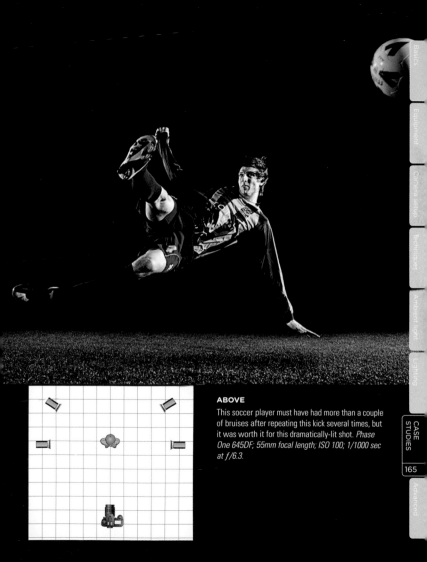

Basics

Equipment

Camera setup

Techniques

Ambient light

Lighting

CASE
STUDIES

165

Advanced

ABOVE

This soccer player must have had more than a couple
of bruises after repeating this kick several times, but
it was worth it for this dramatically-lit shot. *Phase
One 645DF; 55mm focal length; ISO 100; 1/1000 sec
at f/6.3.*

Making Black Stand Out Against Black

Making a black subject stand out from a black background—while still making both subject and background remain black rather than a dark gray—can present quite a big challenge.

The best way to manage is to use rim-lights to shine a subtle edge of light on your subject. It's this highlight right at the edge of the subject that makes them stand out from the background and creates a three-dimensional look. If the subject needs to be shown full-length, it makes things even trickier. Essentially, you have to use lights that are capable of shining a full-length highlight down the side of the whole subject, which means the size of the light almost needs to equal the size of the subject. If the subject is a person, this means using large strip lights as the rim-lighting sources.

Strip lights were almost impossible to find for small flashes until Lastolite unveiled their model, which carefully modifies the output from the point light source and fills the length of a strip softbox. Two of these lights, positioned behind the model, and at an angle of at 45 degrees to her, provide a nice rim of light all the way along her body. The main light was a softbox placed higher than the model's head and aimed downwards.

For the tighter shot, the lights were moved closer to the frame and in this image the rim-lighting effect is far more obvious as the light wraps around the model's arms. Also, for this shot a narrower aperture was chosen to avoid changing the power of the lights.

BELOW LEFT

A pair of strip lights attached to Nikon SB800 strobes puts a rim of light around the edge of this ballerina's body to make her stand out from the black background. *Nikon D3X; 50mm focal length; ISO 100; 1/200 sec at f/3.5.*

Basics

Equipment

Camera setup

Techniques

Ambient light

Lighting

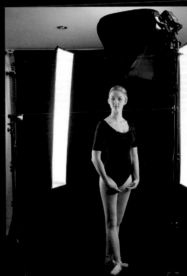

BELOW

A tighter shot means the lights could be moved in closer and the rim-lighting effect is more obvious. *Nikon D3X; 50mm focal length; ISO 100; 1/200 sec at f/34.*

BELOW

This shot shows the relative positions of the lights to the model and black seamless paper background.

Lighting a Room to Look Natural

This shot of a luxury hotel room may look like it was illuminated by just the natural daylight from outside as well as some of the lamps inside, but four powerful flashes were used to manage the contrast and make it look natural.

The overriding factor was the ambient light coming in through the windows on what was a very dull day. This light was given a little extra force by a Ranger Quadra unit outside the window, hidden behind the brown drapes, which shone some interesting light on both the back of the center couch and the sculpture on the small table. You can see the effect of this light by checking out the shadow of the sculpture on the wall directly behind it.

A second Quadra was also used inside the room, slightly to the right of the camera position and aimed at the corner behind the camera. This acted like a big fill light to reduce the gloominess on the right side of the room.

A third light was bounced into the room's left corner, which illuminated the breakfast table by what looks like window light. There is no window there, just some cupboards, but this light gives an airier feel to the room.

The final light was gelled to a tungsten color and placed in the bedroom just visible to the left of the frame. This augmented the low level of warm light in the room to give some real depth to the shot.

The eye of the person viewing the photograph goes on a journey from the outside balcony, to the inside of the room, to the breakfast area, and finally the bedroom. All the lighting looks relatively believable and natural—even though it's not!

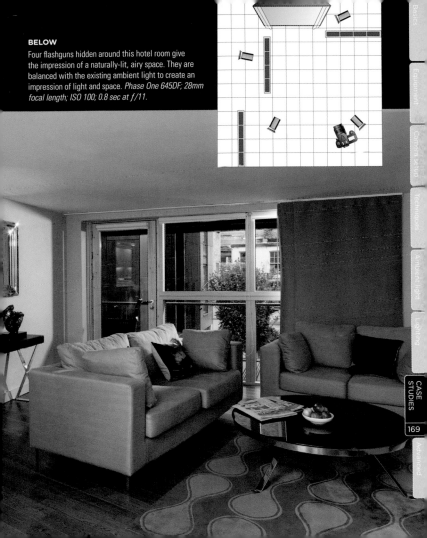

BELOW

Four flashguns hidden around this hotel room give the impression of a naturally-lit, airy space. They are balanced with the existing ambient light to create an impression of light and space. *Phase One 645DF; 28mm focal length; ISO 100; 0.8 sec at f/11.*

Basics

Equipment

Camera setup

Techniques

Ambient light

Lighting

CASE STUDIES

169

Advanced

Using Ringflash For Fill

Ringflash seems to have picked up a bad reputation, possibly due to its use on fashion shots as the main light, leaving telltale shadows right around the outside of the subject. There seems to now be a general view that this has been overdone and that the ringflash is something of a one-trick pony.

To immediately discount the myth, one ringflash trick is to leave very distinct circular catchlights in a subject's eyes. A ringflash is also particularly good as a fill light, as its light comes from the axis of the camera. Combined with some off-camera directional lighting, the ringflash really does reduce contrast in a very professional-looking way.

In this shot of an extreme sports athlete, the main lighting was an off-camera Elinchrom Ranger Quadra fired through a gridded beauty dish. This was high and to the subject's right, causing a natural-looking shadow from the peak of his cap across his face—a shadow that nonetheless needed to be reduced. Two more gridded Quadras were positioned on either side of the subject to put an element of rim-lighting on both sides of his face. Then a ringflash was used around the lens to fill in the contrast and create lovely circular catchlights in the subject's eyes.

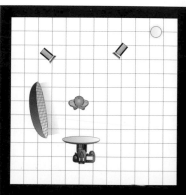

RIGHT
Three gridded, directional lights were used as the main and rim-lights in this picture. However, it was a ringflash that provided the fill light and put the distinctive catchlights in the subject's eyes. *Phase One 645DF; 80mm focal length; ISO 100; 1/400 sec at f/16.*

Basics

Equipment

Camera setup

Technique

Ambient light

Lighting

CASE STUDIES

171

Advanced

Lighting Up a Forest

Turning a dark forest into a well-lit playground for motocross bikes is a complicated task, requiring every light to be built up separately before the bikes themselves can be let loose.

The shot below was taken for a double-page spread in a motorcycle magazine, but the natural light was awful. It was dark and gloomy—not the kind of environment the magazine wanted to showcase these brand-new bikes in. To combat this, a corner in the forest was chosen, and the lights were built up one at a time. Four Elinchrom Ranger Quadras were used, fitted with

18cm reflectors to stop the light spilling around too much. These were triggered by the built-in Skyport radio triggers—essential as some of the lights were hidden behind trees!

When the lights had been put in place, the riders were instructed to ride through in formation. The first rider went wide and smashed into the soft earth, so the dust was sent flying, and the second rider stayed farther back to be rim-lit by the hidden flash. It took several passes to get it right, but it worked well in the end. The shot turned out bright and well-lit, and was run across two pages in the magazine.

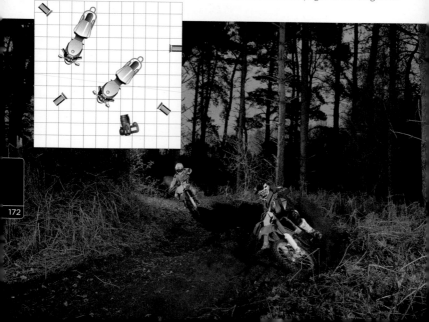

Basics

Equipment

Camera setup

Techniques

Ambient light

Lighting

TOP

First, a base exposure was set so that there would be some tone in the sky behind the trees. With a maximum sync speed of 1/250 sec and the ISO kept at a base of 100 for maximum quality, an aperture of ƒ/5.6 made the sky go dark and retain some tone. If you look closely, there actually is a motorcycle going round the corner in this shot!

TOP

The first flash to be put into position and its power adjusted was a backlight hidden behind a tree in the distance. This was moved around until the tree obscured it. The light from this would backlight the second rider, and really light up any dust kicked up.

ABOVE

Now the backlight was turned off, and two more lights were introduced, one on either side of the track. The light on the left illuminates the bush on the left, and the one on the right lights up a tree trunk and the area of forest in front of it.

Nikon D3X; 24mm focal length; ISO 100; 1/250 sec at ƒ/5.

ABOVE

A final light was installed to the right of the camera position and acted as the main light on the foreground. The position of the two side lights was also tweaked to give a nice, even coverage on the track. You can see the hidden light at the back, rim-lighting some of the leaves on a tree. Now the lights were set and the track was ready for the riders!

One Location, One Light, Three Photos

Working for magazines often means getting a variety of shots very quickly. If you can do this without changing location or the lighting to too great a degree, so much the better. These three shots all look very different and were all taken within a few minutes using just one light—an Elinchrom Ranger Quadra fired through a gridded beauty dish.

The first shot (right) shows the location well. The model, a boxer, is posed in the doorway of an old barn, rim-lit by the sun coming from behind. The light on his face is from the Quadra, placed to the right of the camera and exactly in line with the sun. This shot is an ideal "scene-setter," showing a nice amount of the barn and the yard in the background.

By leaving the subject and lights in exactly the same place—with the same exposure—but moving camera position, the second shot (opposite top) looks totally different. This time the subject turns to his left to face the camera a little more, and the background melts into the gloominess inside the barn. This is an ideal double-page spread shot for a magazine, with lots of room to drop on a big headline and some type.

The third shot (opposite below) again has a very different feel. By moving the boxer into the barn, but out of the direct sun, then increasing exposure to compensate, the inside of the barn is suddenly visible and bright. The flash has also been moved and its power reduced massively—now it acts as a small fill light to reduce the contrast. So we have three shots all taken in a matter of minutes, with

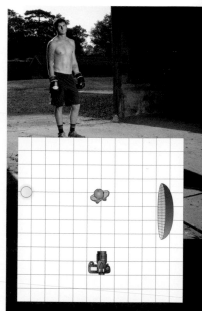

ABOVE
This shot shows the location well, with the boxer rim-lit by the sun and facing directly in to the flash. *Phase One 645DF; 55mm focal length; ISO 100; 1/320 sec at f/10.*

one light and location. An establishing shot, an opener, and a moody upright shot that can be used on a single page. Providing a choice of shots like this shows your work is of a professional standard.

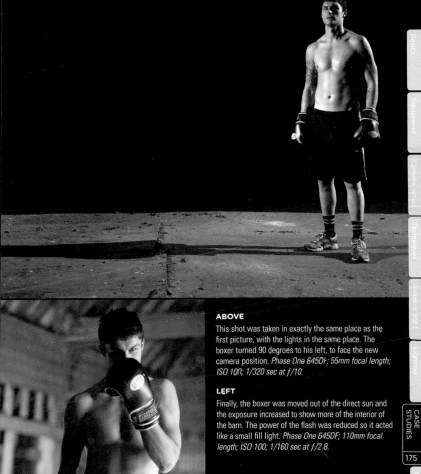

Basics

Equipment

Camera Setup

Techniques

Ambient light

Lighting

ABOVE

This shot was taken in exactly the same place as the first picture, with the lights in the same place. The boxer turned 90 degrees to his left, to face the new camera position. *Phase One 645DF; 55mm focal length; ISO 100; 1/320 sec at f/10.*

LEFT

Finally, the boxer was moved out of the direct sun and the exposure increased to show more of the interior of the barn. The power of the flash was reduced so it acted like a small fill light. *Phase One 645DF; 110mm focal length; ISO 100; 1/160 sec at f/2.8.*

ADVANCED

Now you've learnt the basics, we'll take a deeper look at some more advanced flash techniques. If you can master these, you'll be well on your way to becoming an expert on how to manipulate the light in any situation.

Basics

Equipment

Camera setup

Techniques

Ambient light

Lighting

Case studies

Using flash can be hugely addictive. You can start with an experiment or two—such as taking a single flash off-camera to play with creating a different look with shadows, and before long you'll be buying an umbrella, lightstand, and basic flash triggers. The size of your camera kit can easily escalate as your skill and confidence increases—along with the quality of your photography.

One softbox probably won't be enough, as you may want to experiment with the effects given by different sizes and shapes of softbox. Then there are honeycomb grids of different sizes, as well as snoots, umbrellas, and more. You may even find yourself spending hours reading the spec sheets of different beauty dishes, just to see how their light fall-off differs—a fascinating, but time-consuming hobby!

In this chapter we'll look at some advanced techniques that will really let you utilize your collection of kit. You'll delve into the exciting world of high-speed flash sync, in all its various guises (some is relatively simple to do using your camera's built-in lighting systems), and discover your camera's limits. We'll also look at a few handy tips for keeping your kit dry and how to use it in conditions that more cautious photographers might not attempt—such as out in the great outdoors.

You'll really know you've been bitten by the flash-bug when you find yourself examining every photograph you like and trying to work out how the shot was created: what sort of lights and modifiers were used, and what their position and distance was. Once you start looking at light with this amount of attention, your journey toward being a truly great photographer will be well under way.

LEFT

The telltale lighting signs here are the twin shadows on the floor at either side of the subject and the hard light that has been cast on him. It's obvious that two hard-light sources were used, and the pools of light produced by them show they must have been channeled through something like a grid to stop them spilling around and lighting the whole of the floor and back wall. *Nikon D3X; 56mm focal length; ISO 100; 1/200 sec at f/10.*

Advanced High-speed Sync

We've already seen how using Canon's E-TTL and Nikon's CLS system enables you to set a shutter speed higher than your camera's designated sync speed. This is called "Auto FP" or High Speed Sync (HSS). The flash pulses many times during the exposure as the shutter opening moves its way up the frame of the sensor.

You can't see the flash doing this—it's far too quick. It does reduce the flash power hugely, and as it's highly likely you'll be using this technique outdoors on a sunny day when you need lots of power, it's less than optimal. Added to that the issues around CLS or E-TTL using an infrared trigger system, and it can be unreliable.

There are other ways to achieve this, however. The first is to upgrade to the new Pocket Wizard Flex and Mini transmitters, currently only available for Canon and Nikon. These work using radio signals, so

are far more reliable than infrared. They don't need line of sight between the transmitter and receiver, so their range is far greater. They still use the camera's HSS or Auto FP mode, so the power of the flashes is reduced, but what the Pocket Wizard system does is to cleverly time the output of the pulses so that they are more efficient than when using CLS or E-TTL.

This means that in Nikon's case, less of the flash power is "wasted" before and after the shutter, so there is a small increase in power. The Nikon does have

BELOW

A Phase One medium-format camera and matching P40+ back, using a leaf-shutter lens, can sync full-power, short duration flashes at up to 1/1600 sec to eliminate virtually all motion blur. This shot, taken at 1/1250 sec, shows virtually no blur or ghosting on the leaping sportsmen. *Phase One 645DF; 55mm focal length; ISO 100; 1/1250 sec at f/9.*

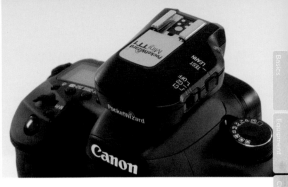

Basics

Equipment

Camera setup

Techniques

Ambient light

Lighting

Case studies

ADVANCED

179

ABOVE LEFT

The Pocket Wizard Flex receiver sits right underneath the Canon EX580 Mark II flash to give full automatic high speed sync.

ABOVE

A Pocket Wizard Mini transmitter on a Canon EOS 5D Mark II enables high-speed sync, as long as a dedicated Canon flash is used.

an built-in power threshold so there is not much of an improvement. However, in Canon's case, there is no upper cap and the Pocket Wizards really do improve efficiency. You can get the equivalent of up to a full stop more power– that's almost double the effective power output.

Certain lower-end cameras, however, use an electronic shutter. These tend to be compact cameras or some older mid-range DSLRs, like a Nikon D70s. These cameras have a normal mechanical shutter that works at up to around 1/125 sec, but after that, the camera's processing just "grabs" a slice of an image frame to get a faster shutter speed. These models can often sync with full-power flash at any speed without resorting to HSS or Auto FP. The unusual thing is that often they will only do this with non-dedicated flashguns, so a Nikon camera will do it with any flash other than a specific Nikon-dedicated flash. It'll also do it with any normal radio triggers.

The truly professional way of getting faster flash sync is to use a medium-format camera that has a leaf shutter inside the lens. A Hasselblad H-series camera can sync at any shutter speed, thanks to its in-lens shutters. However, it only goes as fast as 1/800 sec, which is not hugely fast. The more modern option is to go for Hasselblad's Phase One with their 645DF camera and range of leaf-shutter Schneider lenses.

The Phase camera has two shutters. The first is a regular focal plane shutter in the camera body that works with any lenses and goes up to 1/4000 sec. This can only sync at up to 1/125 sec, but if you fit the leaf-shutter lenses, and use the P40+, P65+, or IQ range of Phase One digital backs that go up to 80MP, then you can sync with flash at up to 1/1600 sec. Of course, this kit is very pricey but the quality is sublime, and it lets you underexpose the background like no other camera combination.

Hacking Sync With Power Pack Heads

Using the camera's built-in Auto-FP or High Speed Sync (HSS) setting is a great way of making your camera's flashes sync at all speeds. This works because at speeds greater than the conventional sync speed, the shutter is never fully open, but is a slit that moves across the shutter. To provide coverage with flash at speeds like this, the flashgun pulses very quickly, though pulsing flashes aren't as bright as one big burst of light, so the power is reduced and the flash's effectiveness is far lower.

There is another way of using this type of technique, except with more powerful flashes. If you use larger, pack-powered flashes—like an Elinchrom Ranger or Ranger Quadra—these are far more powerful, though the duration of the flash is often a lot longer than on small, hotshoe-style guns. That's especially true if you use the pack's standard heads rather than any available super-fast action heads.

So instead of using a pulsing light from a small flash, you instead use the longer and slower burn of a flash from a slower pack system—it's like using it as a very short continuous light source.

If your shutter speed is 1/1000 sec, for example, and your flash duration is also 1/1000 sec, then as long as you time the flash to go off at precisely the right moment, you will get an exposure where the flash lights up the scene. The key to doing this is fooling your camera into thinking that it is using its own Auto-FP or HSS system. What this does is actually trigger the flash earlier than if it was in normal operation at sub-sync speed. If you use Auto-FP or HSS, the flash goes off as soon as the first shutter curtain starts to move, which is exactly what you want.

As the slit of the shutter moves up the sensor, the long-burn flash exposes the sensor to its light. You may not get a perfectly even burn of light across the frame, so some parts may be slightly brighter than others, but in reality, if you are outdoors mixing flash with ambient light, it is often hardly noticeable. One way of making your camera system work this

RIGHT

This shot shows an even flash coverage from Elinchrom Ranger S-heads when used with a shutter speed of 1/1000sec on a Nikon D3X. This shutter speed is high enough to ensure virtually no motion blur and to darken the sky dramatically. *Nikon D3X; 24mm focal length; ISO 100; 1/1000 sec at f/6.3.*

way is to put a dedicated flash on the hotshoe, set to work as a high speed flash using Auto-FP or HSS mode. However, make sure to turn the power of this flash right down so it doesn't really affect the exposure.

You then need to use this flash to trigger the power packs to go off. One way to do this is via an optical slave. Alternatively, if your hotshoe flash has a standard PC jack socket, you can use this to trigger a radio trigger such as a conventional Pocket Wizard. A second Pocket Wizard receives this signal and triggers the pack heads to fire. A neater solution is to use the new Pocket Wizard

Flex and Minis. With these triggers, you plug them into your computer and can then alter the flash sync timing. Getting this right takes some experimentation, but it is worth it.

Remember that when you work with flashes in this way, you are essentially using them like a very fast continuous light source, and this means that changing shutter speed and aperture affects the overall ambient light and flash exposure. Changing the power of the pack head also affects its flash duration and color temperature, so some experimentation can be required to find the optimum setting for what you want to achieve.

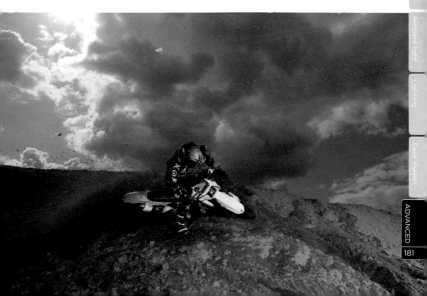

Basics

Equipment

Camera setup

Techniques

Ambient light

Lighting

Case studies

ADVANCED

181

Tips and Tricks

The more you use flashes in your photography, the more tips and tricks you tend to pick up along the way.

A useful tip is to keep everything in order. Specifically, it means labeling all your equipment so that if you mix with other photographers you know what kit is yours. It also helps if you can count your kit back into the bag at the end of the day.

It's also good to get some sort of system to help you set your flashes up as quickly as possible. If you have three flashes and label them A, B, and C, then it's obvious which one you should set on channel A, B, and C if you are using different wireless groups. Work out a system that makes sense for you, and stick to it. The quicker you can set your kit up, the easier it is to focus on what's important—taking a great photo.

Another tip is not to put your flashes away just because the weather is poor. If rain or mud makes you run for cover, you're missing out on lots of great photo opportunities. A clear plastic bag makes a perfect rain cover for a flash, especially if tightened up at the bottom with a strap that uses hook-and-loop fasteners. Using a see-through bag means the light can get out easily, and you can see your flash settings, too. It also means any infrared receiver windows don't get blocked. Don't try to seal the bag properly, though—flashes can generate a lot of heat so you don't want them to cook in there. It's better to leave an air gap at the bottom of the bag.

If you are using your flashes outdoors, especially on rough ground, you'll soon realize that getting lightstands to stay put can be a bit of nightmare. Some stands, like Manfrotto's popular 001B Nano, has very thin legs. These can actually be pushed into the ground to provide a more stable base, but they do bend quite easily.

Some outdoor flash photographers borrow from the world of fishing and buy fishing pole rests. These are available in a range of sizes and come with a spike on one end to dig into the ground, and a screw thread on the other. You can even find models that take standard photographic spigots, so you can easily fix a coldshoe on top. These poles often telescope out, using a small thumb screw, and they are widely available for not very much money. They're worth their weight in gold!

As a final tip, the best way to get more flash power is to use more flashes. If you go from one to two flash units, you double the power and get an increase of 1 stop, and by adding two more, you double this. The problem is often how to get four flashes so close together, and how to make them sync. Lastolite has recently launched a "Quad Flash" bracket, which holds four flashguns close together, fits in a large softbox, and only requires one radio trigger as a cable runs between each hotshoe.

The crucial point to remember is that more power equals more light, as well as a faster recycle time, as you can run the flashes at a much lower power level.

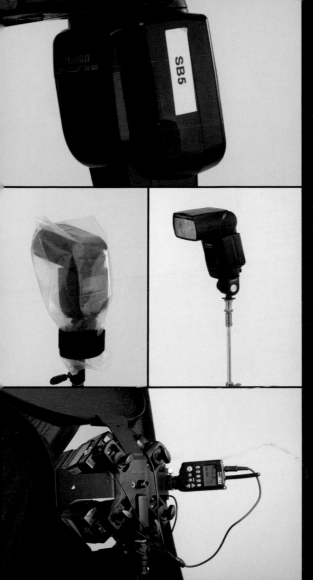

Bases

Equipment

Camera setup

Techniques

Ambient light

Lighting

Case studies

LEFT

Lots of different labeling machines make it easy for you to identify your kit. It can help in getting lighting set up fast, too.

FAR LEFT

A plastic bag and a hook-and-loop tie strap add some excellent shower-proofing to this Canon flash.

LEFT

A flashgun mounted on top of a fishing pole is a cheap and easy way to hold your flash stable on rough ground where lightstands might easily fall over.

LEFT

Lastolite's latest adapter allows four flashes to be fitted into a softbox for far more power.

Reverse Engineering

So now you know all the flash theory and how to put it into practice. You're armed with all the information you need on how to create great flash pictures in a studio or on location.

You know all about the properties of light—quality, direction, intensity, evenness, color, and contrast, and how to manipulate each of those properties using various light modifiers.

A final piece to the jigsaw is to look at photographs you like, and try to work out how the lighting was done for each shot. They may be naturally lit, lit with continuous lights, or with flash: you need to really look and consider what lighting challenges the photographer had to overcome and how

BELOW

The main light on the portrait is obviously a large light source to the right of the frame and slightly above the subject: this can be seen by the direction of the shadow made by the nose. A second light, off to the left of the frame and behind the model, was used for rim-lighting and is harder and more directional than the main light. You can also see a shallow depth of field was set, as the model's furthest shoulder is out of focus, so the flashes were obviously not used at high power. *Phase One 645DF; 110mm focal length; ISO 100; 1/200 sec at f/4.*

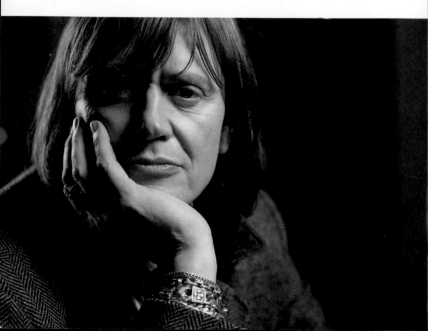

he or she did it. This doesn't just go for photographs—visit an art gallery and see how some of the Old Masters used light, and pay attention to every movie you watch to get an understanding of how the set was lit.

A good aid is to look closely at the eyes in a portrait, or examine any reflective surfaces in the shot, as they will often have a reflection of the lights used in the photo. Also pay attention to shadows, as each shadow was caused by a light source. The clues are all there: learn from how others work, and experiment with the techniques in your own photography. You need to be obsessed with light in order to use it to create something truly special.

BELOW
The ambient light provides the light on the buildings in the background. The light source on the subject is a gridded bare flashgun to the right of the camera: you can clearly see the pool of light it is making around the model. *Nikon D3X; 24mm focal length; ISO 400; 1/100 sec at f/4.*

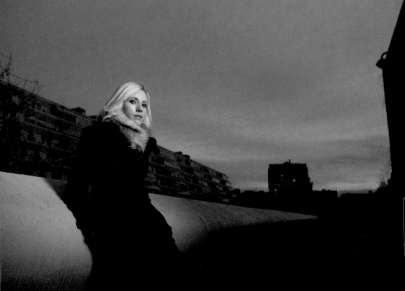

Basics

Equipment

Camera setup

Techniques

Ambient light

Lighting

Case studies

ADVANCED

185

Glossary

AMBIENT LIGHT

Or available light. Refers to the existing light—either natural like the sun or artificial like household bulbs—rather than the flash output.

AUTOMATIC MODE

A setting on the flash and camera where the exposure is worked out for you by the system's internal electronics. This can work using the camera's own built-in TTL system or via a cell on the flash itself.

BACKLIGHT

A light that separates the subject from the background. Sometimes called a separation light.

BARN DOORS

Barn doors attach to the front of flashes and are intended to stop light spilling onto certain areas of the subject.

BEAM ANGLE

The width of the pool of light output from a flashgun. Typically altered to match a focal length of lens.

BEAUTY DISH

A parabolic reflector dish fitted with a central reflector. Usually used in beauty and makeup shoots. Produces light that's relatively soft and broad, but often harder than a softbox. Available in a variety of sizes and finishes.

BOOM

An adjustable arm, usually positioned on top of a stand, that extends a light over a subject.

BOUNCE

Tilting your flash head so the light is reflected off a surface like a wall or ceiling.

BOUNCE CARD

A reflective piece of card that is fastened via hook-and-loop fastener to a flashgun for the main output beam to bounce off.

BRACKETING

Taking the same shot at different exposures to ensure one is "correct." Can also be used as "flash bracketing" where only the flash exposure changes. Bracketing is also good for taking images to use in HDR (High Dynamic Range) photography.

BUTTERFLY LIGHTING

A slightly high-angle, slightly diffused light source, centered on a subject's face to minimize nose shadow and emphasize cheekbones and flatter the face.

CAPACITORS

The flashtube is connected to one, or a series of capacitors, which store large quantities of energy to be released when the flash is fired.

CATCHLIGHT

The reflections of a light source in a subject's eyes.

COLOR TEMPERATURE

This is the color of any light source measured in Kelvin. (*see* Kelvin)

CLAMSHELL LIGHTING

Typical beauty lighting, with an overhead beauty dish aimed slightly down, and a fill light or reflector directly underneath it. The photographer shoots from between the two.

CLS

Creative Lighting System. This is Nikon's intelligent system for metering flash exposure. Can use an SU800 controller.

COLDSHOE

A clamp that holds the base of a flashgun without having any electrical contact.

CONTRAST

The degree of difference between the light and dark areas of a scene.

CTB/CTO

"Color Temperature Blue/Orange." Color correction gel to correct daylight to tungsten light, or vice versa.

DIFFUSED LIGHT

A softened light with less shadows and a more even coverage. This is usually achieved by directing light through a translucent material, for example, through a softbox or shoot-through umbrella.

DIRECTIONAL LIGHT

Light that does not spill and is directional. Soft Light can be made fairly directional by placing a grid on a softbox.

Basics

Equipment

Camera setup

Techniques

Ambient light

Lighting

Case studies

Advanced

DOME DIFFUSER

A plastic diffuser that fits on top of a flashgun. Sometimes called a Stofen after a commonly used brand.

E-TTL

Canon's intelligent system to meter flash exposure. Can use an ST-E2 controller.

EZYBOX

A softbox made by Lastolite that quickly snaps open. Can be made especially for flashguns.

FALL-OFF

The size of the area on a surface where light and shadows merge. Soft sources produce a gradual transition, and a subtle gradation of tones, while hard sources change abruptly.

FILL LIGHT

A secondary light source used to "fill in" the shadows cast by the main light.

FLAGS

Flags are usually solid shapes of material or card. They are often used to block light from going into unwanted areas, or to soften or reflect the light. They can be held in front of a light by hand, on a stand, or via an arm.

FLASH DURATION

This is the measurement of how long the flash fires for and is usually in 100ths or 1000ths of a second. A fast flash duration will give a more consistent color temperature and can be used to stop action more effectively. Small hotshoe flashes have very fast flash durations, and larger pack-powered systems tend to be slower.

FLASH METER

A flash meter is designed to read the fast durations of flash light and can determine the correct exposure. The ISO is set along with correct camera sync speed, then the aperture can be measured by the meter. When using two or more lights, a meter reading can be taken from each source to calculate contrast ratio. Many people nowadays rely on the camera's LCD screen and histogram to check exposure, but this does not work out ratios.

FLASHTUBES

The flashtube is made from quartz or Pyrex and is filled with xenon gas. When the power is released from the capacitors, the trigger circuit ignites the gas in the flashtube.

FLAT LIGHT

The results of low-contrast or close-to-the-lens lighting. Or too much fill.

FRESNEL

A convex lens, typically used to focus the beam of light in a continuous light source.

F-STOP

A number relating to the size of the aperture set on the camera's lens which affects exposure.

GEL

Also sometimes called Filter Gel. A piece of colored gelatin placed over the flash to alter the color of the light output.

GENERATOR OR POWER PACK

A generator is a large studio-type flash unit that features a power pack with sockets for external heads with flashtubes. It is powered by the mains, although some battery-powered pack units are becoming popular.

GOBO

A gobo is an object placed between the light source and the subject, so that its shape is illuminated onto a background.

GUIDE NUMBER

A rating of the power of a flashgun. Using the guide number, ISO and flash-to subject distance, you can work out the f-stop you need to set for the correct exposure. Divide your flash guide number (at a given ISO) by the distance to subject in meters to give you the f-stop.

HAIR LIGHT

An accent light limited to the top of the head.

HIGH KEY

Lighting that results in predominantly middle-gray to white tones.

HIGH SPEED SYNC

A flash mode in which shutter speeds higher than the usual maximum sync speed can be set. Usually achieved by using a flash unit that pulses. Can be called HSS or Auto FP.

HONEYCOMBS

A honeycomb or honeycomb grid looks like a bees' honeycomb with a series of small holes across its width. Used in front of a flashgun, it channels the light into small direct pools, ideal for the portrait and product photographer.

HONL

A line of light modifiers developed by photojournalist David Honl.

HOTSHOE

A mounting port on top of a camera onto which an external flashgun or flash trigger fits. Most cameras use a standard size hotshoe, apart from Sony, who have their own unique fitting.

INTENSITY

Light level or output. The "strength" of the incident light independent of subject reflectivity.

JOULES

Joules are a measurement of electrical energy, rated the same as watt seconds. (see Watt seconds)

KELVIN

The Kelvin is a unit of temperature measurement. Degrees Kelvin, or color temperature is used in color photography to indicate the color balance or spectrum of light emitted from a light source. Daylight is roughly 5600 degrees Kelvin and most flashes emit light at approximately this value.

LENS FLARE

A ghosting effect when light is directed or refracted into the camera lens.

LOW KEY

Lighting that results in predominantly gray to middle-black tones with few light areas.

MAIN LIGHT

The primary light source. This can be the ambient light or an artificial source, and is typically the brightest light that causes the most prominent shadows.

MODELING LAMP

The modeling lamp is a continuous light source that approximates the affect of the flash but is only available on larger pack-style systems. Some flashes, like Nikon's SB800, can emit a modeling-light effect from the flash-tube for a few seconds.

MONOBLOC

A monobloc is a studio-style flash head that incorporates the flashtube, modeling lamp and power, all in the same unit that run from the mains. Converter packs are available so you can use them off battery packs.

PHASE ONE

Manufacturer of cameras, lenses, and digital camera backs.

QUALITY OF LIGHT

The attributes that affect the quality of light emitted and the overall lighting look. Can be hard or soft, have high or low intensity, can come from any direction in relation to the lens/subject axis, has a certain color, and a beam pattern. Everything but color is affected by the light's size and distance from the subject.

RADIO TRIGGER

A wireless device used to trigger flash (or cameras). Popular brands include Pocket Wizard, Elinchrom Skyport, and Radio Poppers. Often superior to infrared systems as they work over wider ranges and don't need line of sight.

REMBRANDT LIGHTING

The dramatic emphasis of a few planes or features of the subject's face by using accent lights or shadowing devices that keep the rest of the scene very dark. Typically, there is a small triangle of light on the cheek of the subject nearest to the camera.

RATIO

This is the split of light between the various lighting sources. A ratio of two or three to one means that one light will be two or three times the power of the other. This will create highlights and shadows that give a more three-dimensional look to a portrait or product shot.

RECYCLE TIME

The time it takes the capacitors in a flash to recharge and be ready to fire again after the flash has been discharged. In other words, the time that it takes the capacitors to recharge themselves ready for the next shot.

RIM-LIGHT

Subjects appear to have their back turned to the light. Sometimes several sources are aimed at the subject from hiding places, more or less behind the subject.

RING FLASH

Also known as a ring light. The ring-around-the-lens electronic flash that gives an image without shadows or modeling.

SLAVE UNIT

An electronic "eye" that triggers a flash whenever it picks up a flash from another unit. Typically it's a built-in light-sensitive system.

SOFTBOX

A softbox is a box made from a rigid framework, with diffused material stretched over it and a piece of diffused material on the front. They are widely used because they produce an even spread of light over a large area. Softboxes come in different shapes and sizes, such as square, rectangular, hexagonal, and round.

SNOOT

An attachment for the front of flashguns to channel the light into a small pool, often used as a hair light.

STROBE

Really a flash used sequentially for special effects, but now shorthand for an electronic flashgun.

STROBIST

A fan of using strobe lights! As popularized by the blog Strobist.com.

SYNC

Short for synchronization. The connection from the flash to the camera. This can be via a lead into the camera's PC socket, or through the hotshoe. The circuit is used to fire the flash head at the precise moment of exposure.

SYNC SPEED

The maximum shutter speed a camera can be set to in order to get full coverage of the subject when a flash fires. At speeds faster than this, the flash doesn't cover the whole frame and a black line can typically be seen on the image.

TTL

Through the lens. Typically a camera measures exposure of a scene by taking a reading through the lens. Can also be used to calculate flash exposures on dedicated systems.

UMBRELLA

Photographic umbrellas convert hard or broad lights into large soft sources. They can be shoot-through or reflective. Reflective umbrellas are also available in a variety of surface finishes, such as gold to warm up a subject, silver to make the light show more contrast, or white for neutrality.

WATT SECOND/JOULES

A watt second or Joule is the measurement of electrical energy used in flash systems to indicate the amount of energy in the flash capacitors. As it does not take into account the energy efficiency of the flashtube or its reflectors, it is not a reliable measurement to comparatively assess light output.

Basics

Equipment

Camera setup

Techniques

Ambient light

Lighting

Case studies

Advanced

Index

Basics

Equipment

Camera setup

Techniques

Ambient light

Lighting

Case studies

Advanced

Acknowledgments

This book could not have been put together without the help of a large number of people. You know who you are, and if your name is missing please forgive me! But that said, I would like to acknowledge gratitude to all of the following:

Dave Beck, Chris and Emily Whittle, Louise O'Shea, Kev Treadwell, Brian Collier, and the crew at The Flash Center.

Gary Astill, Mark Langley, and everyone at Lastolite.

Craig Calder at JP Distribution.

Nic Duckworth of Ameliorate Retouching.

Bob Q. Martin of Bob Martin Photography.

John Owen of Phototraining.co.

Hardy Haase of Flaghead.

Gareth Chubb at CR-Eative.

Lots of colleagues at Factory Media, Emap/Bauer Consumer Media, Bright Publishing, and Dennis Publishing.

Students and staff in the photography department at Tresham Institute in Kettering.

Adam, Zara, Natalia, and Tara at Ilex for all their help and support.

And to the people in many of the photos: Amie Field, Amy Kitchingman, Ashli Rosetti, Dave Willet, Emma Giddings, Gert Krestinov, Jake Nicholls, John Owen, Julian Challis, Katie Green, Leah Hibbert, Max Anstie, Michael Vaughan, Nic Duckworth, Nick Sanders, Richard Jobson, Robin Fenlon, Shaun Simpson, and Tom Church.

Above all, it has been thanks to Nic and Lula Duckworth who have given me the encouragement, space, and support to write and work. I thank you all.

Adam Duckworth B.Sc (Hons) ABIPP